PHOTOGRAPHS BY
# SNOWDON
A RETROSPECTIVE

# SNOW

PHOTOGRAPHS BY

VDON

A RETROSPECTIVE

With contributions from Drusilla Beyfus, Simon Callow, Georgina Howell, Patrick Kinmonth, Anthony Powell, Carl Toms, and Marjorie Wallace

HARRY N. ABRAMS, INC., PUBLISHERS

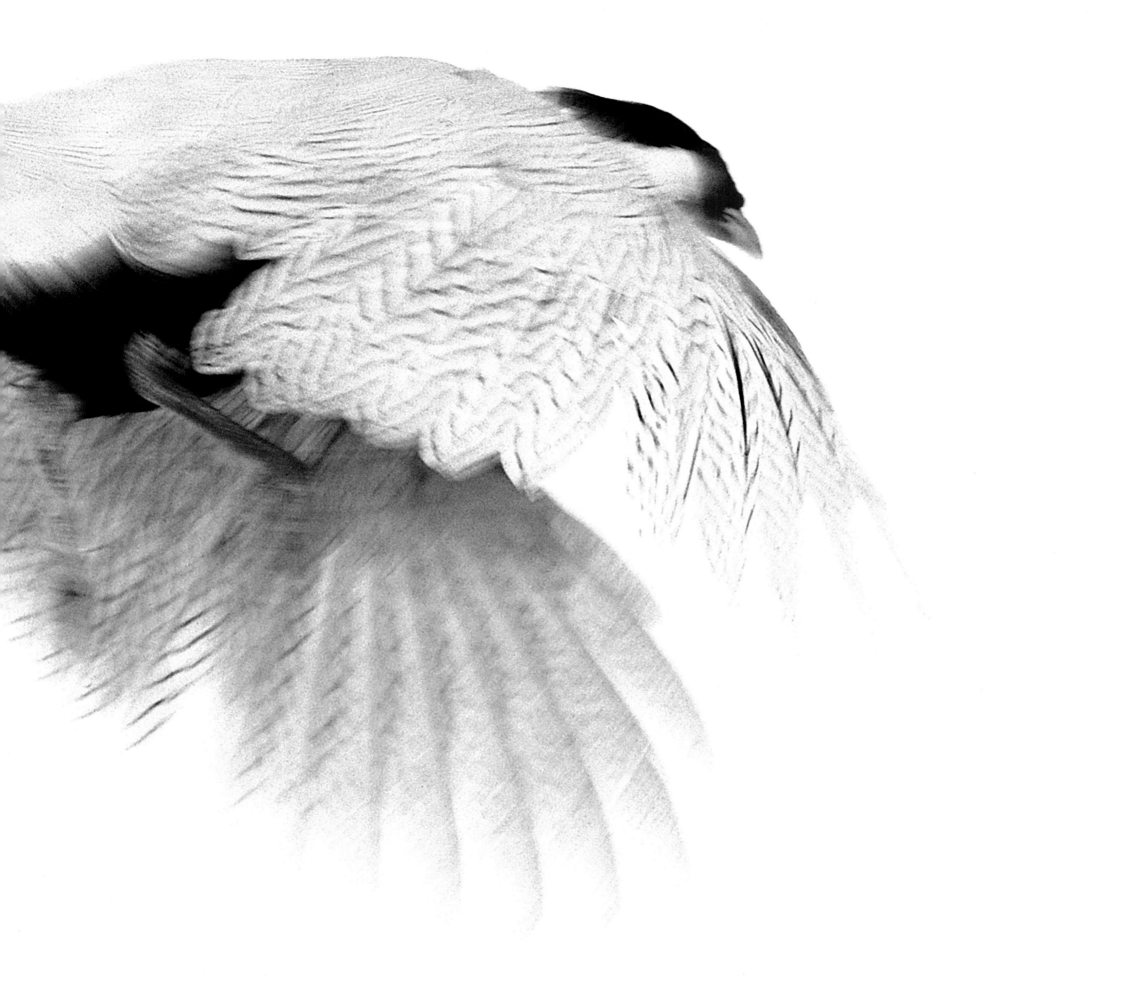

Published to accompany the exhibition *Photographs by Snowdon: A Retrospective*,
held at the National Portrait Gallery, London, from 25 February to 4 June 2000
and at the Yale Center for British Art, New Haven, Connecticut, from June to August 2001.

First published in Great Britain by National Portrait Gallery Publications, London

Library of Congress Catalog Card Number: 99-69364
ISBN 0-8109-4479-0

Curator: Robin Muir
Publishing Manager: Jacky Colliss Harvey
Design: Price Watkins
Picture Archivist: Carla Preston

Published in 2000 by Harry N. Abrams, Incorporated, New York

Printed and bound in Italy
Frontispiece: Silver Pheasant 1988

Harry N. Abrams, Inc.
100 Fifth Avenue
New York, N.Y. 10011
www.abramsbooks.com

# CONTENTS

# FOREWORD

I REMEMBER the first time Snowdon came to lunch. I had never met him before. Even before we had walked along the corridor leading from the entrance hall of the National Portrait Gallery, he had begun to be wildly indiscreet, as well as funny. I have realised since that some of his stories have been well rehearsed, but, as with the best raconteurs, his anecdotes only get better when one hears them again.

His photographs have many of the same qualities. There is a light-heartedness and an anarchic sense of humour to them, as if human beings are there to be enjoyed for their quirky individuality as well as for their creative spirit. As early as the 1950s, his photographs had included elements of social realism, but these never drowned out his essential optimism. Even his most grittily realistic works of the mid-1960s were created alongside those where one can sense his enjoyment of the democracy of new worlds becoming available to him, painters and writers and actors all queuing up to be photographed by him either for the *Sunday Times* or for *Vogue*.

Occasionally one may wish that he took himself slightly more seriously as a fine art photographer (he disparages the status of photography as a fine art medium), but I think that his spirit is essentially jaunty, preferring to record the character of the people who sit to him, rather than wasting too much time on the complexities of composition. After that first lunch, we hopped into a taxi to go to Snowdon's house in Kensington. He was very apologetic about the state of his archive. But I have seldom seen an archive so neat and orderly, with files and files of photographs dating back to the early 1950s, carefully maintained, from childhood to the period living in Rotherhithe as a young-man-about-town, to the Sixties when he was himself part of a broader cultural movement of which he was a recording angel, and through to the present, during which he has continued to be greatly and rightly in demand as a photographer.

All his life Tony Snowdon has known everyone worth knowing. Here they all are, a complete cross-section of society: kings and queens; the Princess of Wales captured as if she had just walked in from a shower of rain; the whole world of London fashion, theatre and the arts in the second half of the twentieth century. Snowdon was always there as participant and observer.

That the National Portrait Gallery might hold a retrospective exhibition of Snowdon's work is an idea that dates back to the late 1960s, when Sir Roy Strong first suggested it. I am very delighted that the exhibition is finally taking place, and am particularly grateful that Snowdon himself has devoted so much time and energy to the project, selecting appropriate images, advising on the contributors to the catalogue and taking the deepest possible interest in all aspects of the display. He has been assisted in the selection by Robin Muir, with whom the Gallery has enjoyed a long-standing and excellent working relationship. At an early stage, Nicholas Coleridge pledged the support of *Vogue* to the exhibition, which was an act of exceptional generosity. And, more recently, the whole project has been made possible by the major sponsorship of Andersen Consulting. I am deeply indebted to all these and to many others besides: Pim Baxter, Martha Brookes, Jacky Colliss Harvey, Kate Crane, Alison Effeny, Fulvio Forcellini, Celia Jones, Emma Marlow, Carla Preston, Ian Price, Ben Rawlingson Plant, Vicky Robinson, Steve Russell, Kathleen Soriano and Ray Watkins.

Charles Saumarez Smith
*Director*

# SPONSOR'S FOREWORD

TO be involved with one of the first major photographic retrospectives of the new century is very exciting. All the more so since its subject, Snowdon, is one of our most accomplished and versatile photographers. Snowdon has played a major role in increasing the popularity of photography, which perhaps makes it all the more surprising that the National Portrait Gallery is the first gallery to launch a comprehensive retrospective of his work. Throughout his long career he has maintained the desire to bring a fresh approach to his subjects, whether these are ballet dancers, models, actors, musicians or painters; or, in his documentary work, children, the elderly or the mentally ill. Neither should we forget his unique contribution to design, the written word and film, all of which he has embraced with the same energy. Snowdon's fondness for London is well documented. As Tony Armstrong-Jones, his first book of photographs, published in 1958, was about London people and London life. It is therefore appropriate that this major exhibition of Snowdon's work should originate in the capital, both because his fascination with London is reciprocated, and because the sheer importance of his work demands a place in one of Britain's most popular galleries.

The sponsorship of this unique record of Snowdon's fascinating work is the first time that Andersen Consulting has supported the National Portrait Gallery. As an organisation that helps some of the world's leading companies to create their future, we take our hats off to what has been achieved by the Gallery over the past few years. A major contribution to the Gallery's success has been the outstanding quality and widespread appeal of its temporary exhibitions. We are delighted to support the Gallery as it goes from strength to strength and to be involved with what we hope will be its most successful venture to date. We also hope you enjoy this unique book, which showcases the full variety of the photographic work of one of the most gifted artists of our time.

James Hall
*UK Managing Partner*
Andersen Consulting

*To my dear grandson, Charles*

# CARL TOMS

PEOPLE meeting Tony for the first time have to undergo a disconcerting critical scrutiny, his X-ray eyes stripping away whatever façade they have chosen to present to the world, trying to discover what makes them tick and whether he should bother with them at all. If he likes what he finds, his friends sigh with relief and the world soon becomes rosy. He can be a scintillatingly funny and enchanting man to be with. He can also, however, as his friends and enemies know, be truly quite maddening, stubborn and wayward, forever doing the unexpected, his often wicked, mischievous sense of humour pushing him into outrageous, convoluted intrigues which can leave one open-mouthed. He has a complicated, illusive, many-faceted personality, constructed on the grand scale and endlessly fascinating, but what one sees is only the tip of the iceberg since he likes to be something of an enigma. I gained some insight into his character before I even knew him because I worked for several years for his famous uncle, the designer Oliver Messel. They are a formidable dynasty, the Messels. His mother was a renowned beauty in her youth and had great style and taste. His great-grandfather, Linley Sambourne, was a famous artist for *Punch* whose house is now a Victorian museum. His great-great-uncle, Alfred Messel, was a famous German architect who pioneered steel and glass construction and who had a street named after him in Berlin. Tony has inherited all of their flair and tenacity along with most of their idiosyncrasies. He is a modern eccentric with an eccentric's absolute determination to have his own way, which can goad people to the brink of assassination only held back by a charm that could halt a ravening beast in its tracks. His restless inquisitive nature seldom allows him to sit down, or even stay in one place for long. He must always be doing something, making something or teasing someone, going to astonishing lengths to set up a practical joke, usually to amuse his friends, but quite often to debunk some pompous pretentious snob, to whom he has taken a dislike.

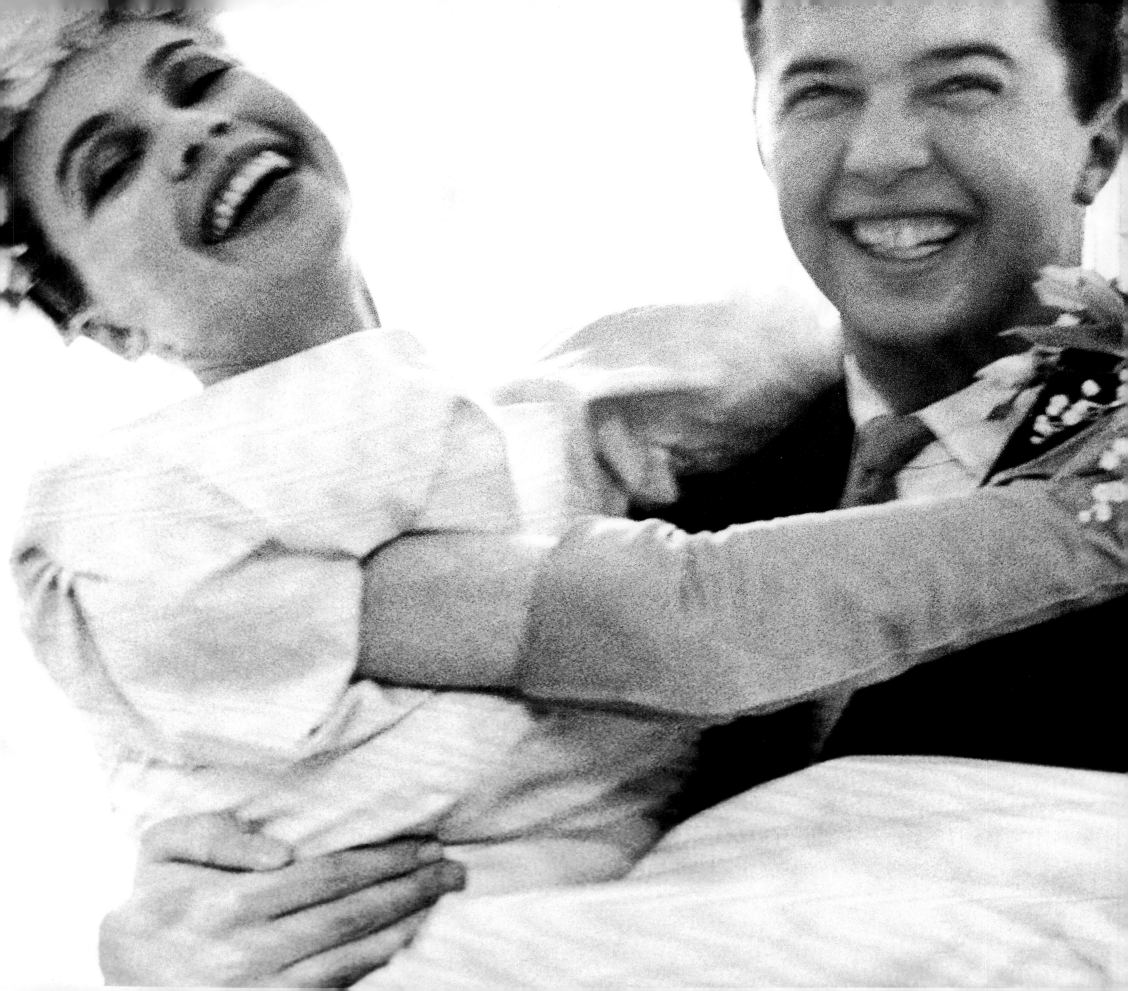

Leslie Caron and Peter Hall's wedding 1956

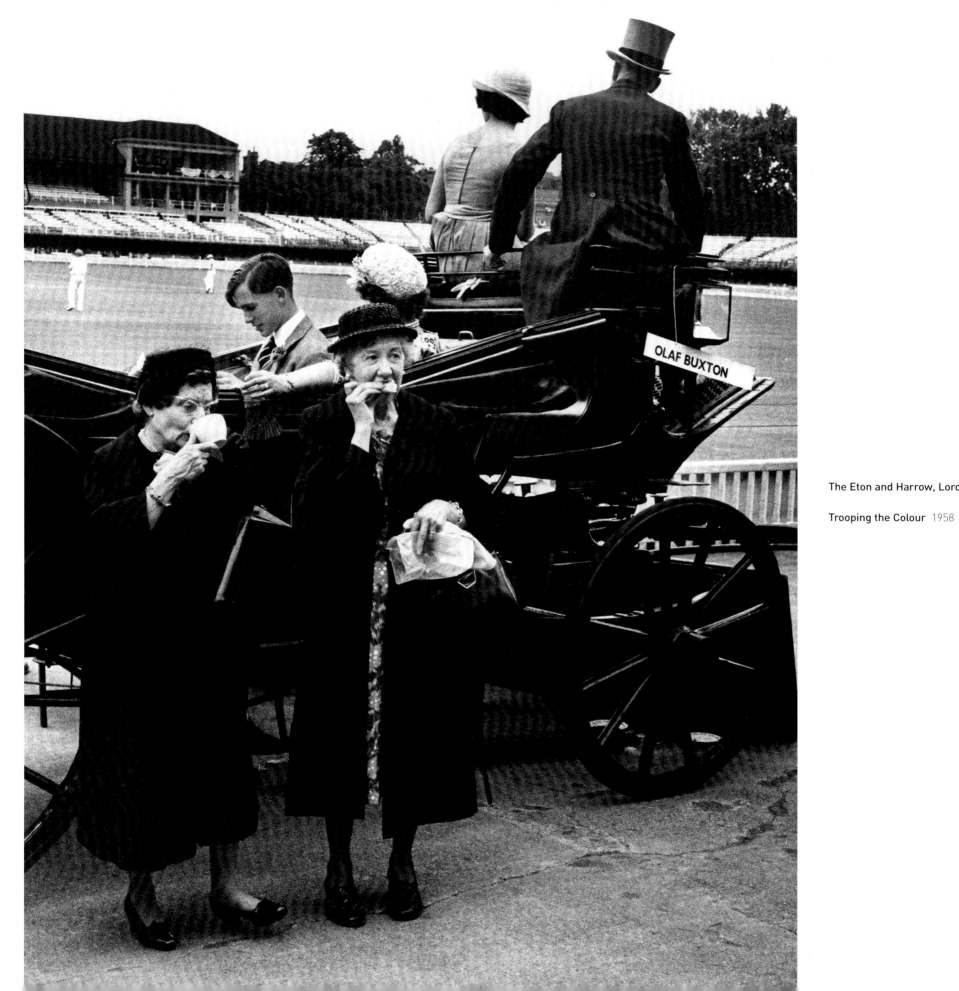

14

The Eton and Harrow, Lord's 1958

Trooping the Colour 1958

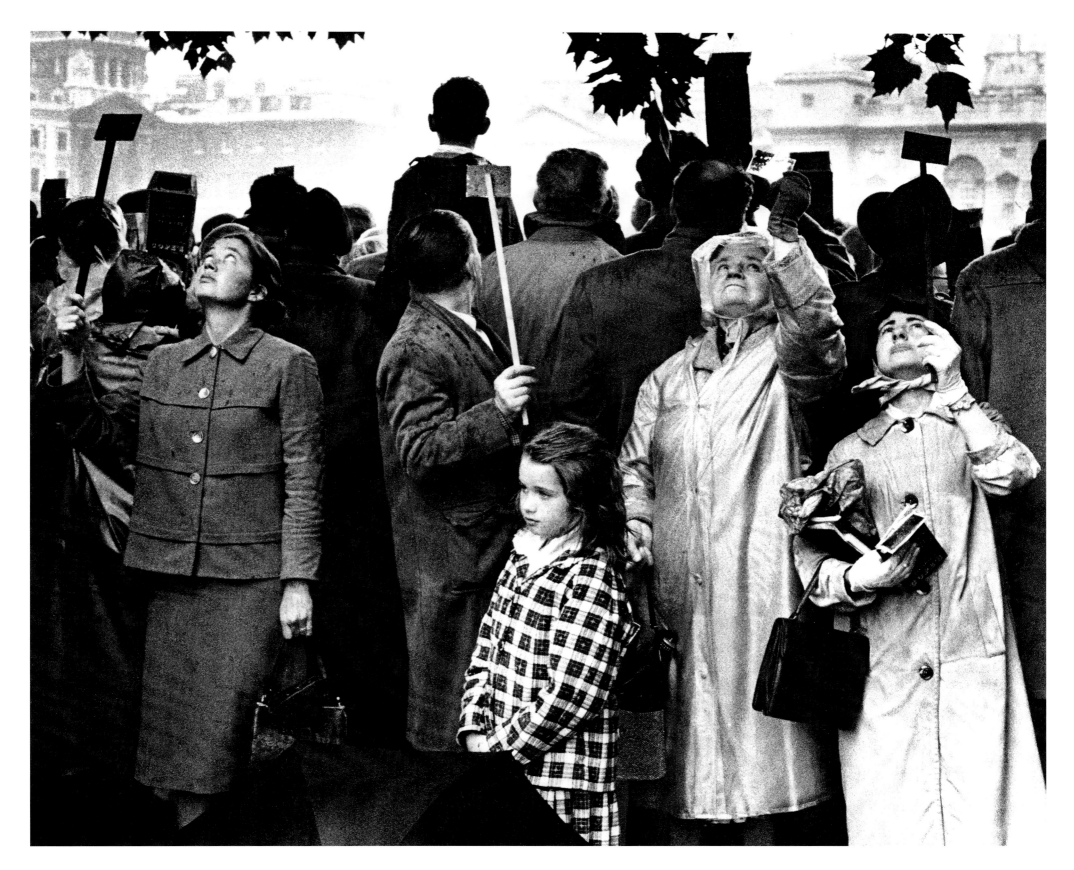

16    The Last Presentation, Buckingham Palace  1958

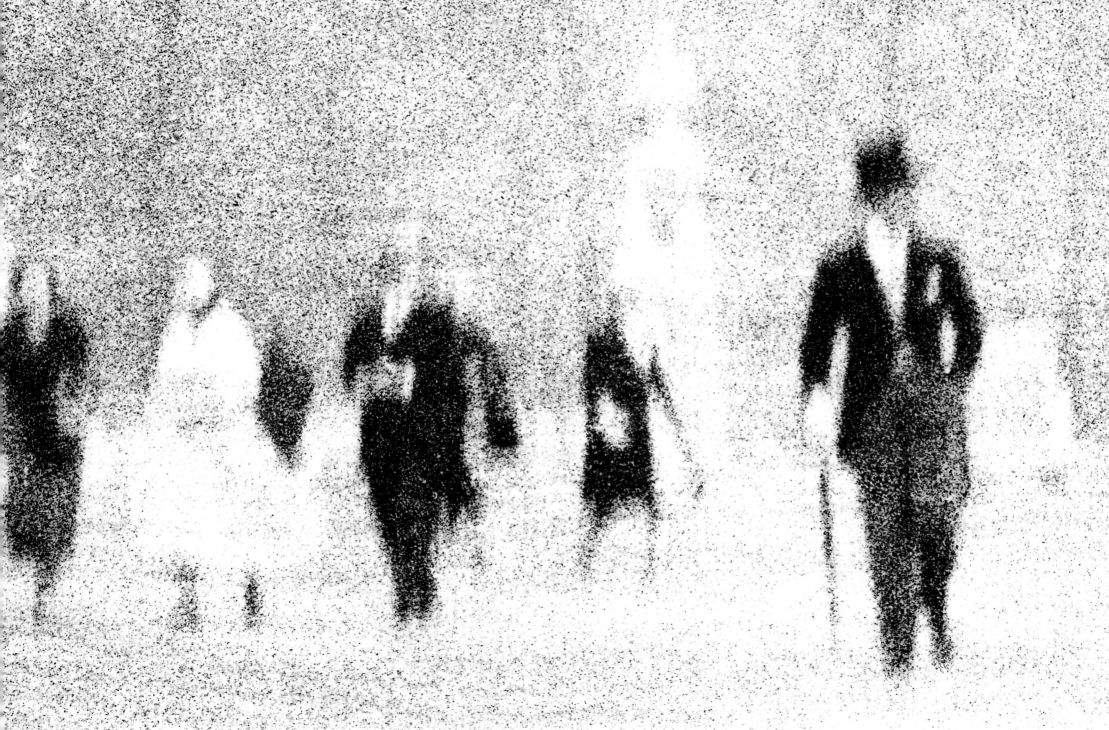

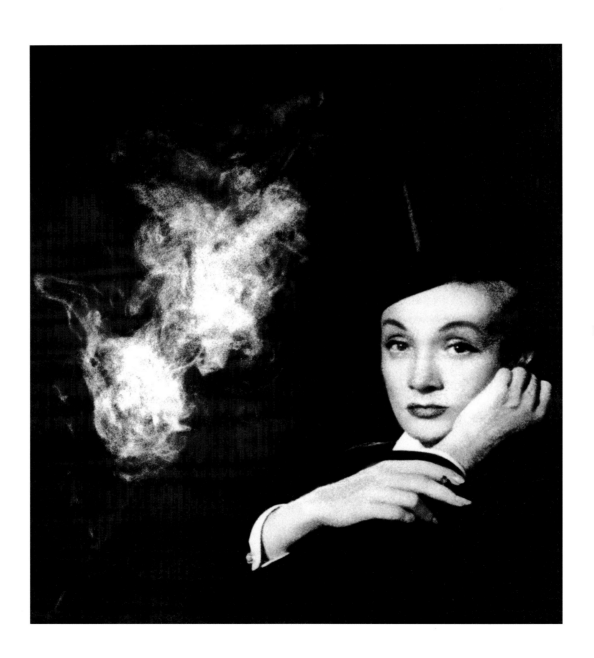

Marlene Dietrich, Café de Paris  1955

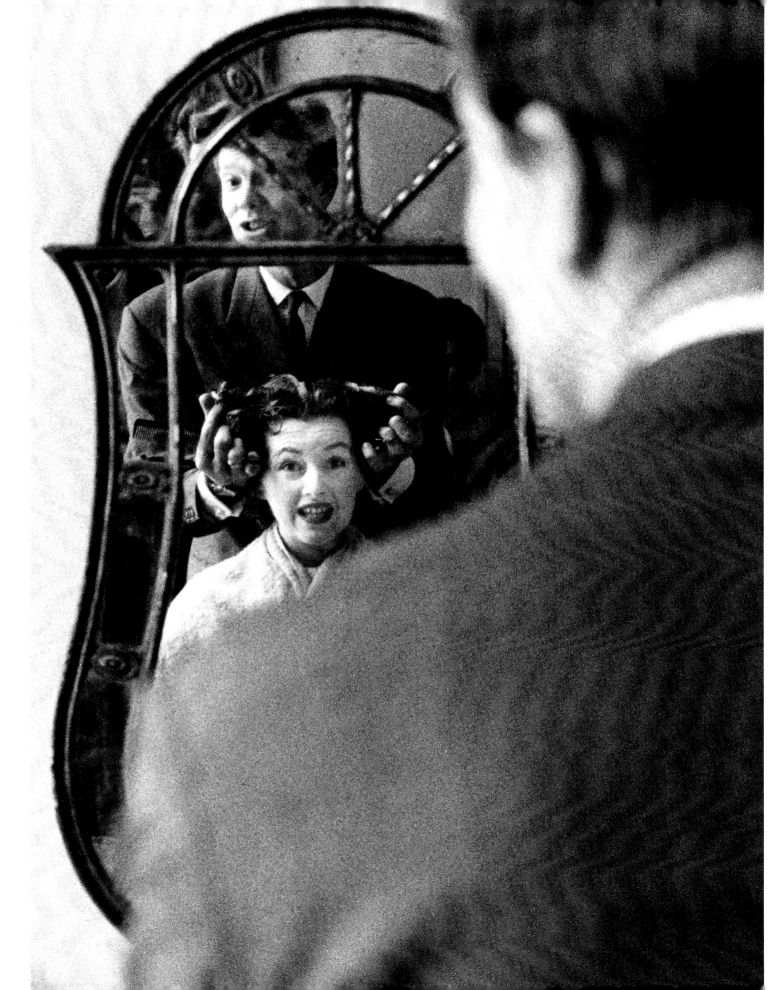

Lady Lewisham with Monsieur René, Mayfair  1958

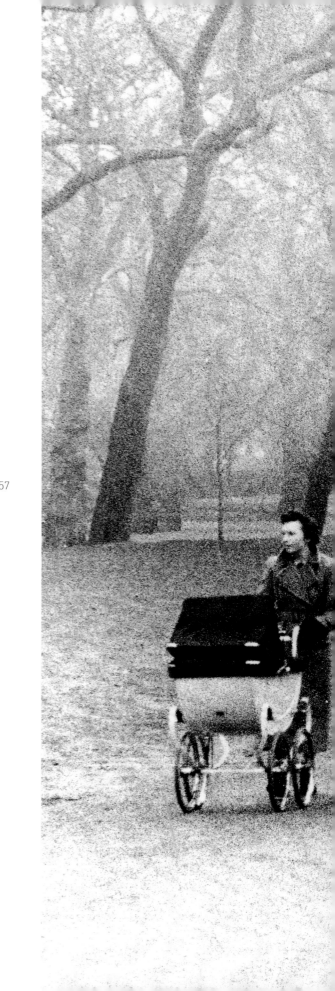

Nannies, Rotten Row 1957

20

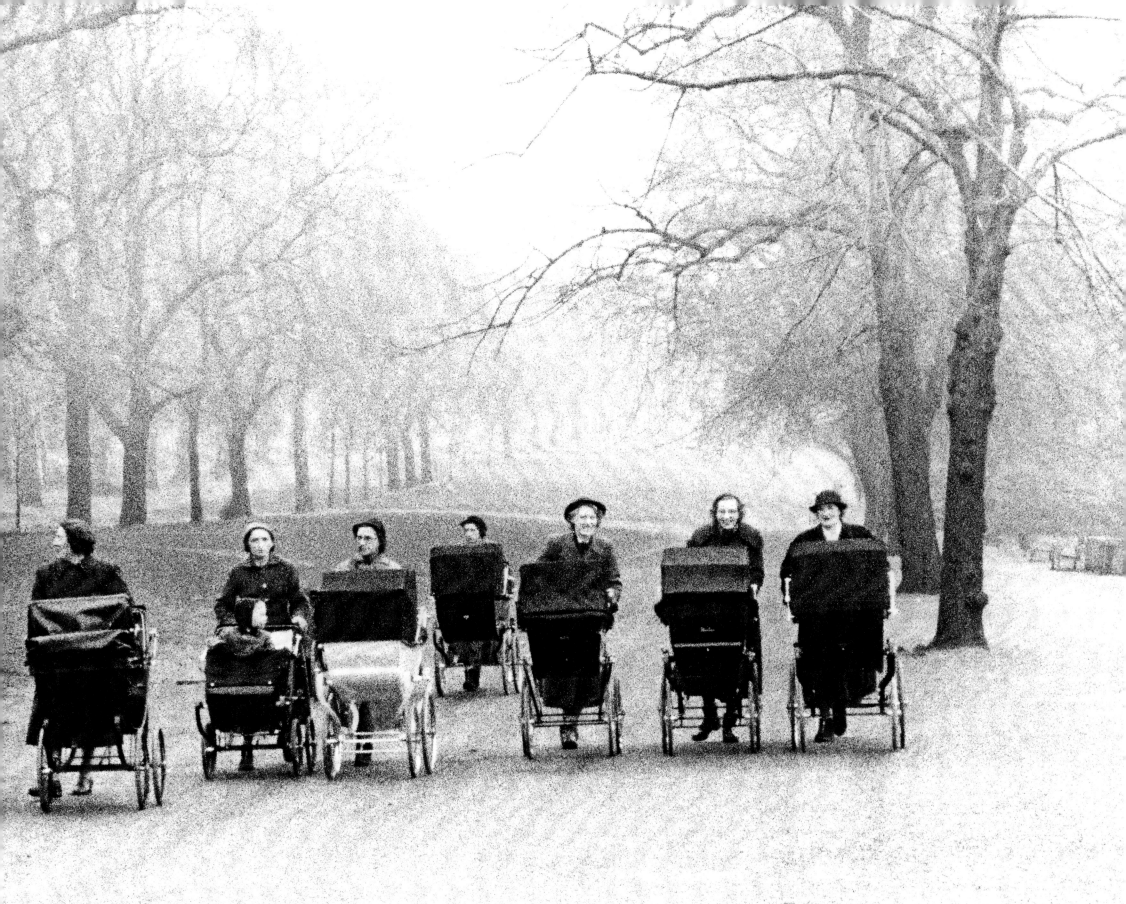

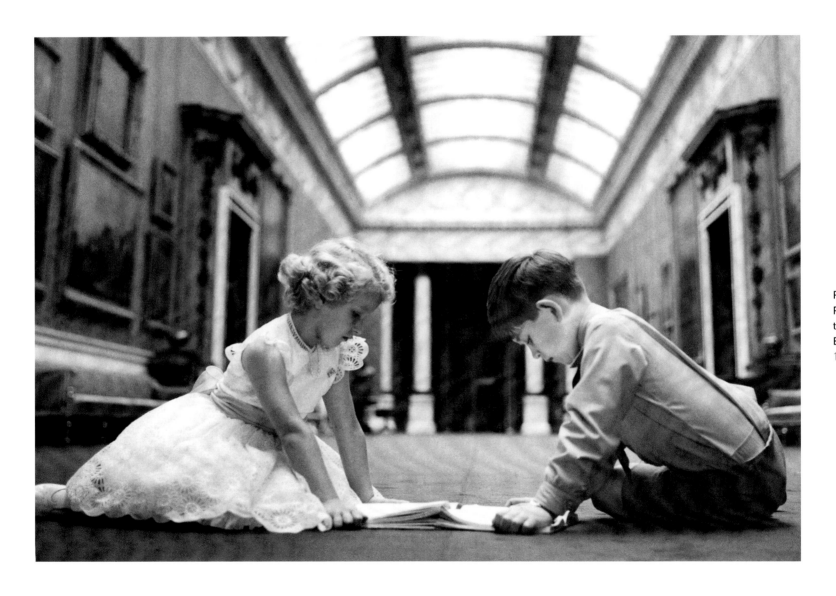

Prince Charles and
Princess Anne,
the Picture Gallery,
Buckingham Palace
1957

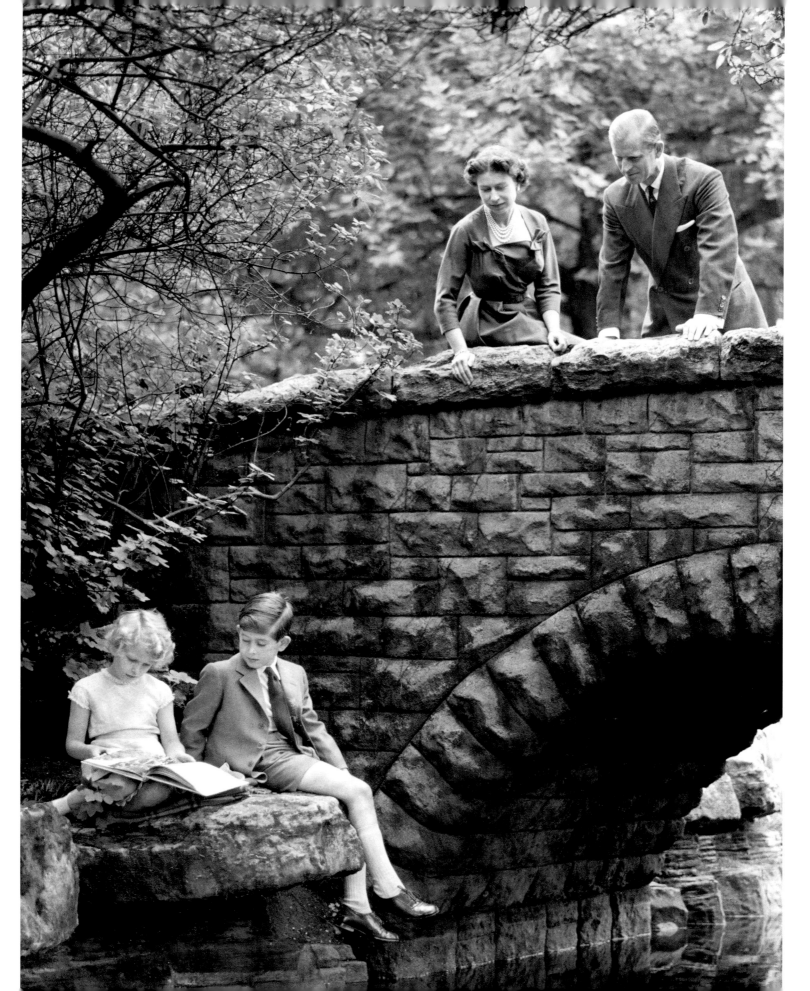

The Queen,     23
Prince Philip
and family,
Buckingham Palace
1957

Overleaf:
Queen Charlotte's
Ball, Grosvenor
House 1958

26    Sunday lunchtime, Bridge House Hotel, Canning Town  1958

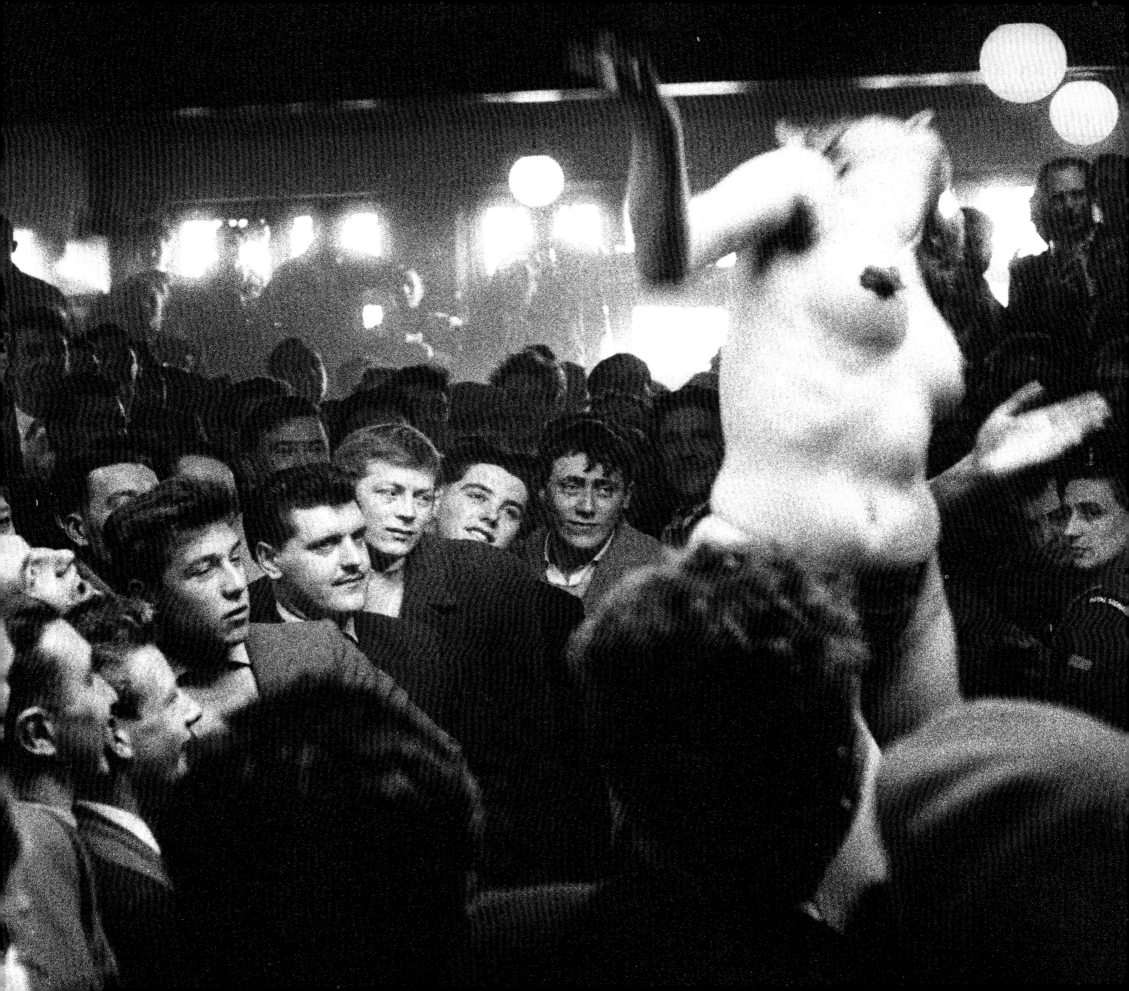

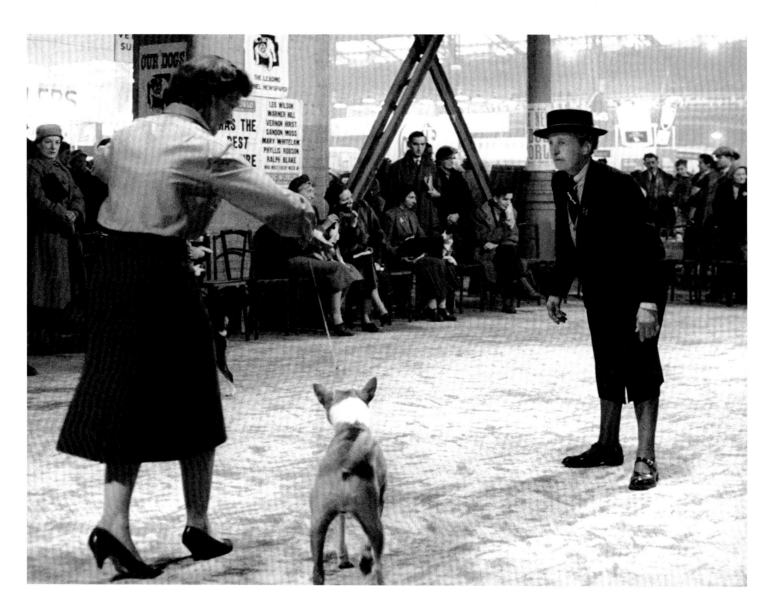

Crufts Dog Show,
Olympia 1958

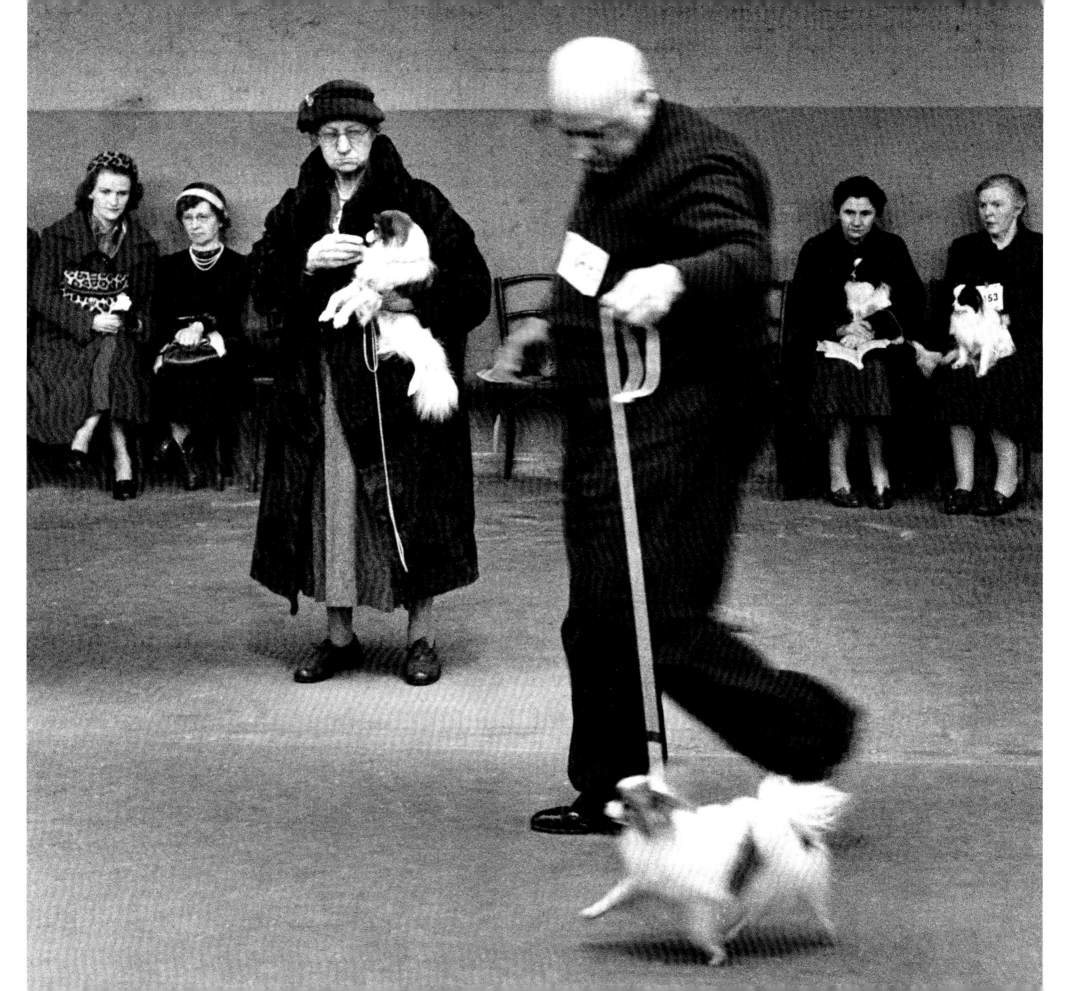

# PATRICK KINMONTH

SNOWDON'S photography was born of the theatre. His eyes were opened by his uncle, the stage designer Oliver Messel, whose work consisted of making illusions out of a few pipe-cleaners and some papier mâché that looked breathtaking from a distance but reverted to their mundane constituent parts upon closer inspection. This shadow-play between ordinary and extraordinary can, in retrospect, be seen to be the foremost influence on the early talent of the photographer who, by 1957 (aged twenty-seven), had already had his first exhibition and was being hailed as heir to Cecil Beaton and John French, the prevailing photographers of the day.

Snowdon's most artistically successful early photograph was, it seems to me, of Alec Guinness in 1956. It was also his first commission for *Vogue*, and was taken on-stage in available light (virtually nil). The result was an image so grainy that once exploited in the printing it degraded into a million black dots, only truly readable from a distance. Looking at it now, it is as if the photographer asks the question, like a medium, 'Is anybody there?' and is surprised to find this unforgettable face emerging from the dark.

Snowdon seems in retrospect to have enjoyed a little too much the disapproval that greeted his Guinness photograph, from the Royal Photographic Society amongst others, and took graininess to further extremes in his 1957 photograph of John Gielgud and in the marvellously blurred and grainy Lowry-like image of Gulbenkian, the oil magnate, strutting around the Round Pond in Kensington Gardens in 1958.

Like Julia Margaret Cameron, whose images are most intense when most technically abject, the young Tony Armstrong-Jones, as he then was, loved the chaotic cookery and improvisation of his first successes. They appealed deeply to his two paradoxical characteristics: a profound wish to irritate the pretensions of the establishment (photographic and otherwise) and an equally determined 'Uncle Oliver'-ish desire to make magic out of nothing – a little light, a little click, nothing to it. In fact one can sense that his home-made equipment was as important to him as anything it produced. Tellingly preserved in his studio is the beautifully fashioned aluminium sound-proofed case he devised to house the 2¼" camera he used for taking stealthy, silent pictures during performances. So too is his first home-made lighting system, which consists of a box lined with forty 100-watt light bulbs. What Snowdon likes about it is the way it splits into two and clips shut with all the bulbs nestling between each other, as much if not more than the simulation of soft daylight it produced in his pictures.

Right from the start of his interest in photography, Snowdon has been attracted by its strange relationship to perceived reality. From Cocteau and Beaton to Angus McBean and Madame Yevonde, surrealism in the Twenties and Thirties influenced the path of studio photography. Borrowings from de Chirico, Magritte and Dalí were rife in artistic circles. Marcel-waved heads burst through walls of silver paper, arms appeared to be surgically removed, ants were freely applied and cracks appeared all over the faces of society beauties (of whom Tony Armstrong-Jones's mother was a sharp-nosed prime example). He played with surrealism from an early age, albeit a *Boy's Own* variety, more party trick than psychological flaying. At Eton he took a skittish picture of a hundred matches, apparently photographed in a long exposure, falling from their box. The illusion is created of time being frozen, of gravity defied by photography. It is a perverse little picture – in fact the matches had been painstakingly glued together, and only appear to be captured by a flash. The surrealism is technical, the joke not only 'How did he do that?' but 'What IS going on?'

Theatre, drama even, was brewing off-stage as well. In 1950 Tony Armstrong-Jones failed his architecture exams at Cambridge and decided to commit himself to a career in photography. His record of the moment is a telegram from his mother which reads 'DO NOT AGREE SUGGESTION CHANGING CAREER TELEPHONE THIS EVENING FONDEST LOVE = MUMMY'. As is so often the case with advice by telegram it came too late. That, one might say, was the point of telegrams.

Snowdon vacillated between immediate, often impressionistic photographs, at their most revealing when least in focus, which anticipate the freedoms and revolutions of the decade to come, and a fastidiously arranged mode of photography which was a direct development of the enforced formality of nineteenth-century studio portraiture. These two tendencies, the stiff-backed versus the wild and free, were mirrored in 1950s London. Dickens's smoke-black city, all tugs, toppers and pearls, was still very much alive (as Armstrong-Jones's book *London* proved in 1958), alongside emergent creative dissidence that recognised no boundaries. Rank and rôle met rock and roll. In the theatre it would lead to new work in which Armstrong-Jones's vivid photographs made their contribution. Significantly, for his first important royal commission, in a moment perhaps of nerves, he chose to revert to the absolute control of a pre-designed portrait in the painterly tradition, even to the point of an extant drawing in which he outlined the exact composition and each sitter's proposed place in it. More significant still in another way, he later met and married Princess Margaret and in 1960 it was unclear whether his work as a photographer would continue.

Suddenly he was an earl and an architect. His horizons both exploded and narrowed. We need only compare the little wooden Messelish bird-cage – all *thé dansant* Gothick – which Snowdon designed in 1959 with the super-modern Regent's Park Aviary of 1963 (now a Grade II* listed building), with its steel-cabled play of compression and tension towering over the zoo, to see this in action. And following the pattern of his life he might not have taken more photographs unless commissioned to do so. But he was, by Mark Boxer, who started the colour supplement of the *Sunday Times* and this, being uncommercial in its aims, allowed Snowdon to return with renewed authority to his photographic career in 1964.

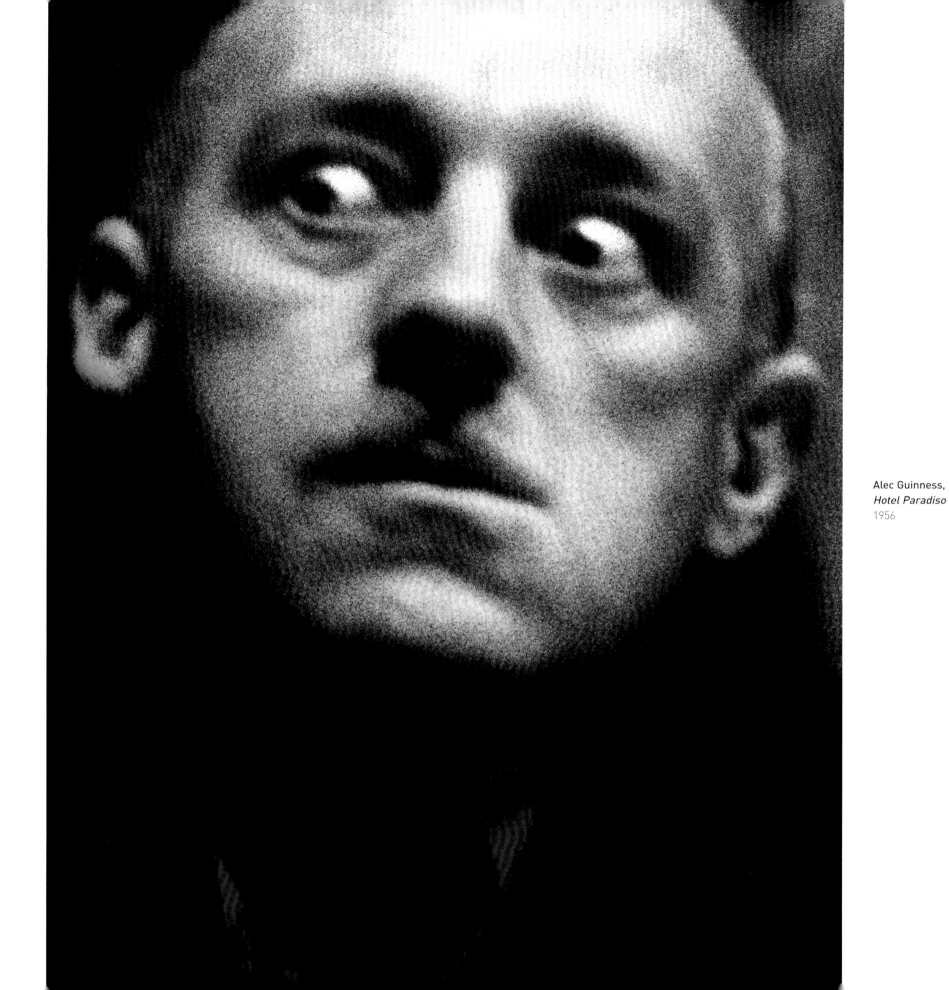

Alec Guinness, 31
*Hotel Paradiso*
1956

Colour supplement it might be, but Snowdon's taste in colour was more about Degas than Day-glo. Just as green is for him the navy blue of gardens (multi-coloured herbaceous borders tremble at his approach), so in his photographic world white is the state to which all colours should actively be seeking to return. 'I don't think in colour,' he said to me recently, 'I don't notice the colour of people's eyes.' Unlike other photographers, his work at the *Sunday Times* began not by taking pictures but by designing a roof-top studio, offices and darkroom. In his kitchen he still has the clock he had made, its numerals proud Times Roman, that told Roy Thompson, then the proprietor, when to go to press. Once darkroom and studio were up and running, a notable series of portraits (a word Snowdon dislikes for its painterly associations) resulted. He photographed not pop culture, nor mandarin culture, but an arts meritocracy. A Snowdon portrait became an honour for its quality (the SNO.B.E) and an imprimatur of taste principally because he was commissioned in the main by *Vogue* and the *Sunday Times*, both of which edited visually by exclusion. This gilded quality was naturally distasteful to him. His reaction was to take some of the most poignant pictures of the 'other countries' of old age and infirmity, unflinching and yet with a sense of refined pictorial sympathy which is scorned too often in contemporary photography as 'good taste'.

This sympathy came from a completely natural source – the experience of polio that confined him to bed for one of the best years of his childhood. It left him with painful but intrepid legs and an understanding beyond words that has consistently found expression in pictures it would have been easier not to take. From those in mental wards (he was instrumental in the masking-over of the doom-laden words 'Hospital for Incurables' above the dismal portal of one such institution) to the very recent dignified pictures of polio victims in Angola, they have been an antidote to the great and the good and include images of profound pathos, such as the hitherto unpublished photograph of a hydrocephalic child with a nurse (1975), with its beautiful, shocking resonance of a Madonna and Child. Recognisable style in a photograph is a vexed issue. It has always seemed proof to me that photography can be art when upon sight of an image we can

confidently decide that it is 'an Atget', 'a Kertész', 'a Cartier-Bresson', 'a Snowdon', so clearly has the subject been overwhelmed by a point of view. Perhaps craft becomes art only when the artist's chosen materials are obliterated by the experience they transmit; when coloured pigment becomes hope or love, when light-sensitive paper becomes dignity, tragedy, icon. Photographers, especially those like Snowdon, who prefer to forget the whole matter in a tide of deprecation ('photographers tend to be failed painters', 'photography is only a craft', he has said), are finding that it is high time they admitted the possibility of their work achieving, if only at its best, the status of art. This is particularly the case since a tribe of determined non-photographers, proudly proclaiming themselves 'artists who use a camera', have re-shaped in the Nineties our perception of what photography can achieve aesthetically.

However it can also be a problem when style in a photograph becomes recognisable. For Snowdon it has occasionally meant too great a reliance on a particular pose in a chair and a particular light that guarantees 'a Snowdon'. Sometimes his very best work is technically his simplest. Take for example the 1985 photograph of Joseph Beuys. The photograph is disarming in its simplicity. Beuys, the great artist, soon to die, wears his iconic felt hat, itself speckled with lint and felt from working. He does 'nothing', just looks at the camera. But it is a look that has become, for all those who see it, definitive. The photograph is not of Beuys, it *is* Beuys, and Snowdon had the authority to allow this man to express himself completely. In a sense it is the meeting of the two people that is the photograph – the camera only bears witness to the event. Granted the material was outstanding, as is also the case with the photograph of Henry Moore's hand holding a tiny maquette, or that of Charlie Chaplin roaring with laughter at a merry lunch in Switzerland, taken with a little snapshot camera. But Snowdon also has his Chardins, those photographs where the mundane is transformed by the power of observation. His photograph of a toad in a glass of water, for example, is, one feels, a wry critique of some other 'toads' that have found themselves in front of Snowdon's camera.

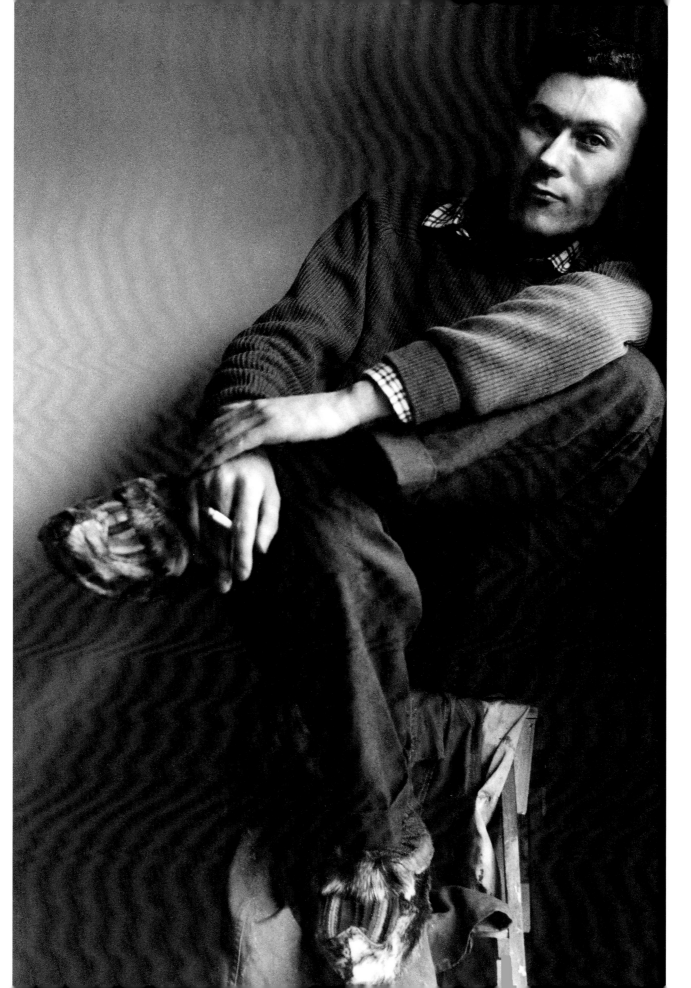

John Osborne 1957 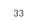 33

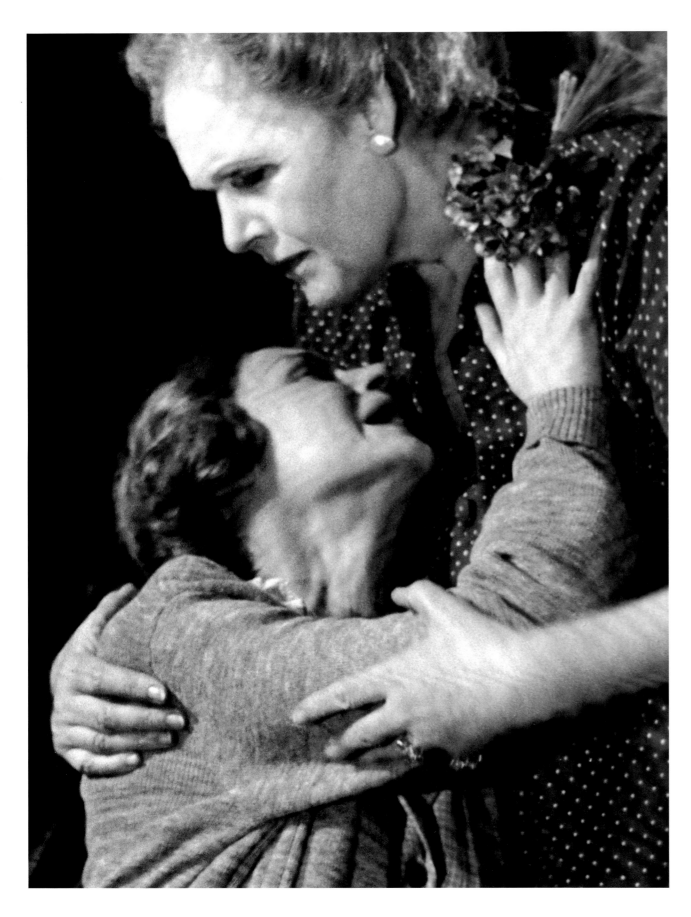

34

Margaret Leighton (left)
with Phyllis Neilson-Terry,
*Separate Tables* 1954

Paul Massie and Kim Stanley,
*Cat on a Hot Tin Roof* 1958

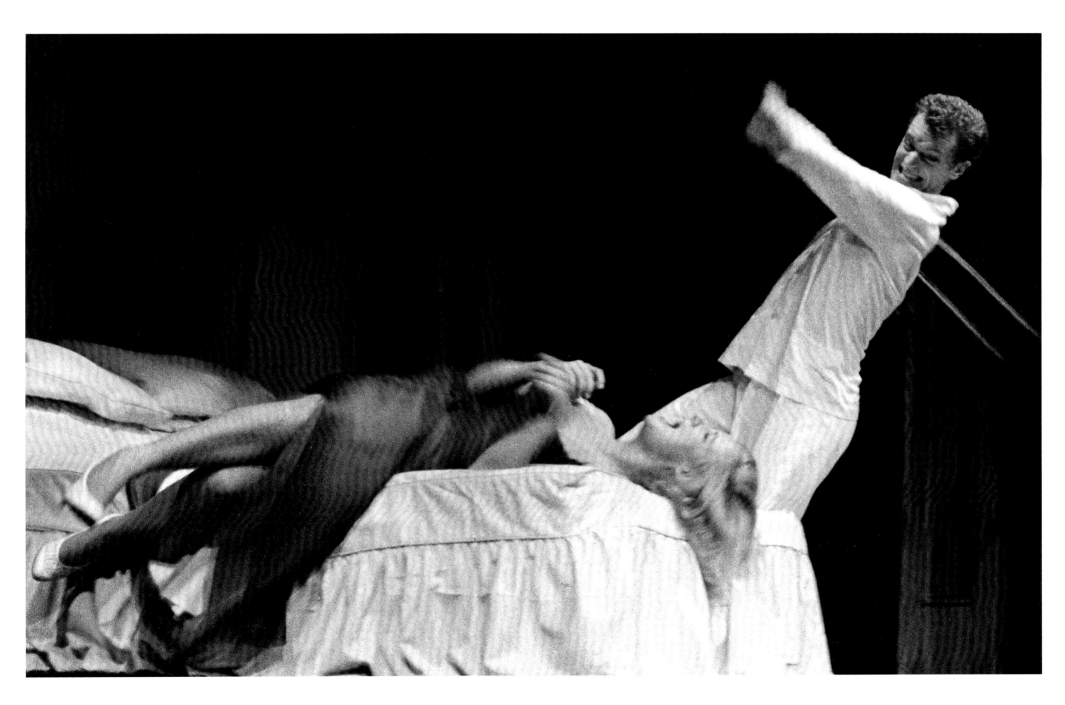

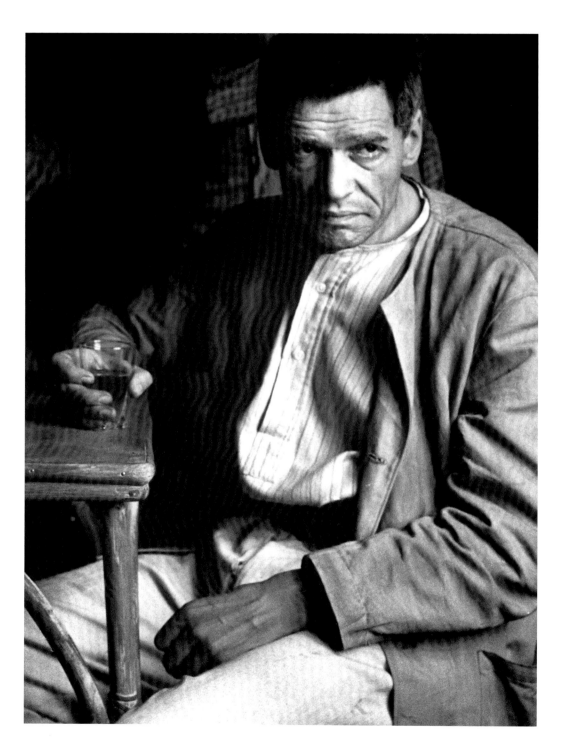

Paul Scofield, *The Power and the Glory* 1956

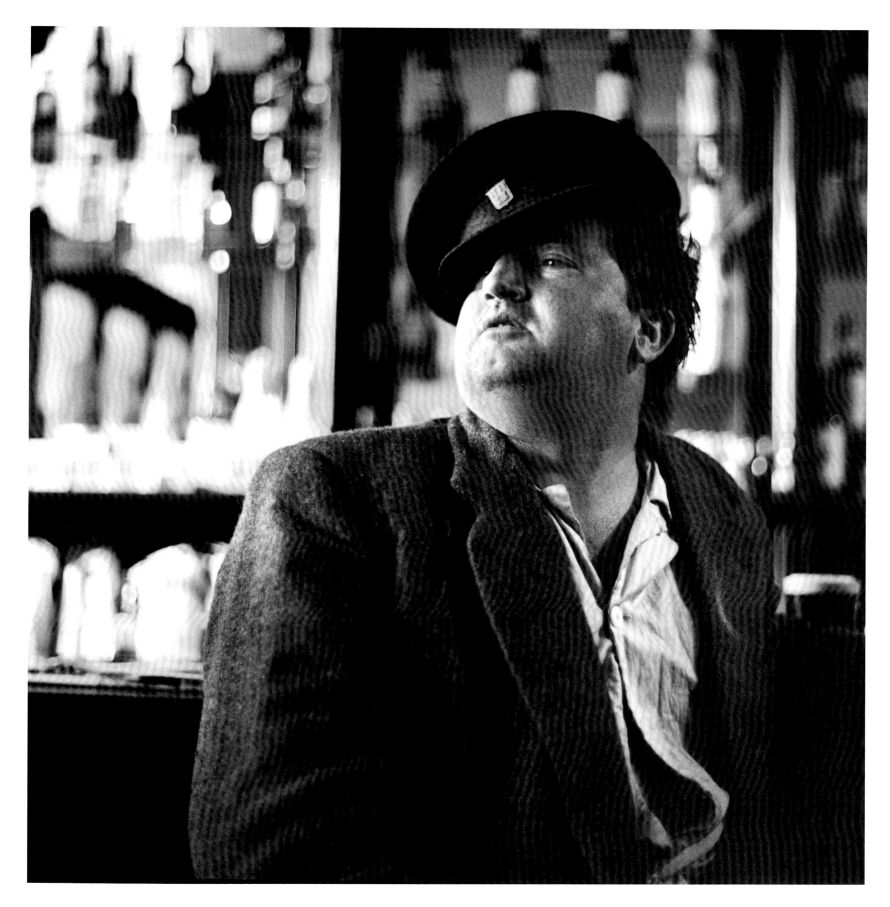

Brendan Behan, Dublin 1957

Laurence Olivier, *The Entertainer* 1957

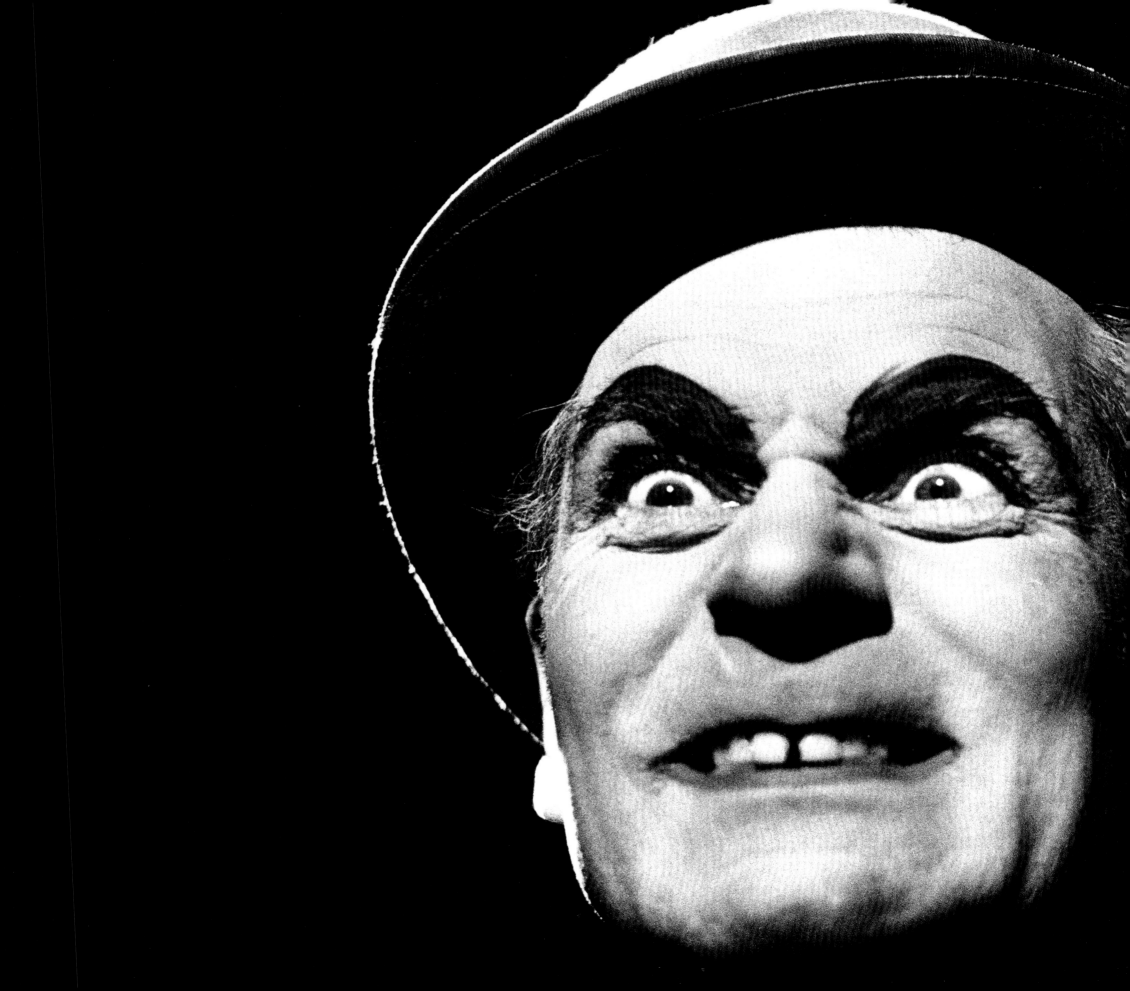

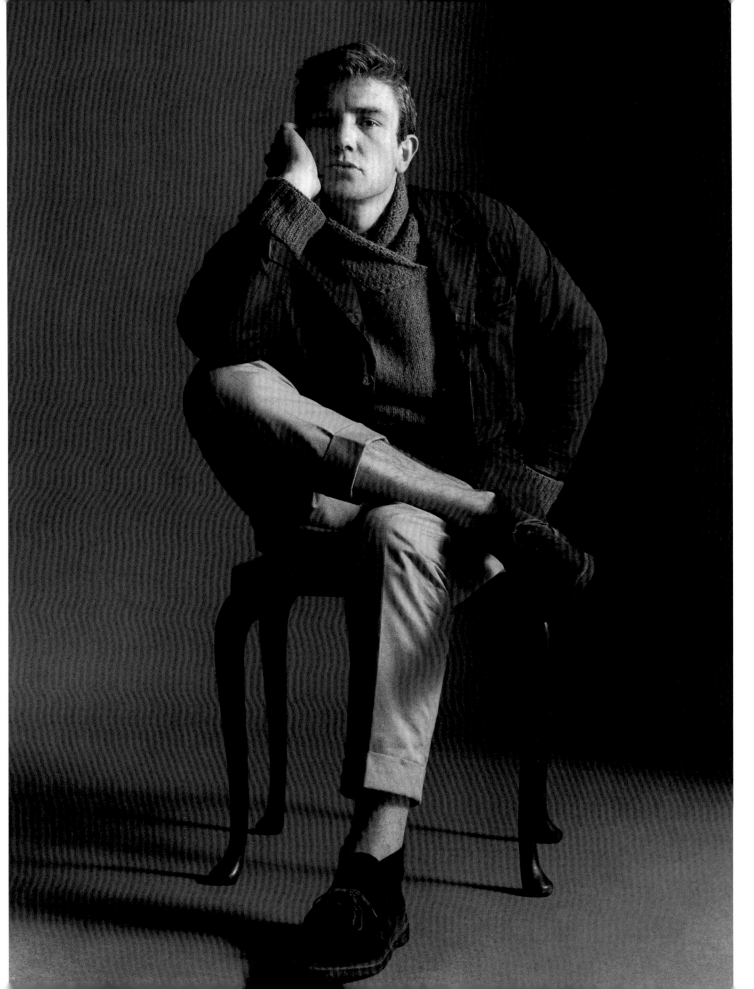

Albert Finney 1959

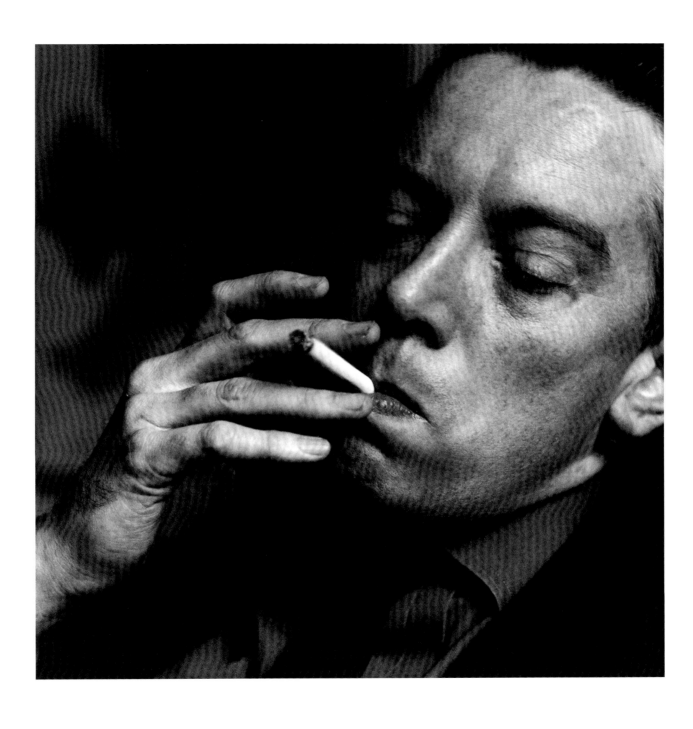

Kenneth Tynan 1963

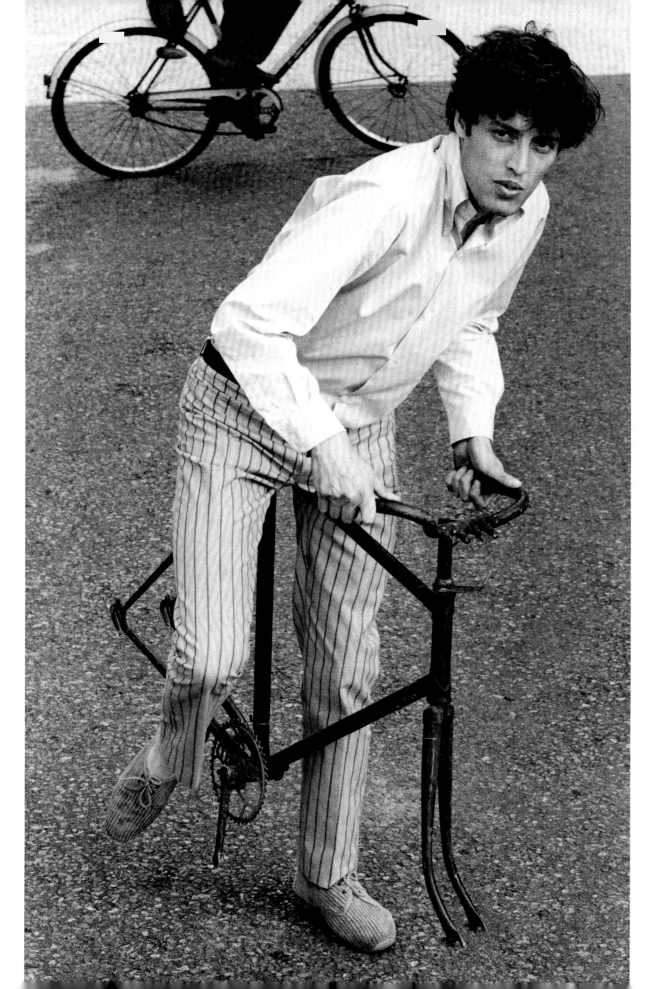

42

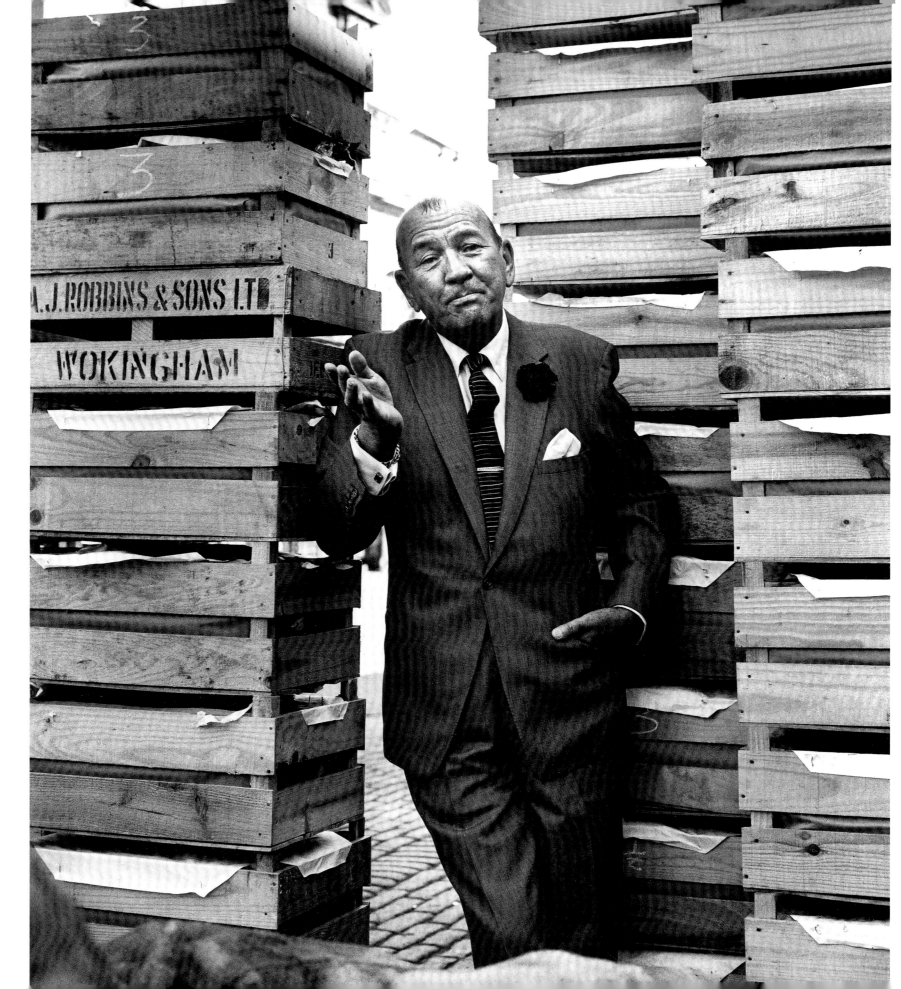

Noël Coward,
Covent Garden 1964

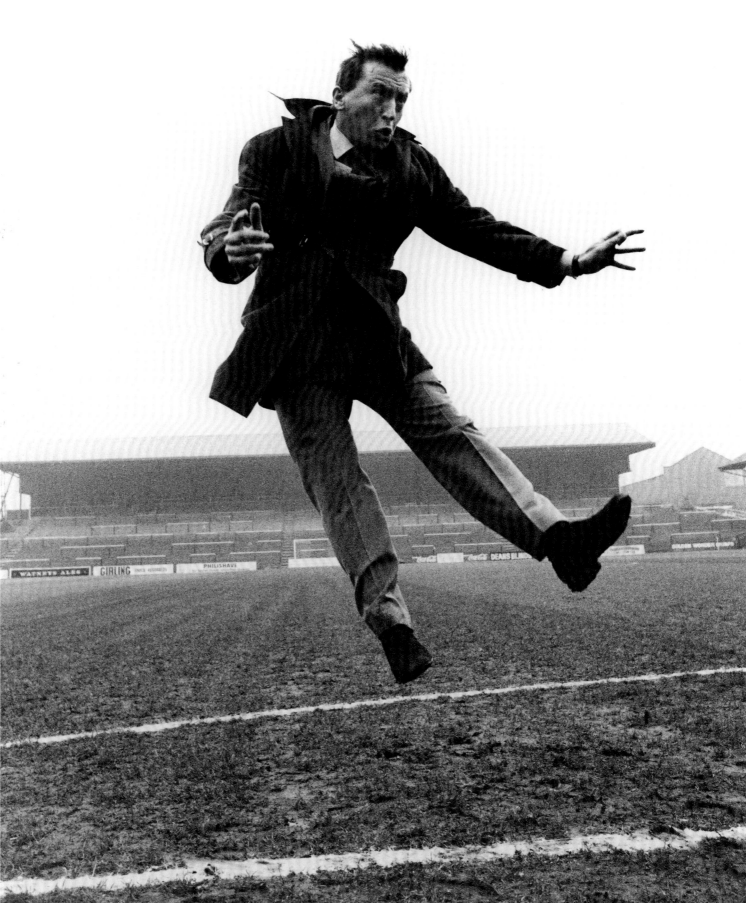

David Frost 1969

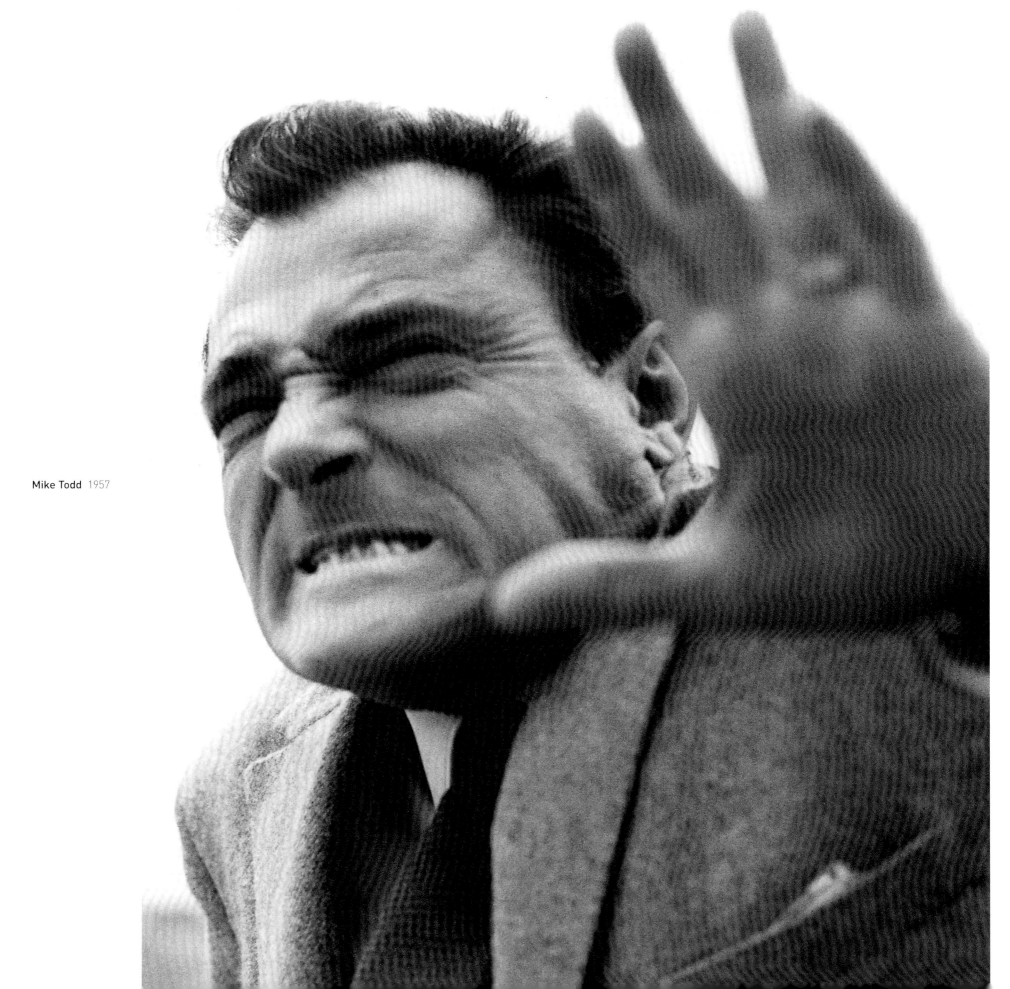

Mike Todd 1957

Dennis Waterman, *Saved* 1965 47

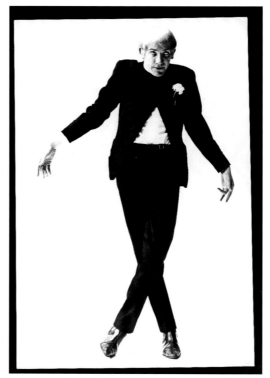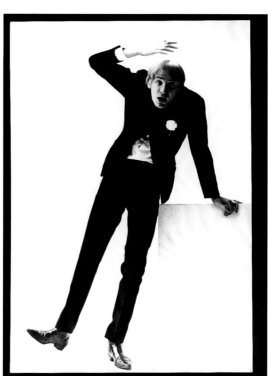

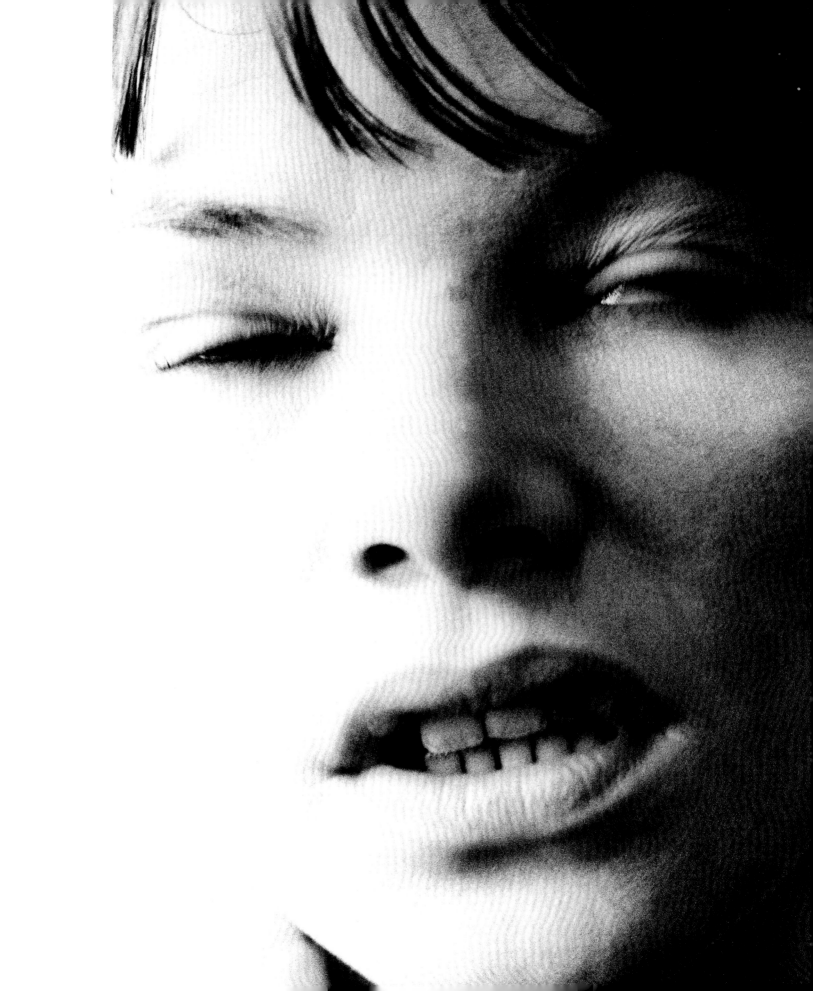

David Warner, *Hamlet* 1965

Glenda Jackson, *Marat/Sade* 1966

50

Maggie Smith and Robert Stephens,
*Hedda Gabler* 1970

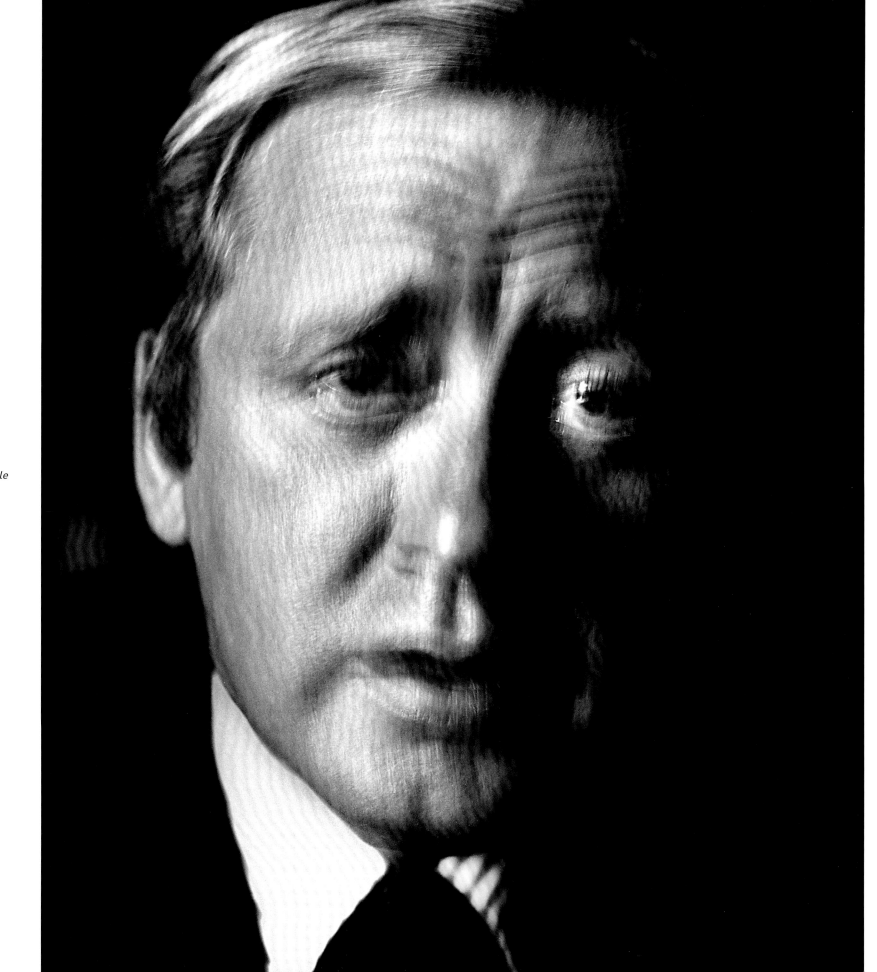

Nicol Williamson, *Inadmissible
Evidence* 1978

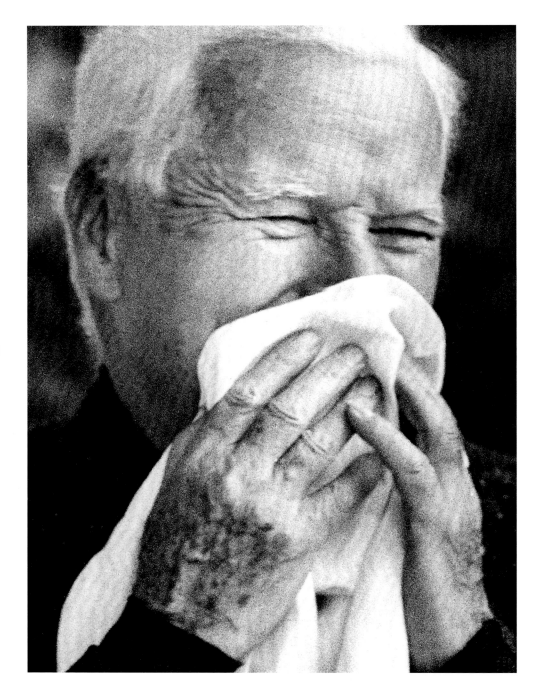

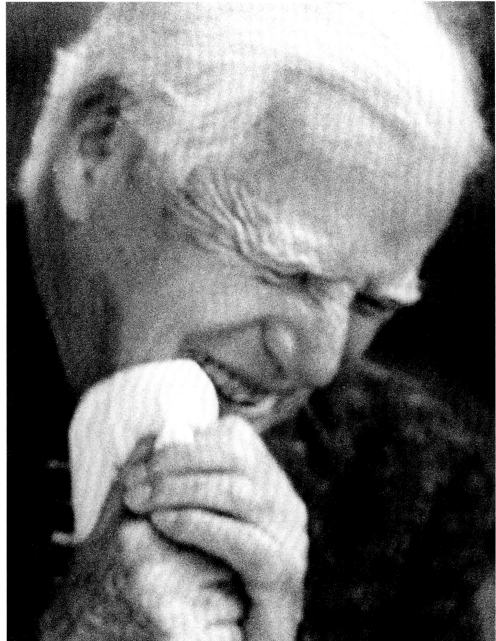

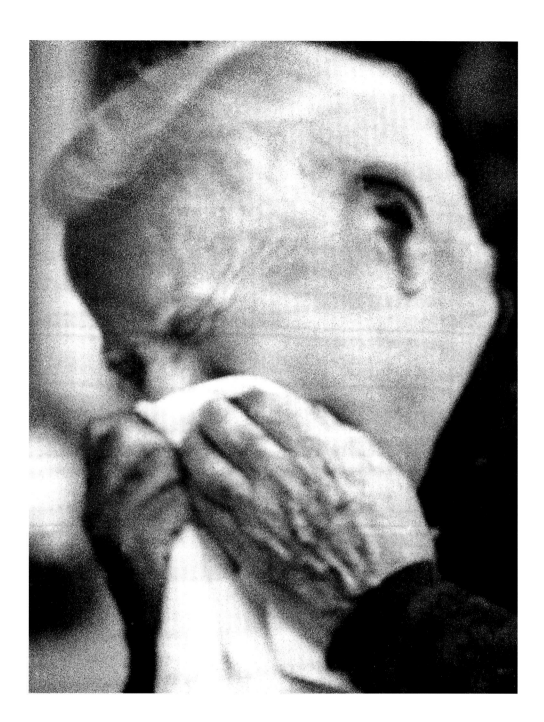

Charlie Chaplin 1964

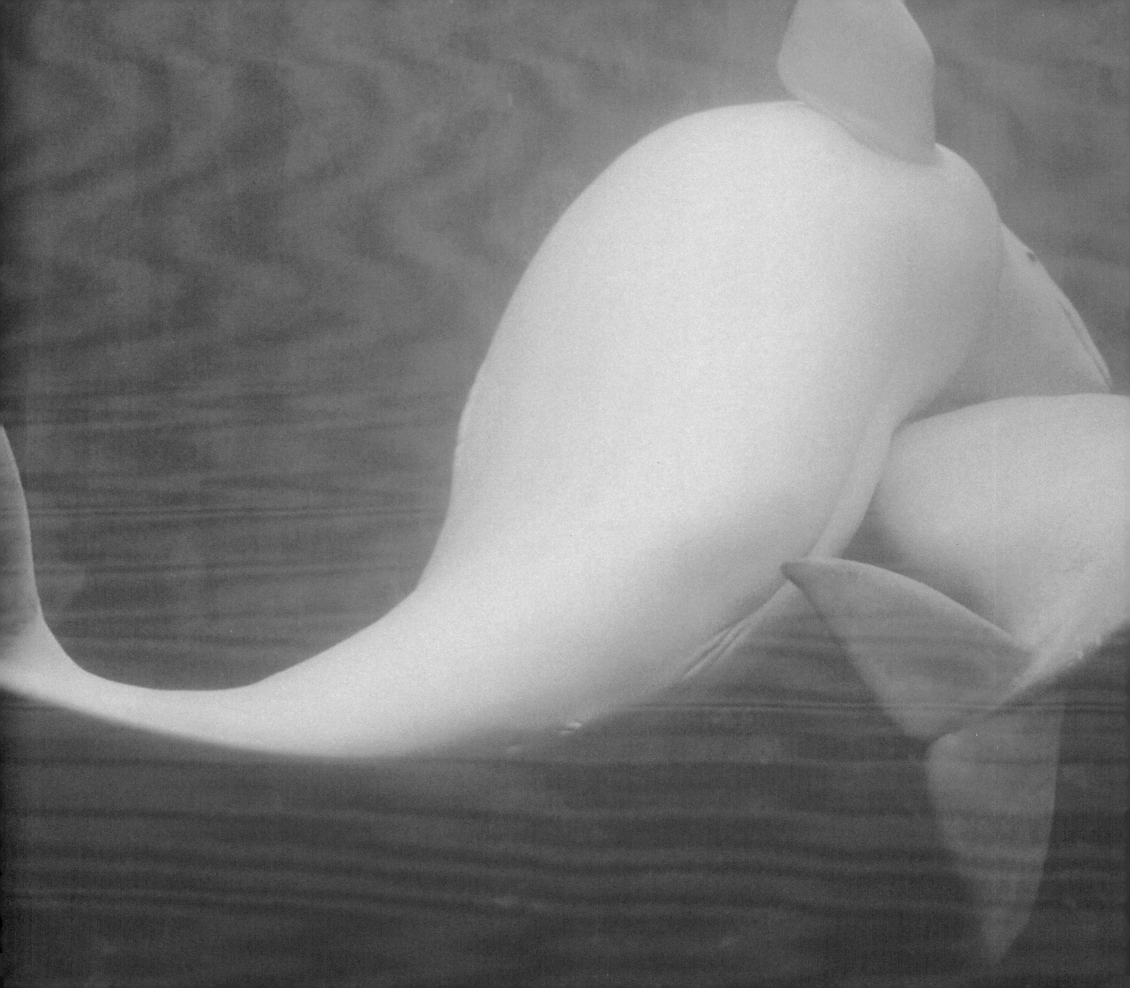

Beluga whales  1968

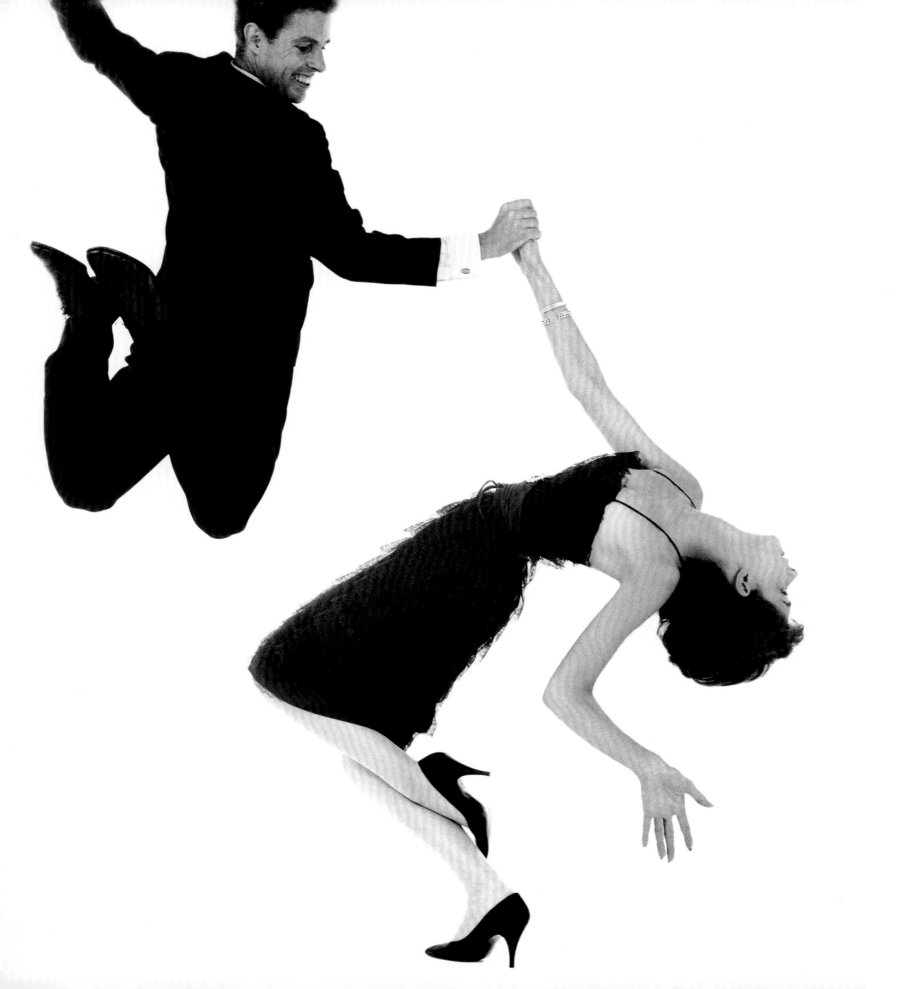

'Get with It', *Vogue* 1959

# GEORGINA HOWELL

SNOWDON is the best of companions and the most exacting. Working for him – he insists that it is working *with* him – is so exhausting that you feel drained for days. A Snowdon sitting begins with a telephone call. Sometimes he calls as himself, protesting utter terror and confusion at the job in hand. Sometimes he purports to be someone else, and such is his gift for mimicry that you truly believe it is Terry O'Neill on the phone, or Barbara Cartland, or Issey Miyake. His Don McCullin turn is a complete portrait of the man in thirty-five words. When subsequently telephoned by the genuine article, friends of Snowdon's have frequently taken it to be him, with dire results.

He seldom reads a book for pleasure, and pretends to be, or perhaps really is, very uninformed about some of the people he is asked to photograph. When I started to work with him, very nervously, I would supply him with potted biographies on his subjects. As I got to know him a little better, I realised that he could do without these prompts. Within a few minutes of merciless scrutiny, he strips away the public image and gets down to base.

Being photographed by Snowdon is no picnic. The tension can be terrific. You hardly dare to breathe. Woe betide the editor standing on the sidelines who tries to interfere, chatting with the subject to help him relax. Putting the sitter at his ease is seldom part of the plan. Impervious to status or fame, Snowdon has ways of peeling away constructed façades. One of his approaches is to indicate that the sitter's clothes are not working for the photograph. The victim is sent unwillingly upstairs to the bedroom to change into one of his own shirts. With great respect to Snowdon, these shirts, which seem selected on the basis of vintage and colour – one favourite a nylony affair with a dewlap Seventies collar that I cannot imagine he ever wore – seem designed to rob the wearer of self-respect. With women, he has other methods, equally certain to destroy any pretensions to glamour. I will just say that before he photographed me he drew me on one side and asked me to pluck a hair out of my right nostril.

It is particularly dangerous for the sitter to betray any trace of a desire to get the job over and done with. If he arrives saying, 'We'll be finished in an hour, won't we? I have a rather important meeting/lunch/appointment', his goose is cooked. Snowdon will prolong the sitting for hours.

If I were asked by a prospective sitter how to avoid the hoops that Snowdon sets up for them to jump through, I would recommend humility, a readiness to do anything he suggests and an immaculate courtesy to match his own. It is fundamental to Snowdon's philosophy that the Greats – Laurence Olivier, Alec Guinness, Peter Sellers, John Gielgud and Vladimir Nabokov among them – arrive on time, have all the time in the world, are courteous to underlings and leave the studio tidy.

Even if the sitter falls far short of these standards, Tony is too professional to walk out. When Jack Nicholson lay on his bed chatting on the phone and dropping names for half an hour while Snowdon waited, then indicated he had ten minutes to spare, the resulting photograph was wonderful. But Snowdon always gets his own back. In those ten electric minutes, he put the star through his paces as though Nicholson were a chimpanzee in a Mary Chipperfield circus.

If a sitting has gone well, all concerned decamp into a nearby restaurant and, if you are very lucky, Snowdon the raconteur will begin to tell stories. These are beyond words hilarious and wicked, aided by his devastating talent for impersonation.

What makes it impossible to forgo his sittings? The edge of excitement, the feeling that anything might happen. He might (he has) filled the studio with flames, naked men, performing elephants... And his charm and humour, which are overwhelming, enchanting, and make you forgive all. And, of course, the end result. I have bought all his books, and over the years I have had great pleasure from looking at them again and again. His photographs are extremely simple and extremely revealing: the subject looks at us without airs or affectations, as if he or she were looking at their mother, and perhaps for this reason his pictures remain forever fresh.

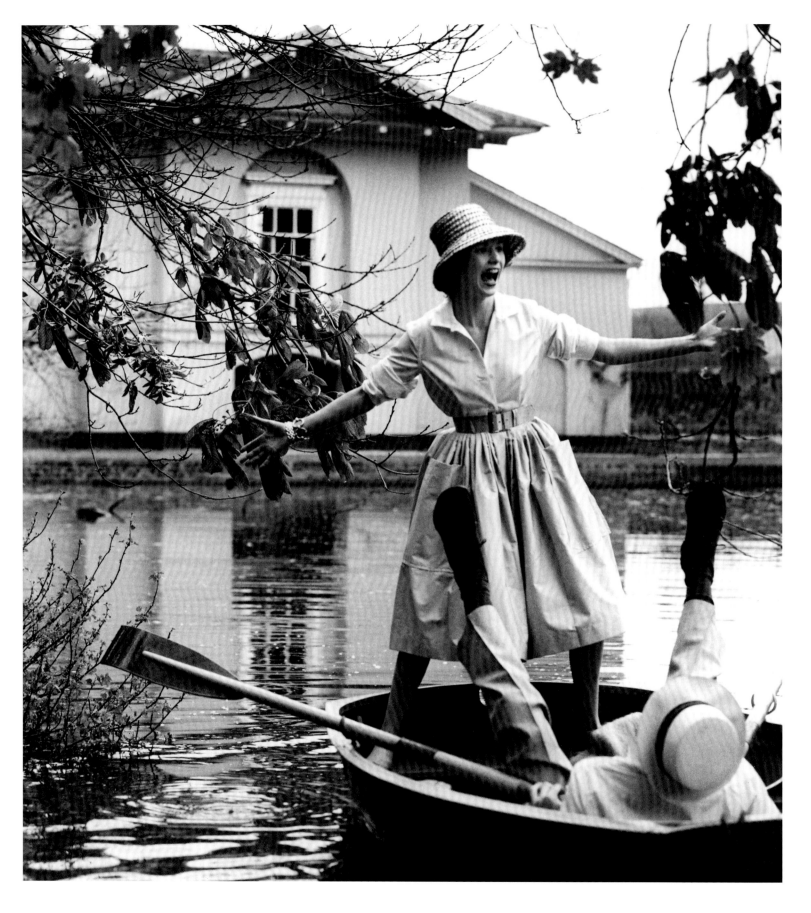

58

'Summer Life',
*Vogue* 1957

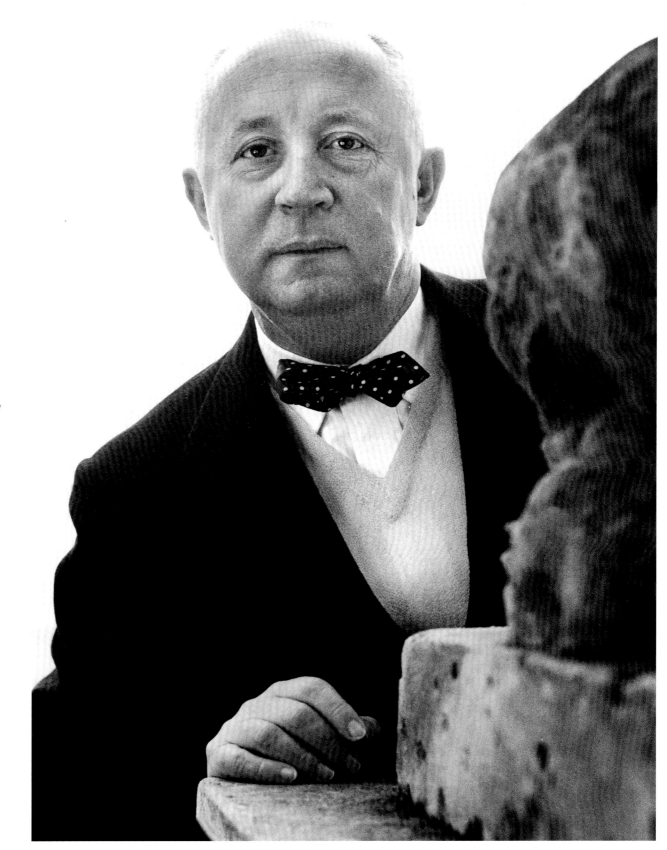

Christian Dior, *Vogue* 1957

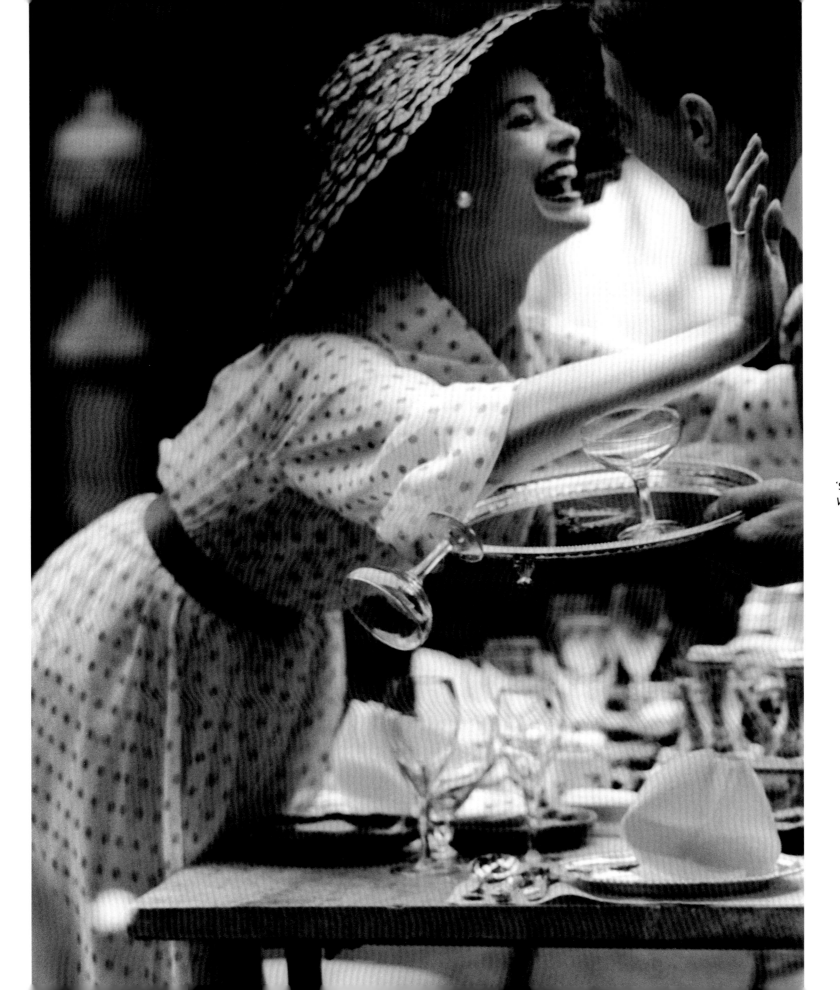

'Summer Life',
*Vogue* 1957

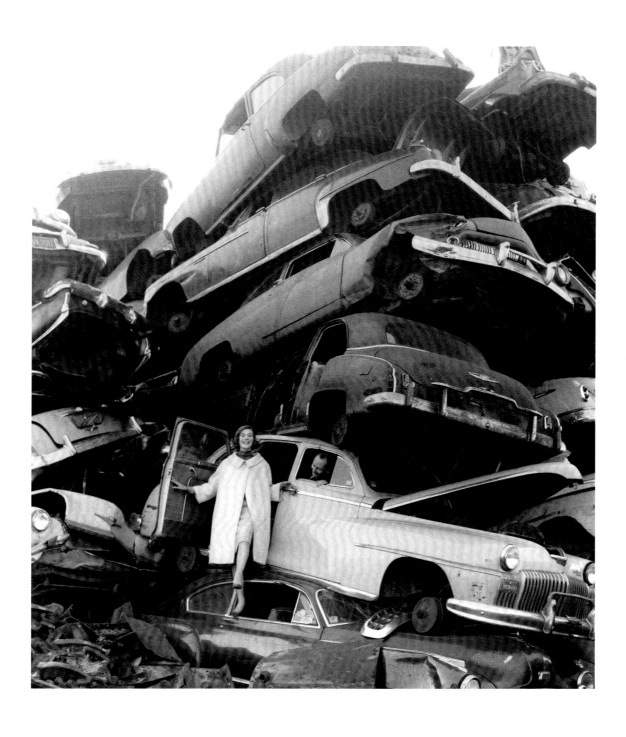

'Comet to New York',
*Vogue*, New York  1959

62

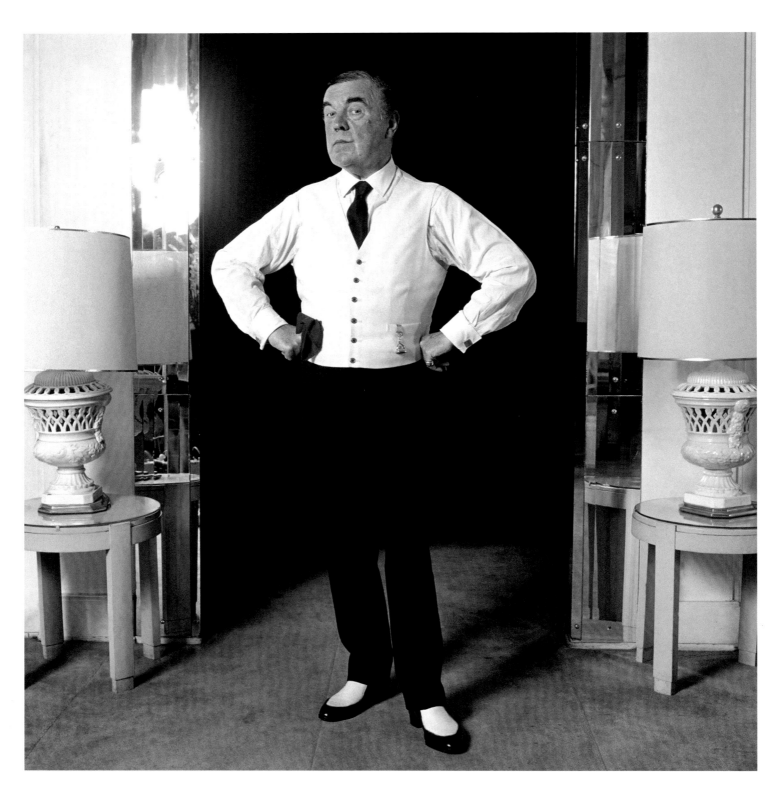

Norman Hartnell,
Mayfair 1968

Mia Farrow,
*The Great Gatsby* 1973

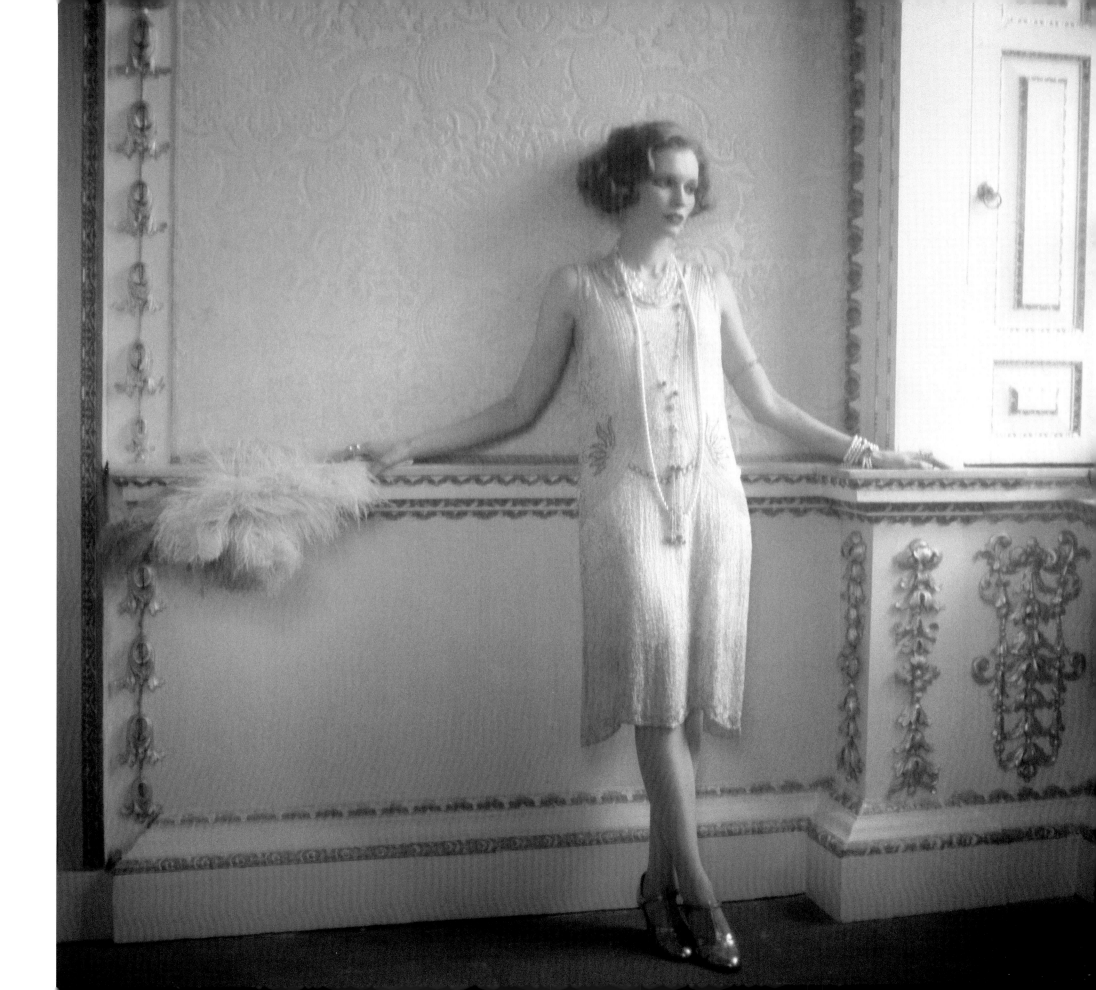

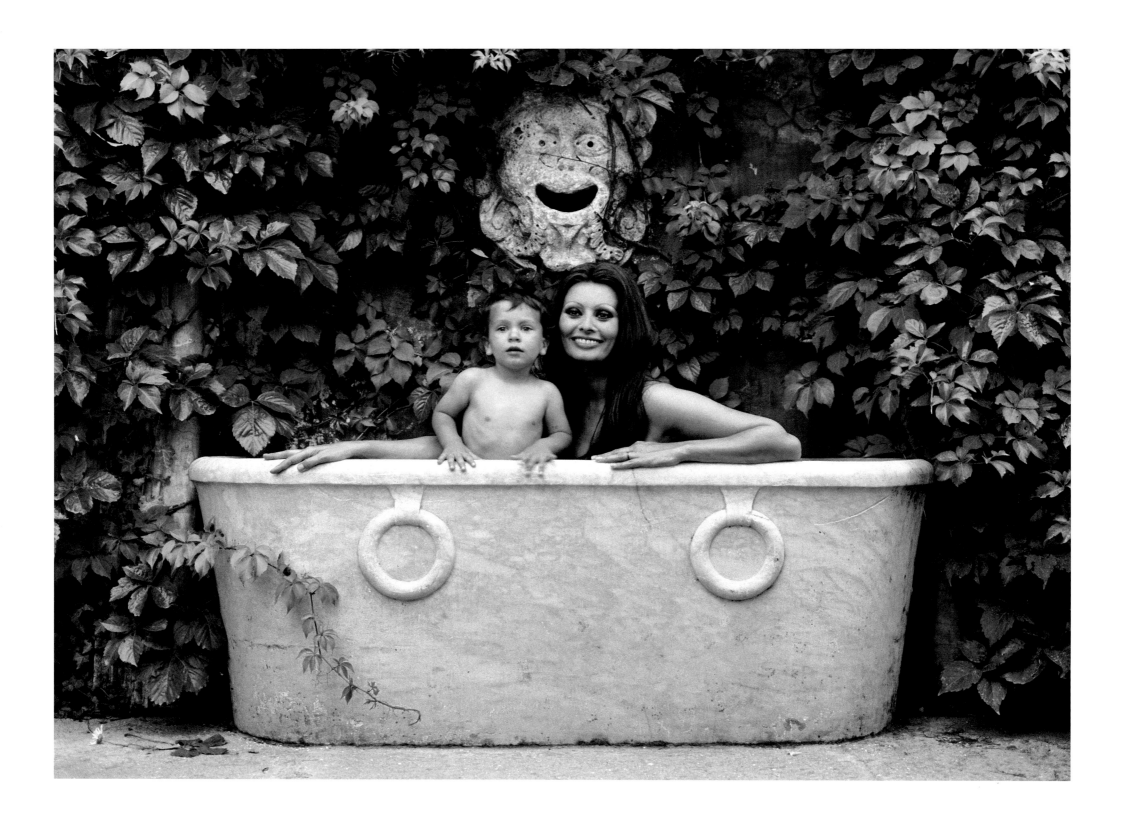

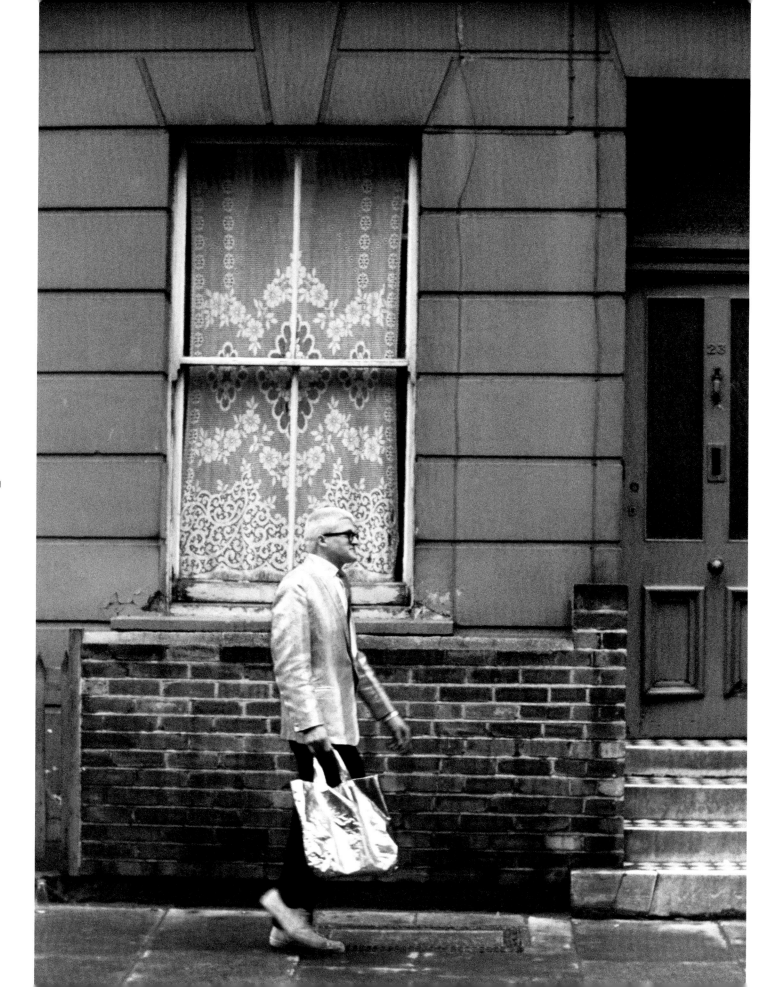

Sophia Loren with her son Chipi, Rome  1970

David Hockney, Paddington  1963

66 *1964*

Peter Blake *1964*

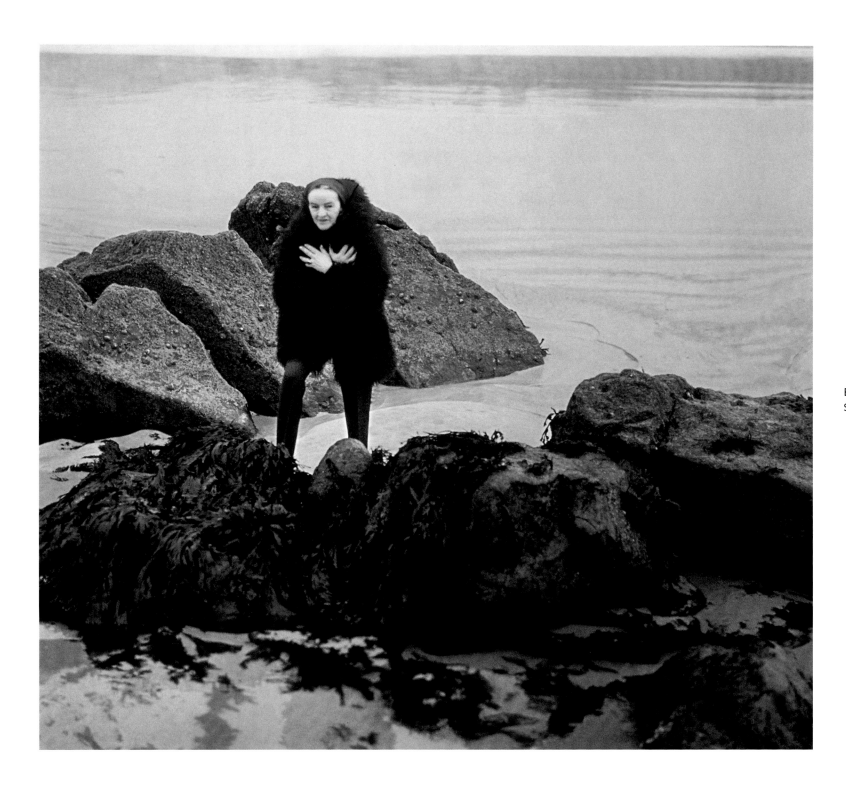

Barbara Hepworth, 67
St Ives 1964

68      Lucian Freud, Paddington 1963

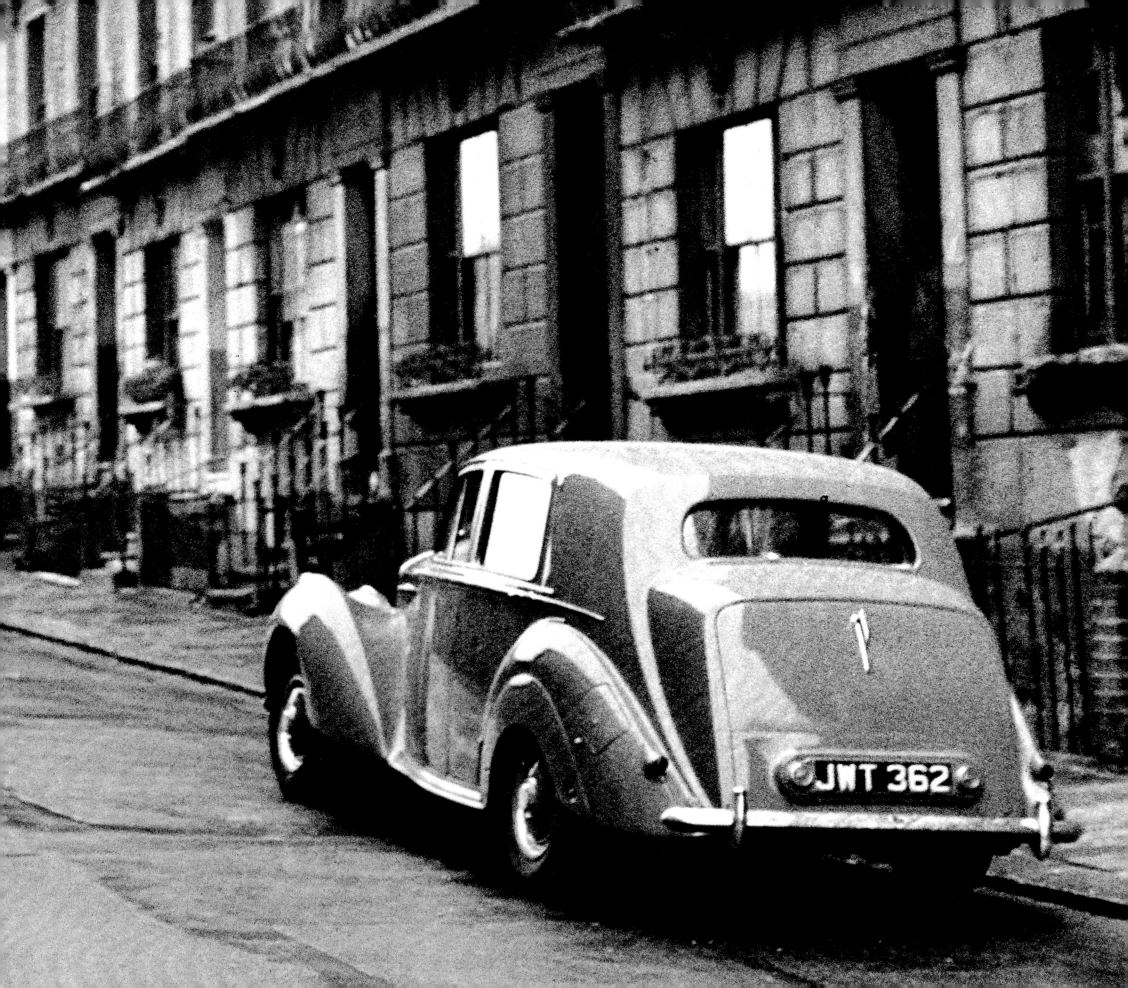

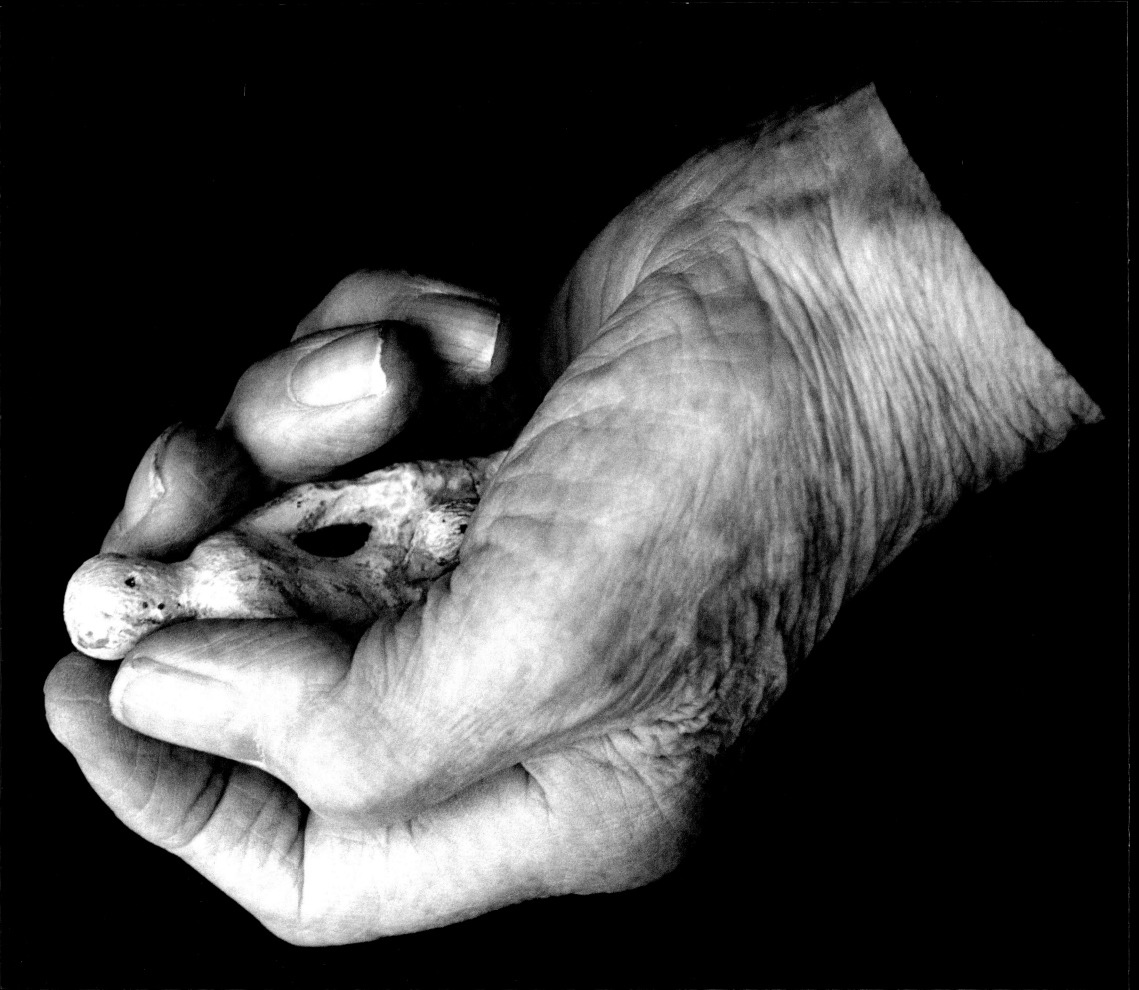

Henry Moore and maquette of
*Mother and Child* 1983

Francis Bacon 1963

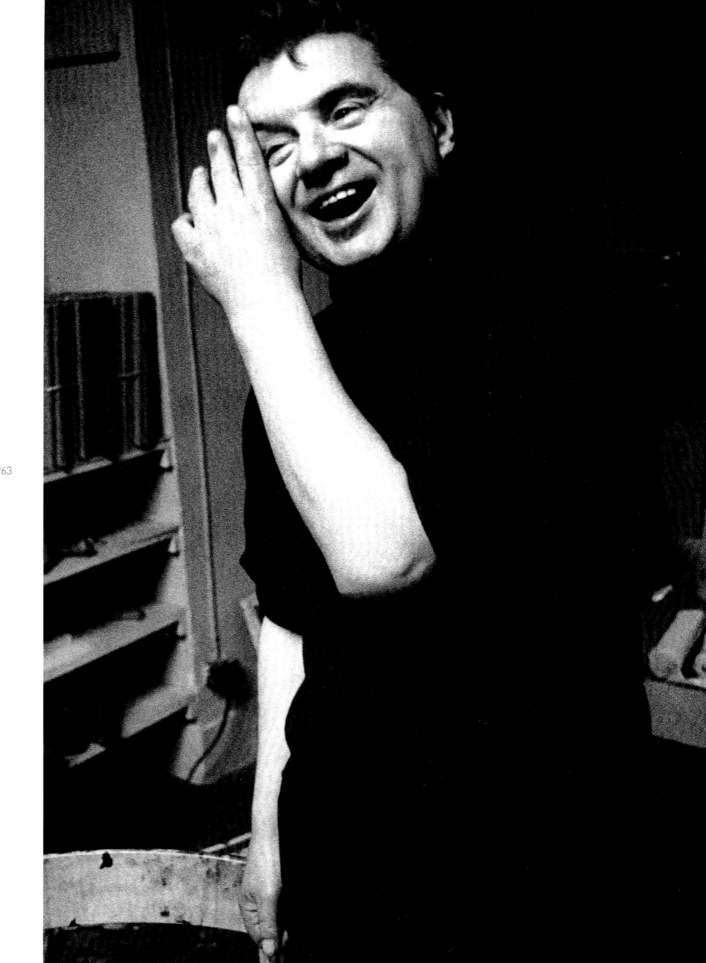

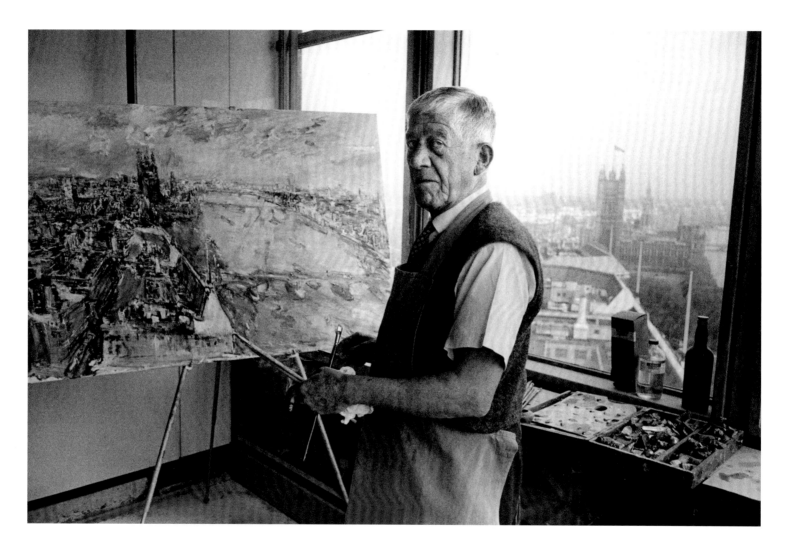

Oskar Kokoschka,
London 1962

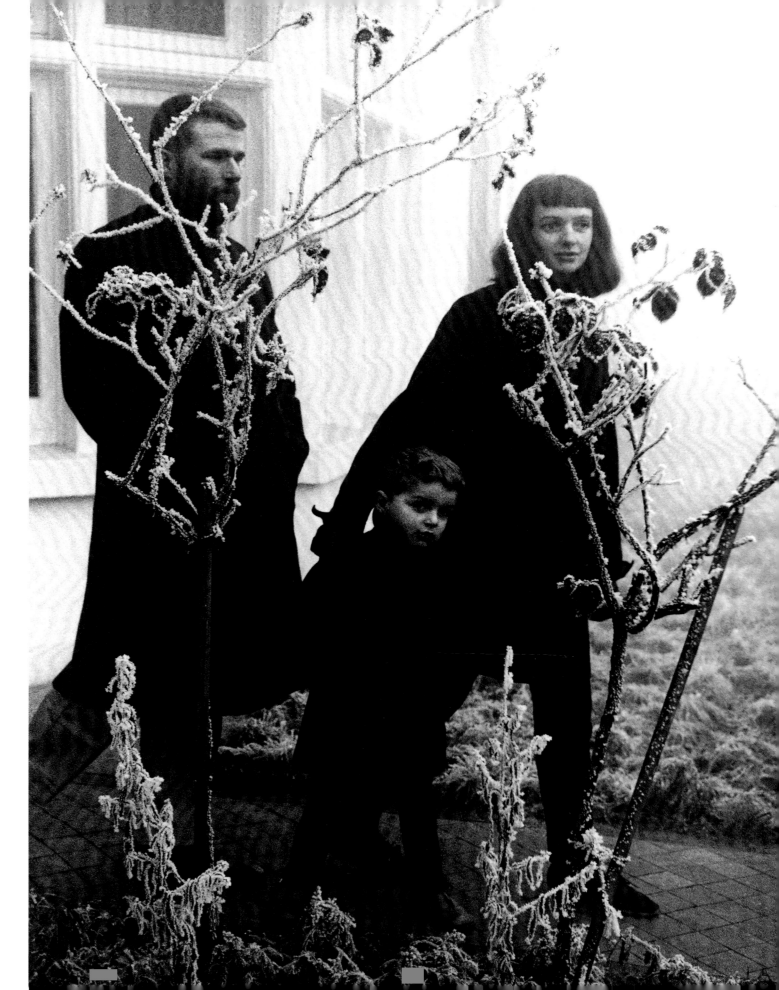

R.B. Kitaj with Elsi Roessler and Lem Kitaj  1962

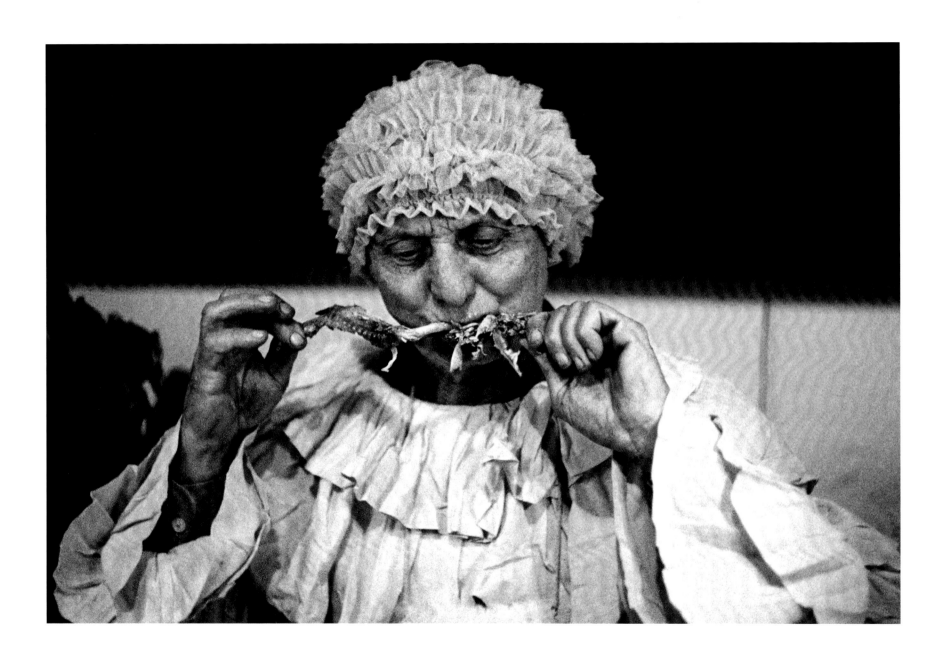

Max Ernst, Huismes 1963     L.S. Lowry, Leather Lane 1963

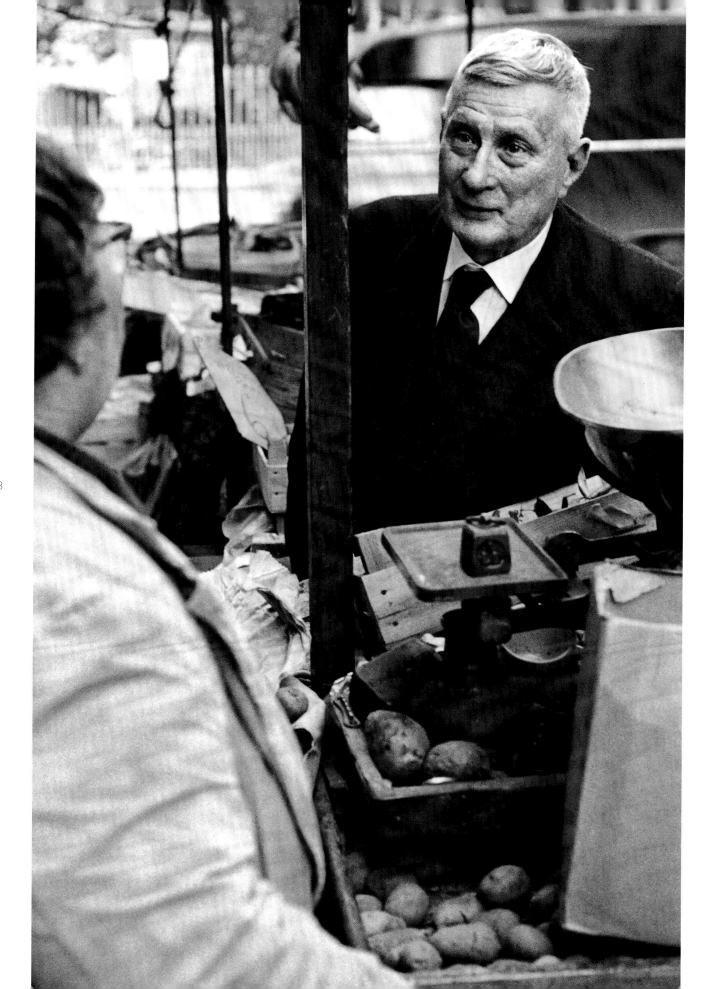

Helen Lessore, the Beaux Arts Gallery 1963

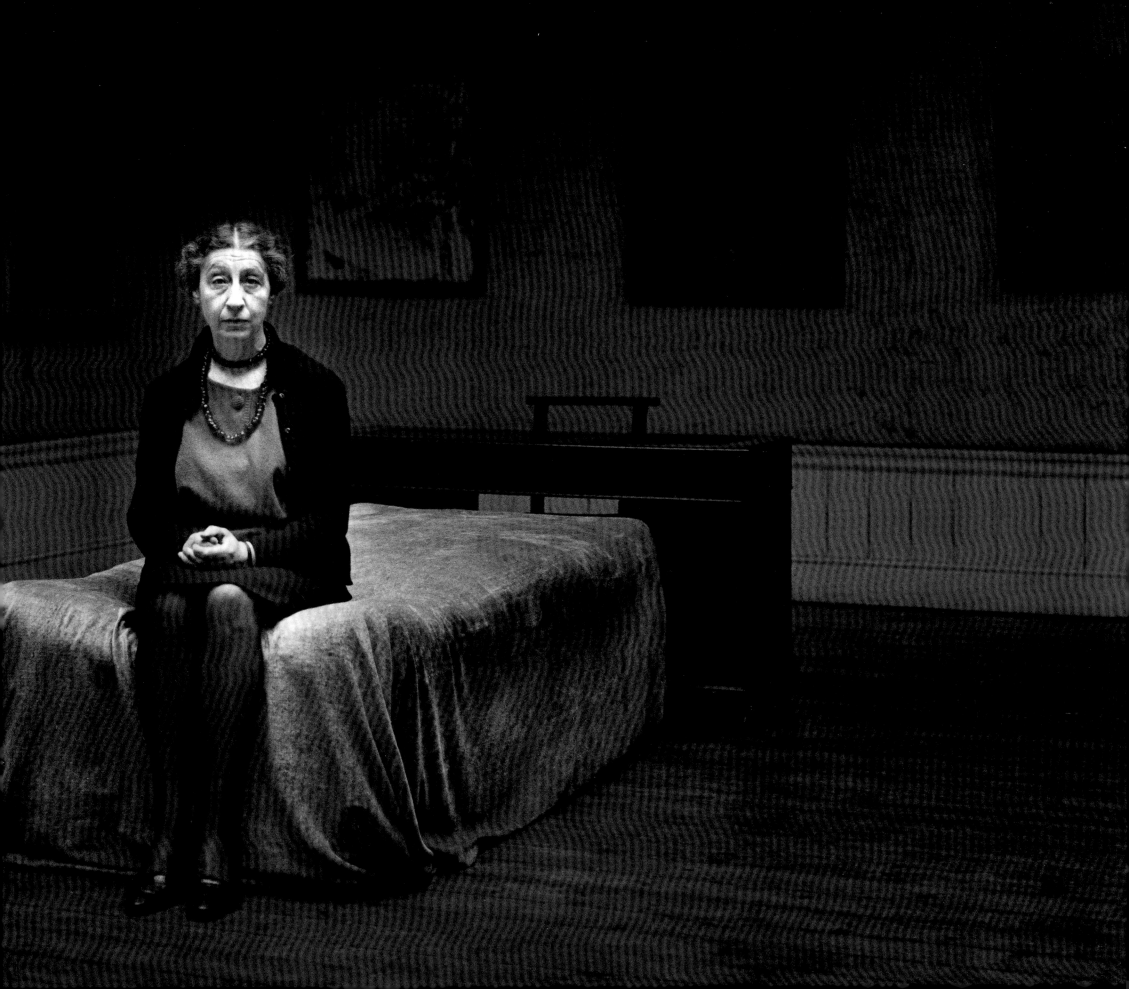

David Sylvester with painting by
Soutine, the Tate Gallery 1963

John Rothenstein, the Tate Gallery
basement 1963

Tamara Karsavina 1958

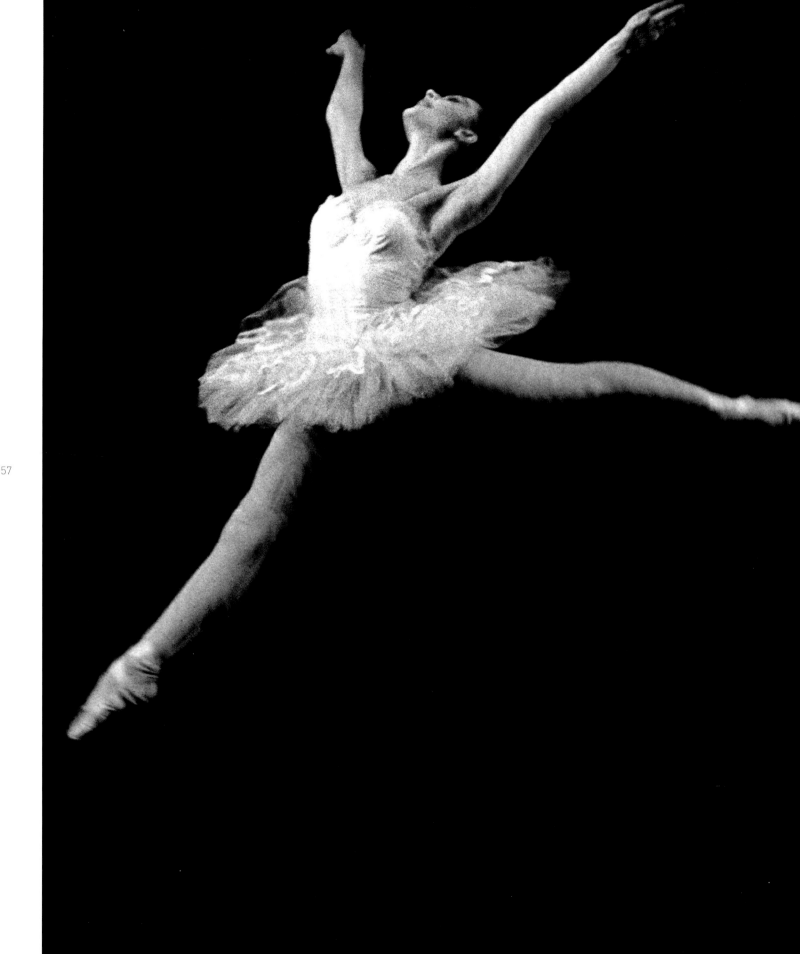

Svetlana Beriosova, *Prince of the Pagodas* 1957

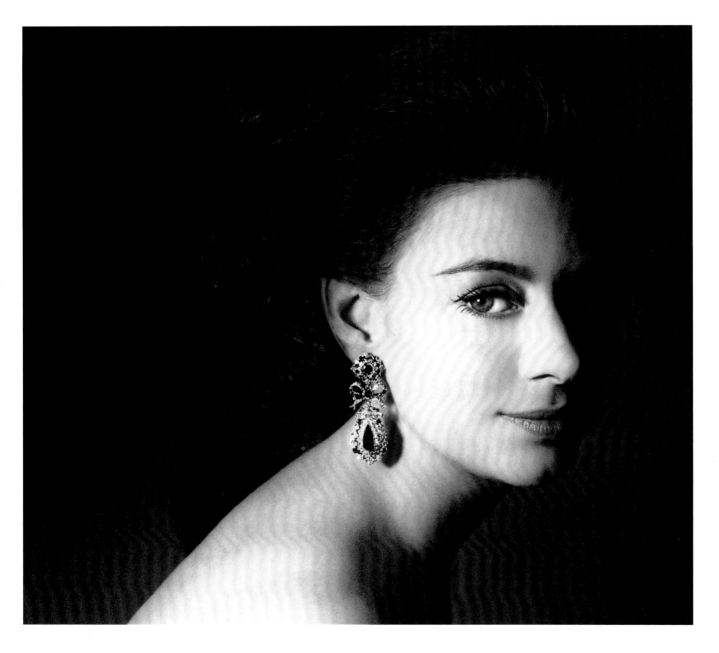

Princess Margaret 1967          Mikhail Baryshnikov 1977

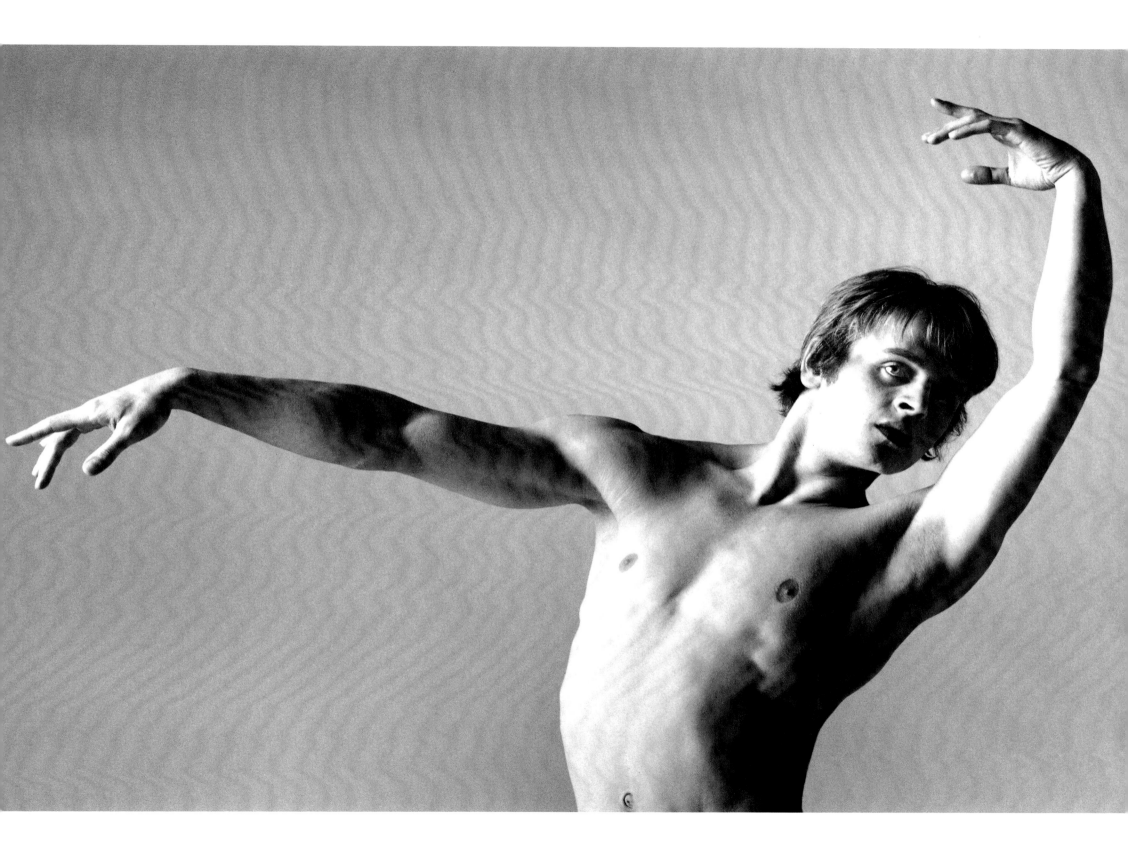

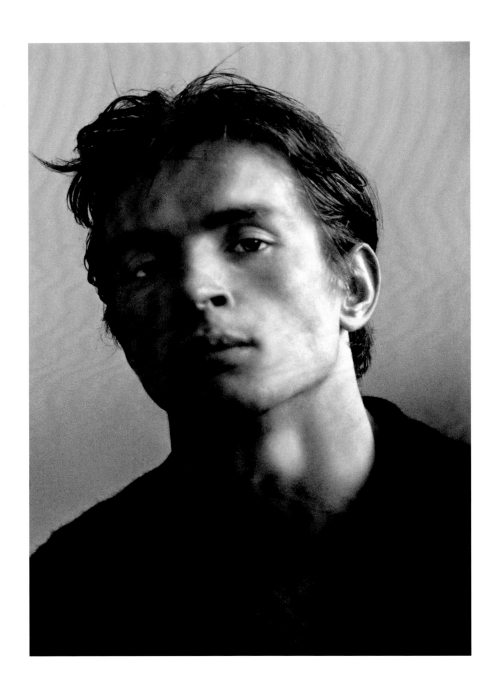

Rudolf Nureyev, London 1963

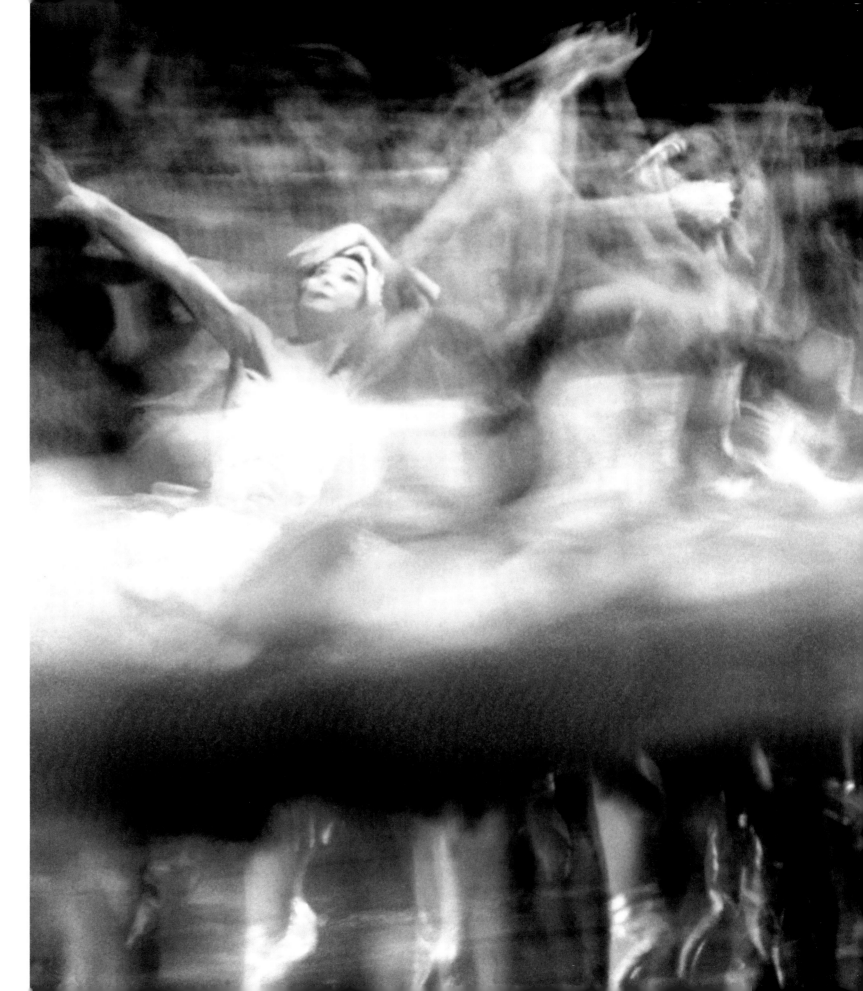

Margot Fonteyn, *Swan Lake*, Vienna  1965

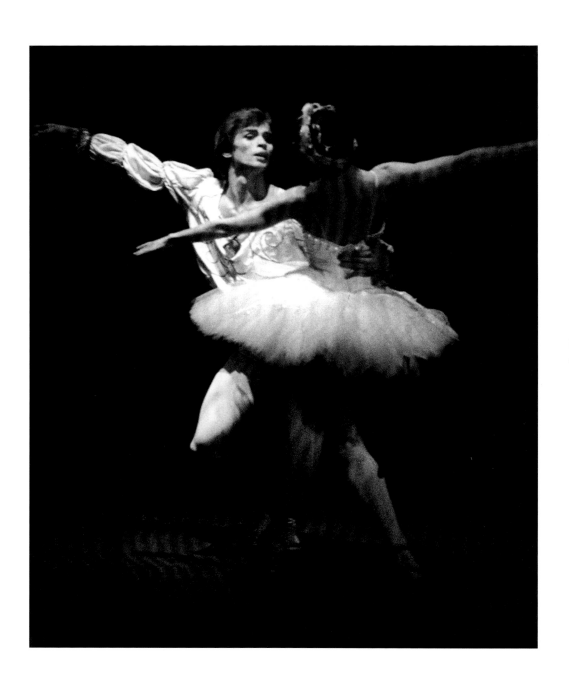

Margot Fonteyn and Rudolf Nureyev,
*Swan Lake*, Vienna 1965

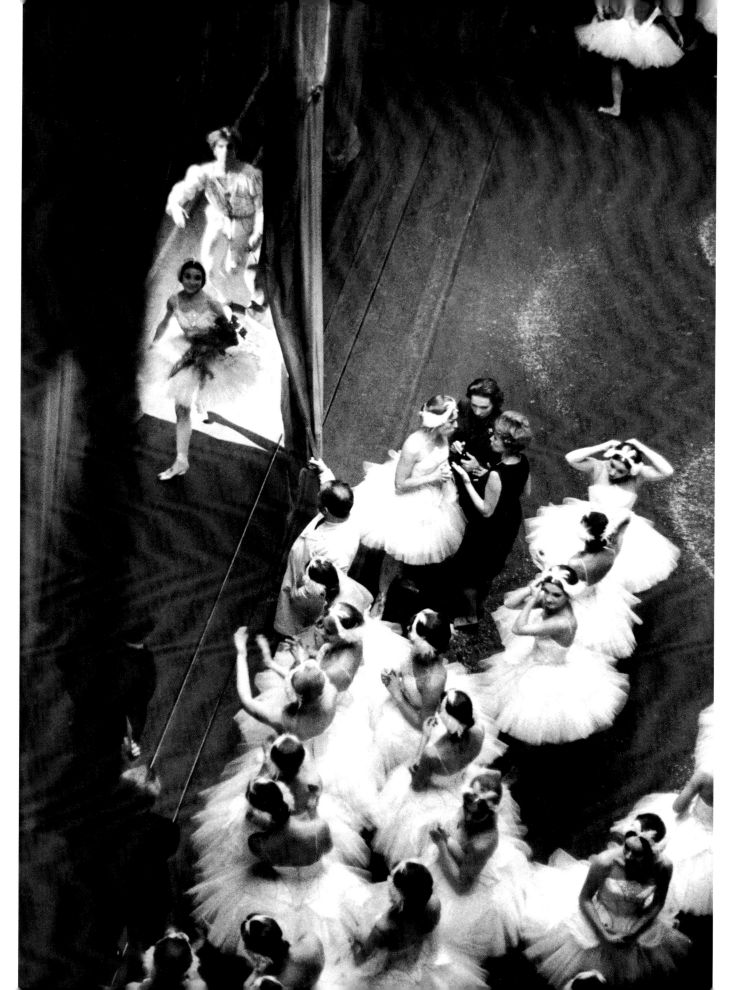

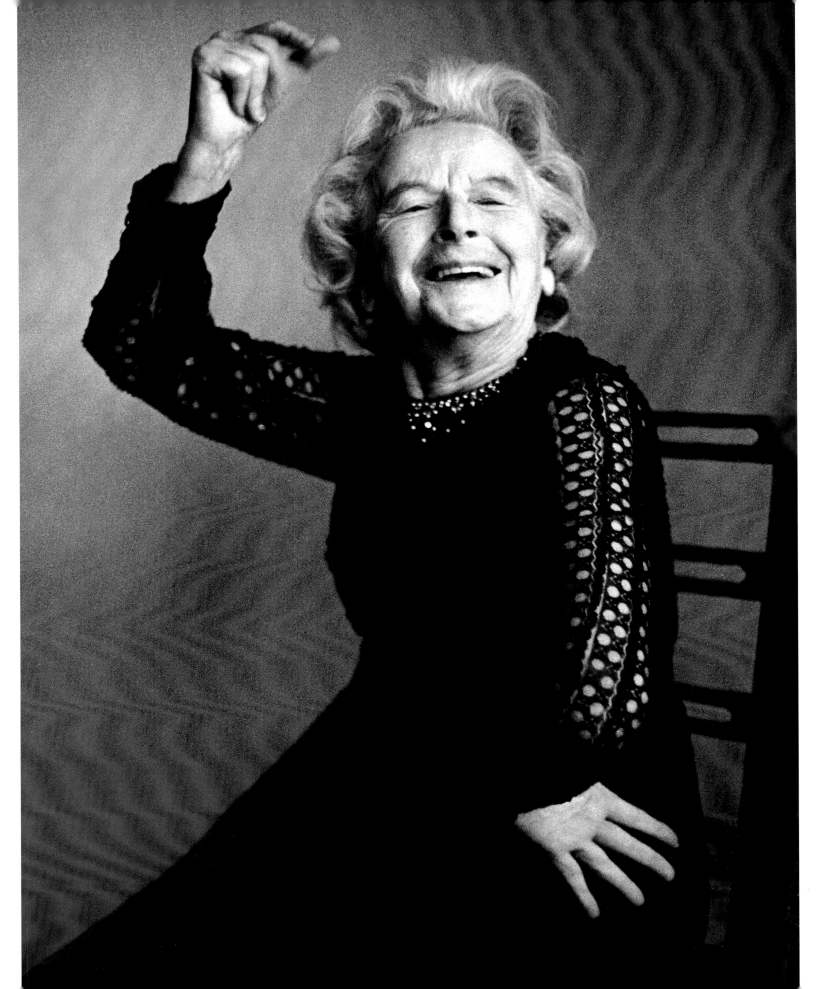

Marie Rambert, taking class  1976

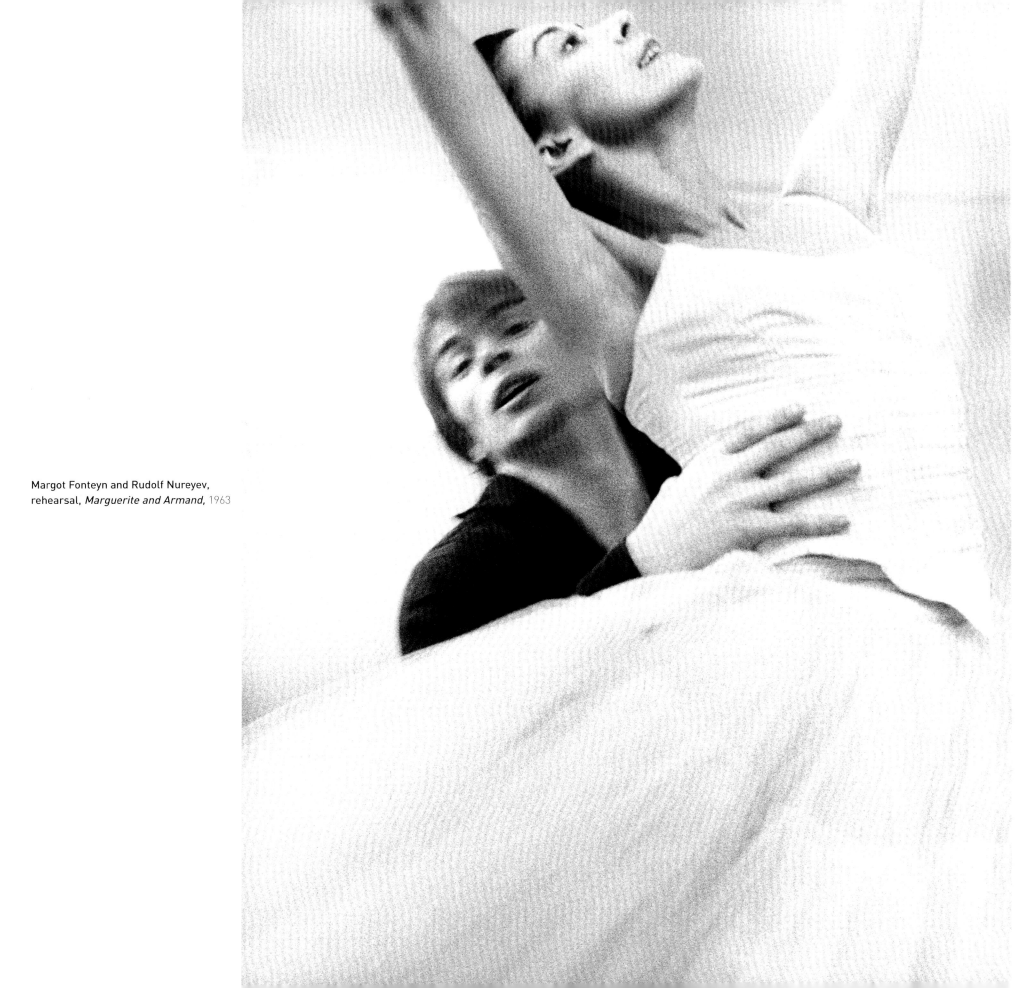

Margot Fonteyn and Rudolf Nureyev,
rehearsal, *Marguerite and Armand,* 1963

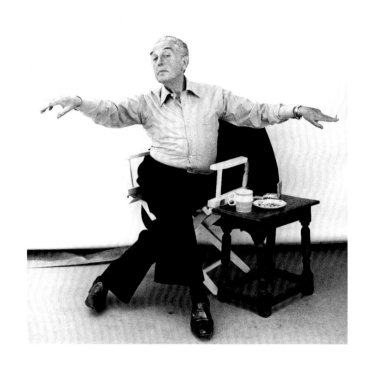

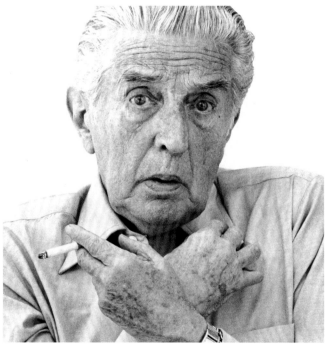

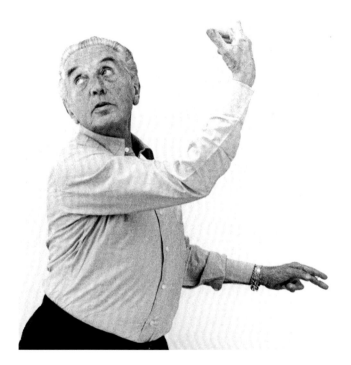

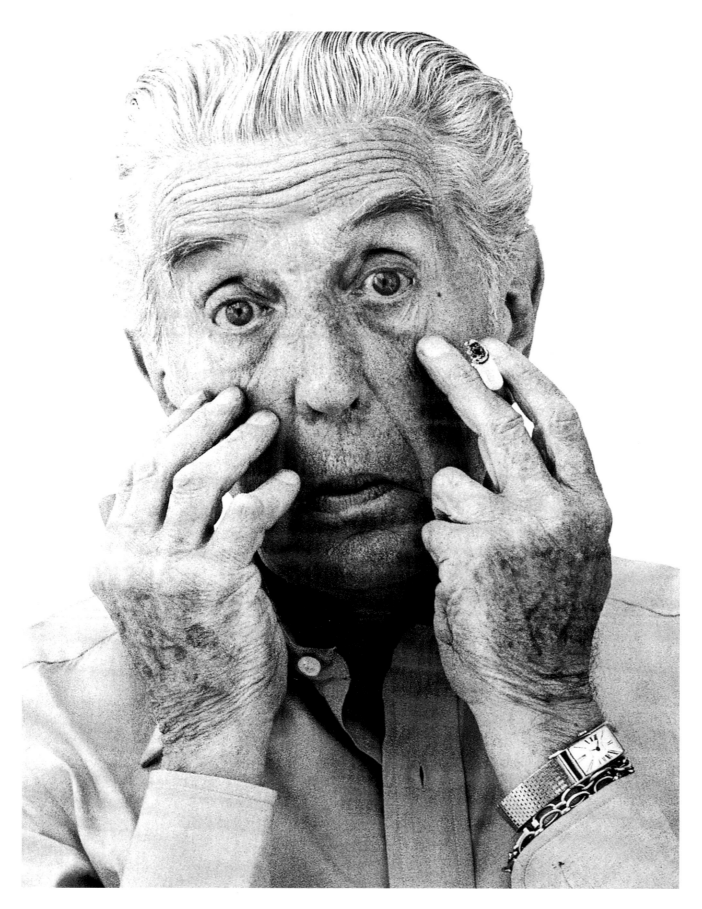

Frederick Ashton 1978

Frederick Ashton and Robert Helpmann, the Ugly Sisters, *Cinderella* 1965

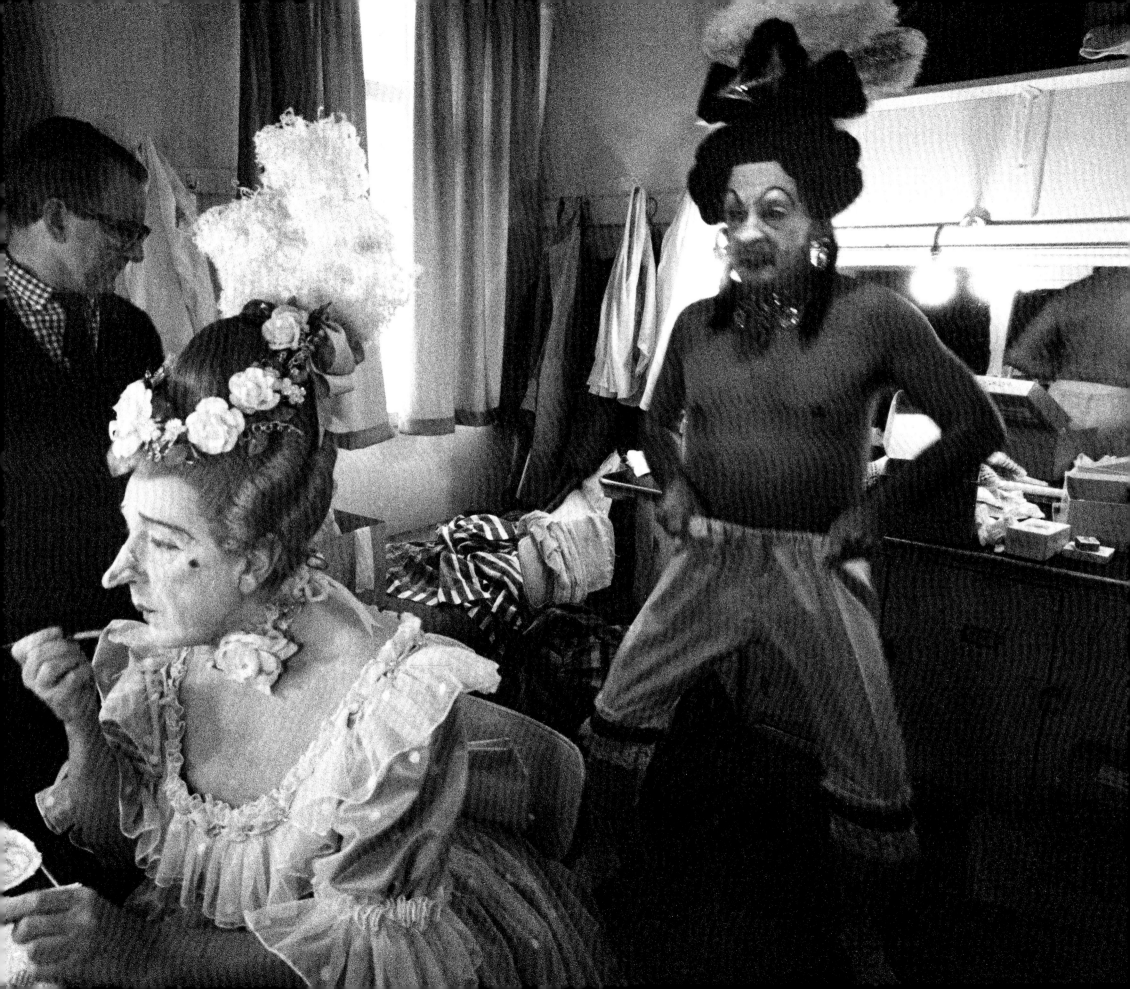

Arab horse, Maryland 1966

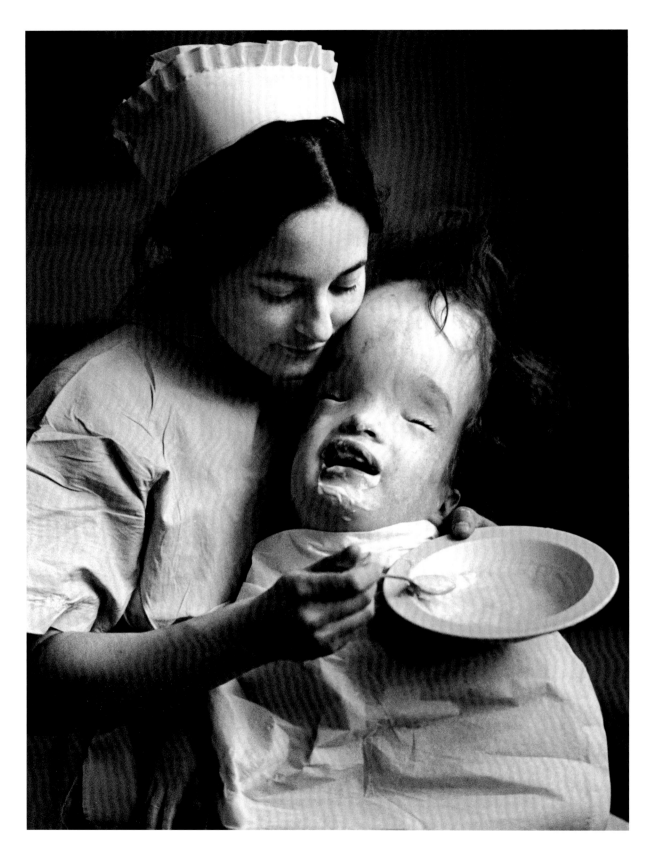

Nurse and hydrocephalic child 1975

# MARJORIE WALLACE

SNOWDON and I made a dedicated if somewhat volatile team, working on a succession of stories for the *Sunday Times* Magazine in the twilight outposts of the disadvantaged and dispossessed. There are few people who, for over a quarter of a century, retain the same qualities of enthusiasm and energy so that every meeting is a surprise – and a temptation to collaborate on yet another crusade.

Snowdon is the leprechaun enemy of hypocrisy and cant, using his charms and cunning to sabotage the authority of those making – in his judgement – unfair, inhuman or elitist decisions: officials who provide outdated aids for disabled people, rail companies who consign wheelchair-users to the guard's van, or architects who design only for the rich and healthy. He can be infuriating to work with, always determined to get his own way, but he is also inspiring. Only those who have been with him as he photographs deaf, blind, physically or mentally damaged people can know the depths of his compassion and the extraordinary lengths to which he will go to capture the invisible struggle behind the ragged face of an old woman, or the tired smile of a refugee. He is never patronising or snobbish. He is as much at ease with a toothless down-and-out as he is with the most elegant society model. In the company of deaf people, he breaks easily into sign language. As a boy left unable to walk after an attack of polio, he understands disability. For Snowdon, poverty, misery, squalor, even deformity are part of the human condition, not to be shunned or exposed in a voyeuristic way but opportunities to reveal redemptive qualities in people who fight misfortune and those who help them.

Our first investigation together was into the alleged abuse of mental patients in the old institutions. There had been a spate of reports on these hospitals. Our job was to uncover further scandals.

Snowdon approached all our assignments more as an undercover agent than as a celebrity photographer. He hated reception committees and contrarily refused to take any pre-arranged pictures, whispering that they were 'boring'. I had the role of decoy, distracting officials while he took 'a little stroll'. For him, as for me, it was important to find out the truth behind the display.

Snowdon liked early starts, the 'dawn raids' as I used to call them. On one occasion, we had been staying in a hotel near Coventry. At 6am, I heard a knock at the door and a familiar voice: 'Let's go now!' I had arranged a visit to a local hospital through the correct channels for later in the day, but Snowdon was insistent. With his irresistible smile he persuaded me. 'You drive and say you're delivering the laundry. I'll put on this cap and be your assistant!' Within half an hour we were in the women's ward, where patients were being washed and dressed by the night staff. The nurses, as keen as we were to improve conditions on the wards, turned a blind eye to the little man with the Leica as he climbed into the communal showers. I had no qualms. Snowdon would treat anyone he asked to photograph with utmost courtesy and the photographs he took there were neither ugly nor intrusive.

The authorities were not always happy with us, nor were our editors, who would wait nervously to see if we produced the story they had commissioned. On a visit to a training centre in Lincoln for young people damaged by rubella, Snowdon took his usual walk around. 'Hands', he gesticulated to me. 'I'm only going to take pictures of hands.' Alarmed, I rang our picture editor and warned him about Snowdon's decision. 'Try and get some other pictures.' But Snowdon was right. The story appeared under the title 'A World in their Hands' and the images were startling: a blind boy's hands on an electric saw guided by the teacher; a deaf, almost blind girl, gripping a pencil as she sketched the precise architectural details of a church window. Once Snowdon broke his 'hands' rule and in the unlit corner of an institutional room, dropped to his knees to snap a little boy whose remaining vision was just able to catch the glinting curves of the soap bubbles blown by his mother. That moment of hope in the child's otherwise dark and silent world became the symbol of a new campaign.

Much as he liked to regard our exploits as daring resistance operations, Snowdon was not always the most protective companion. Ten years after our first field-trip around mental hospitals, we embarked on another tour – to expose the conditions not inside the hospitals, but outside in the bleak hinterland of seaside towns, the bed-and-breakfasts, racketeering hotels and doss-houses into which former patients were being decanted in the name of community care. Here we really did have to use all our skills of investigative reporting, as few other journalists then penetrated this Dickensian underworld. As we approached one of these hotels, as usual unannounced, we heard a savage barking. 'You go on in,' Snowdon said. 'I have a little problem with the camera.' And he dived under the boot of the car. He eventually joined me, an alcoholic landlady and twelve rottweilers.

Only once have I experienced Snowdon the portrait photographer. He had been asked to take a picture of me for a profile in the *Telegraph* Magazine. I couldn't believe the extravagant setting: the crimson canvas rolled down from the studio beams, an array of umbrellas and tripods and a rail of exotic velvet cloaks. He had decided to portray me in imperial style. For three hours, I had to stand with my right hand resting Napoleonically on my breast. I begged to be taken in a more humble fashion. Instead, each time I moved my hand, he would silently walk across the studio floor and replace my fingers exactly as he had first arranged them.

It is precisely this wilfulness, eccentricity and (no doubt in my case) his sense of humour which make Snowdon unique. I am looking forward to our next lunch, where we will joke and reminisce and he will, of course, lure me into his latest campaign – to make life a little more amusing, beautiful or bearable for those less fortunate than him.

'Old Age', *Sunday Times* Magazine  1965

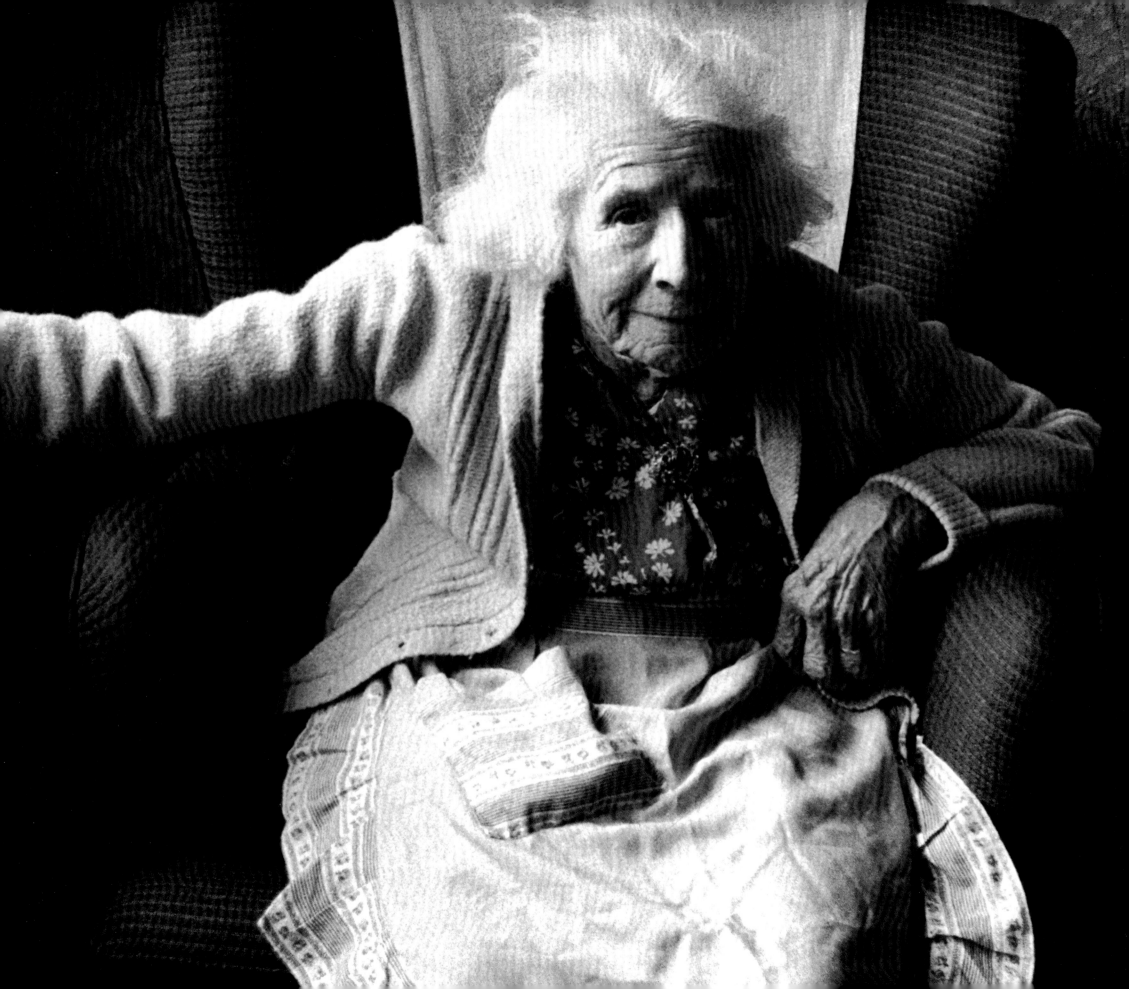

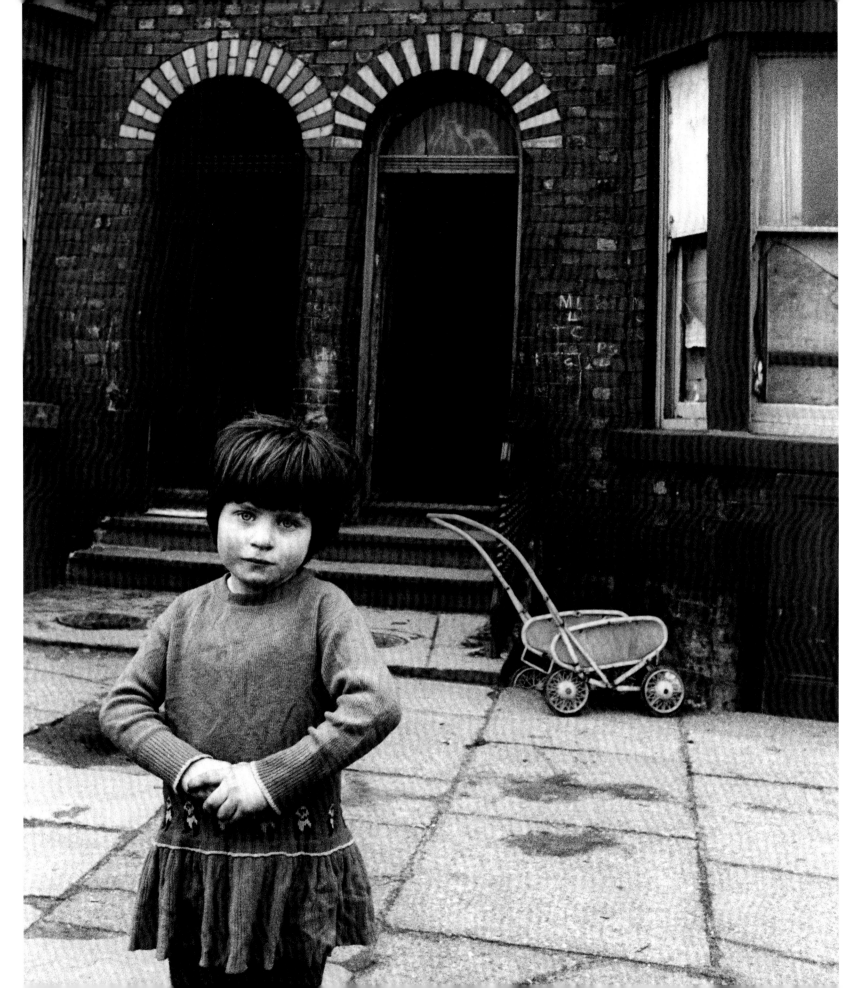

'Children Under Stress',
*Sunday Times* Magazine 1970

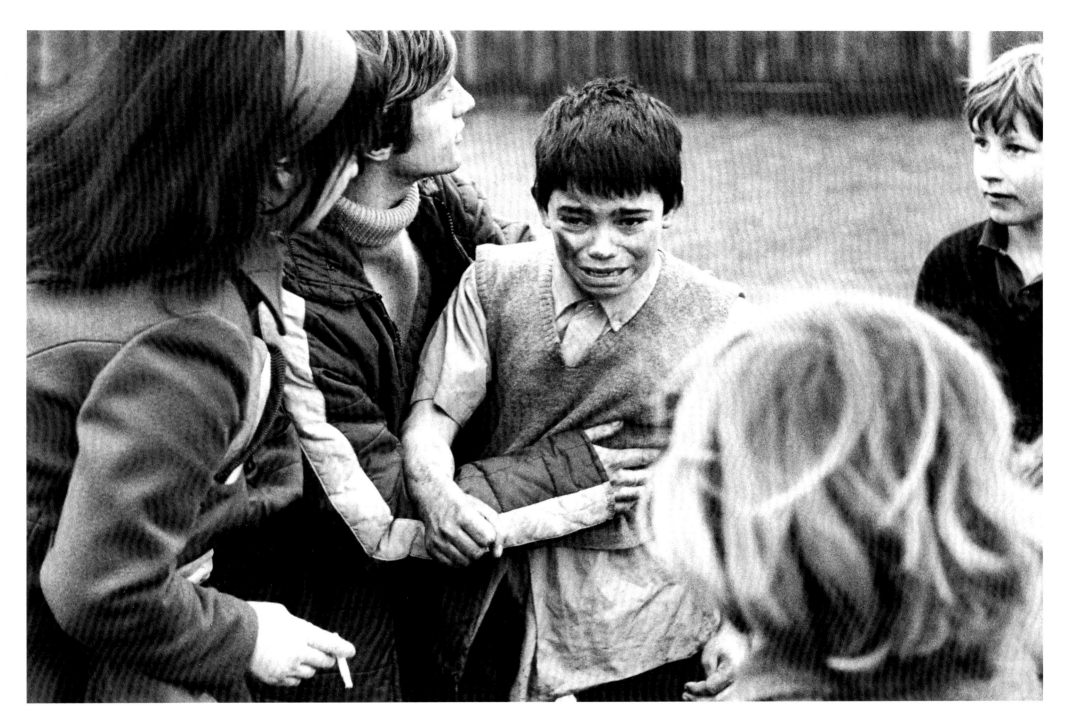

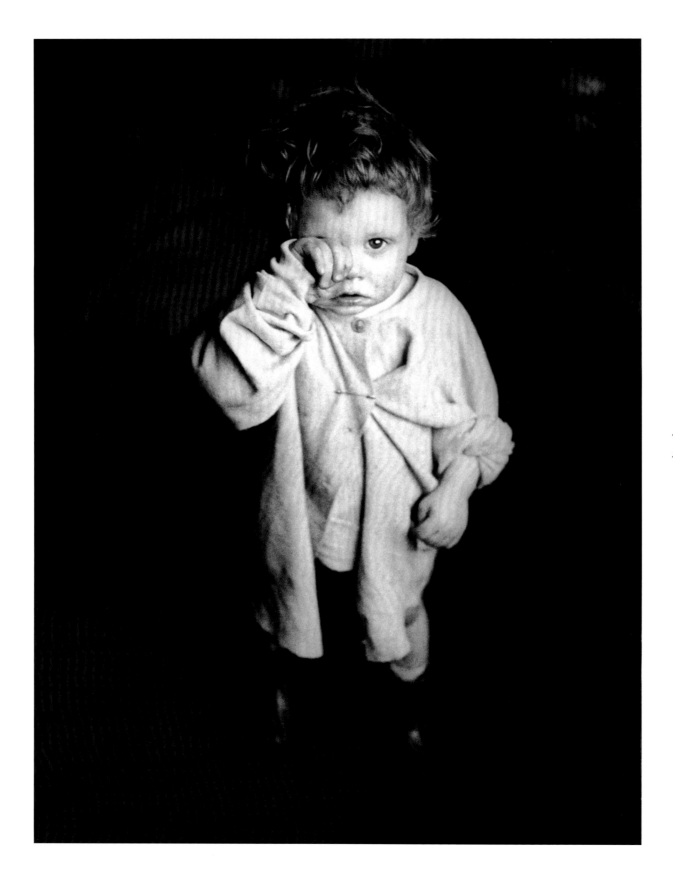

102

'Some of Our Children',
*Sunday Times* Magazine 1965

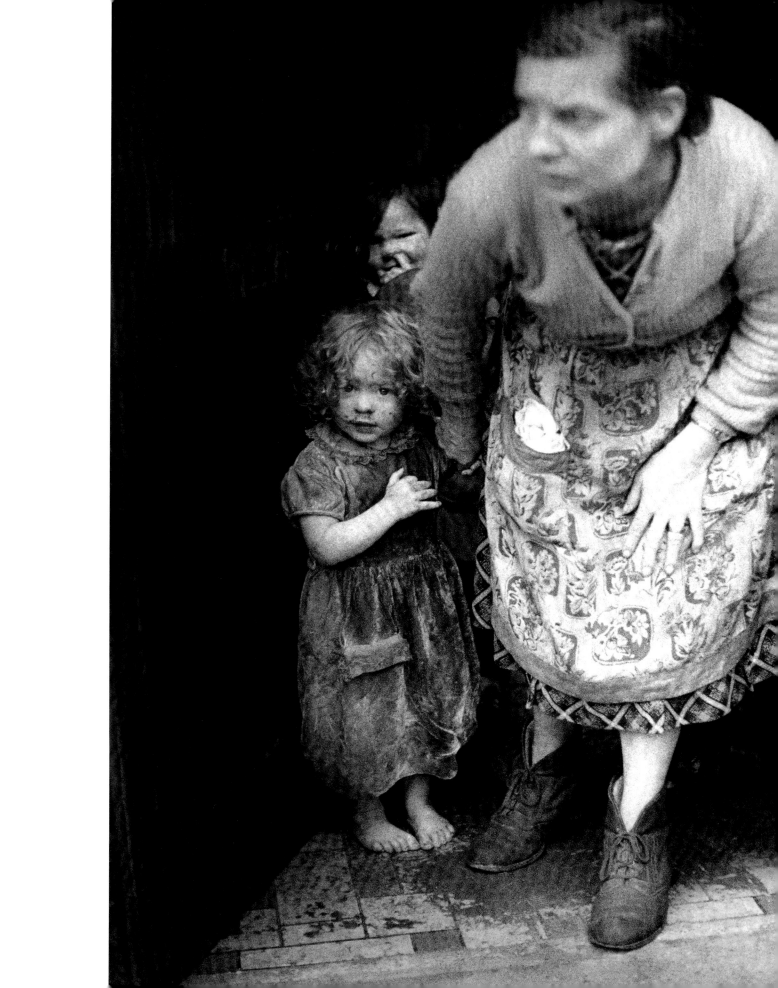

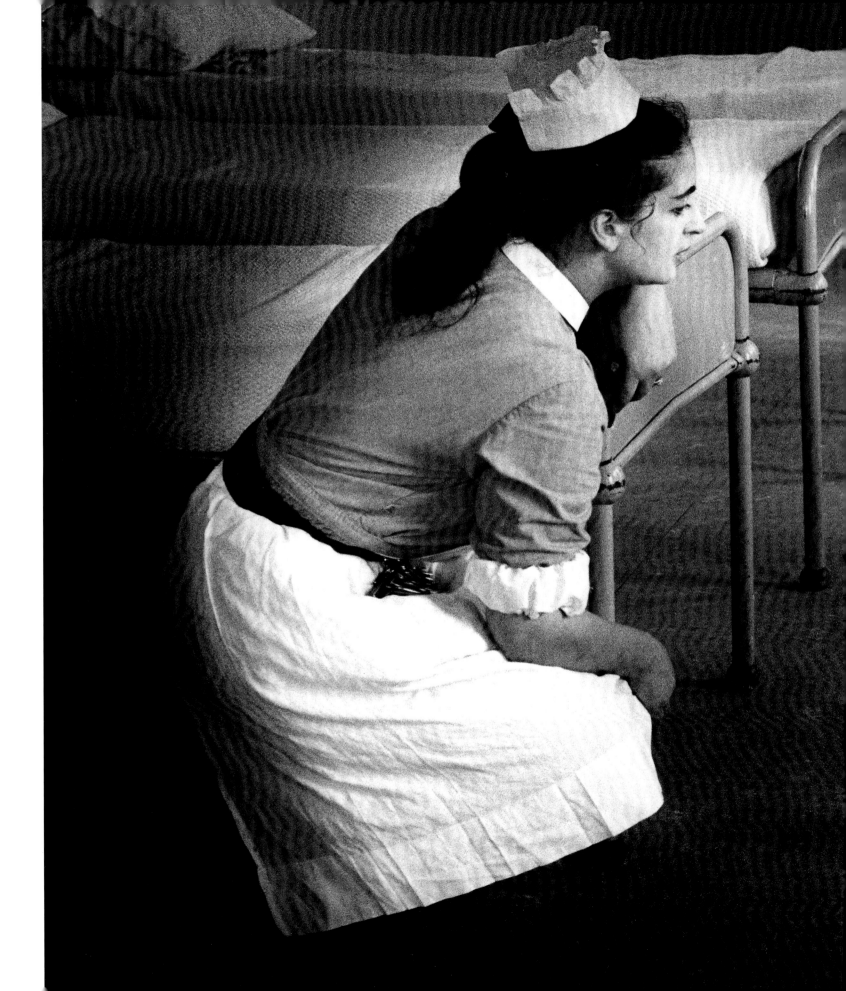

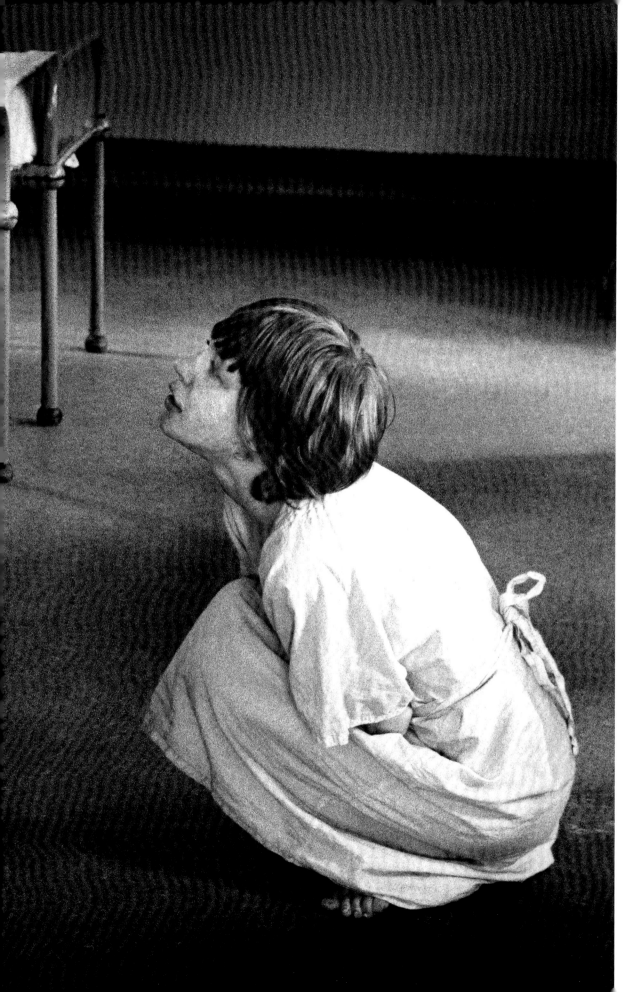

'Mental Hospitals' *Sunday Times* Magazine  1968

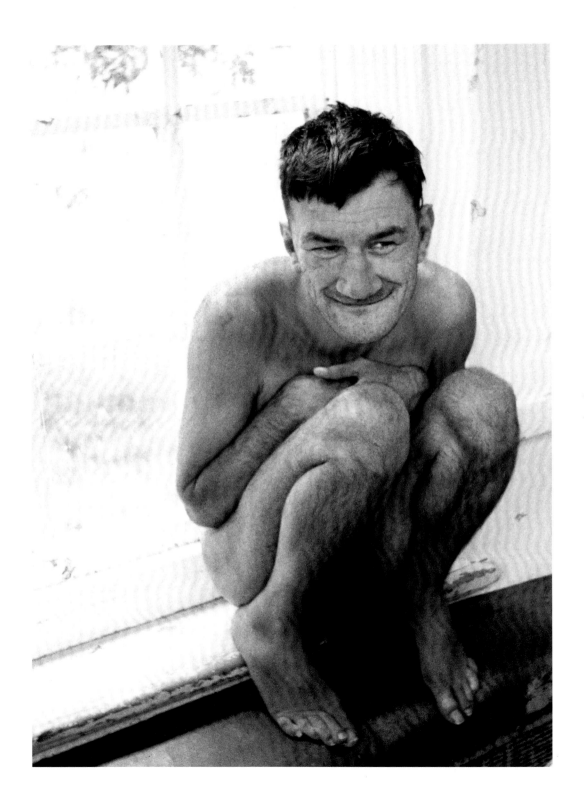

'Mental Hospitals',
*Sunday Times* Magazine 1968

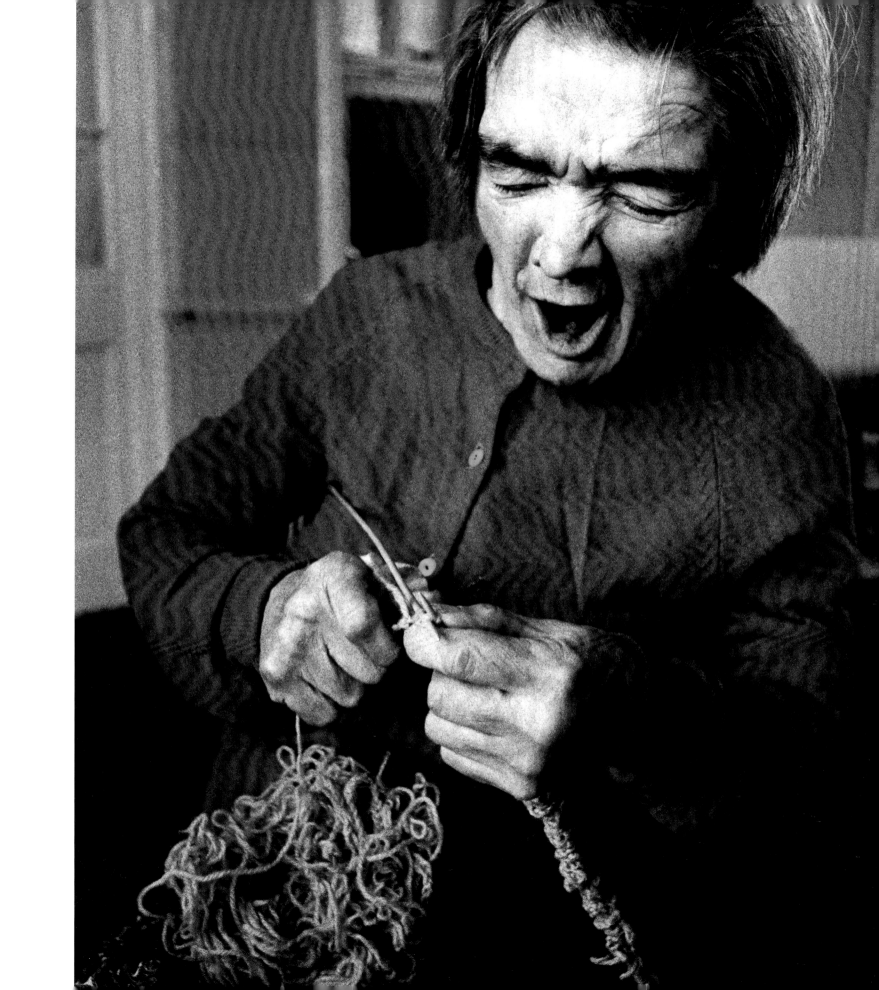

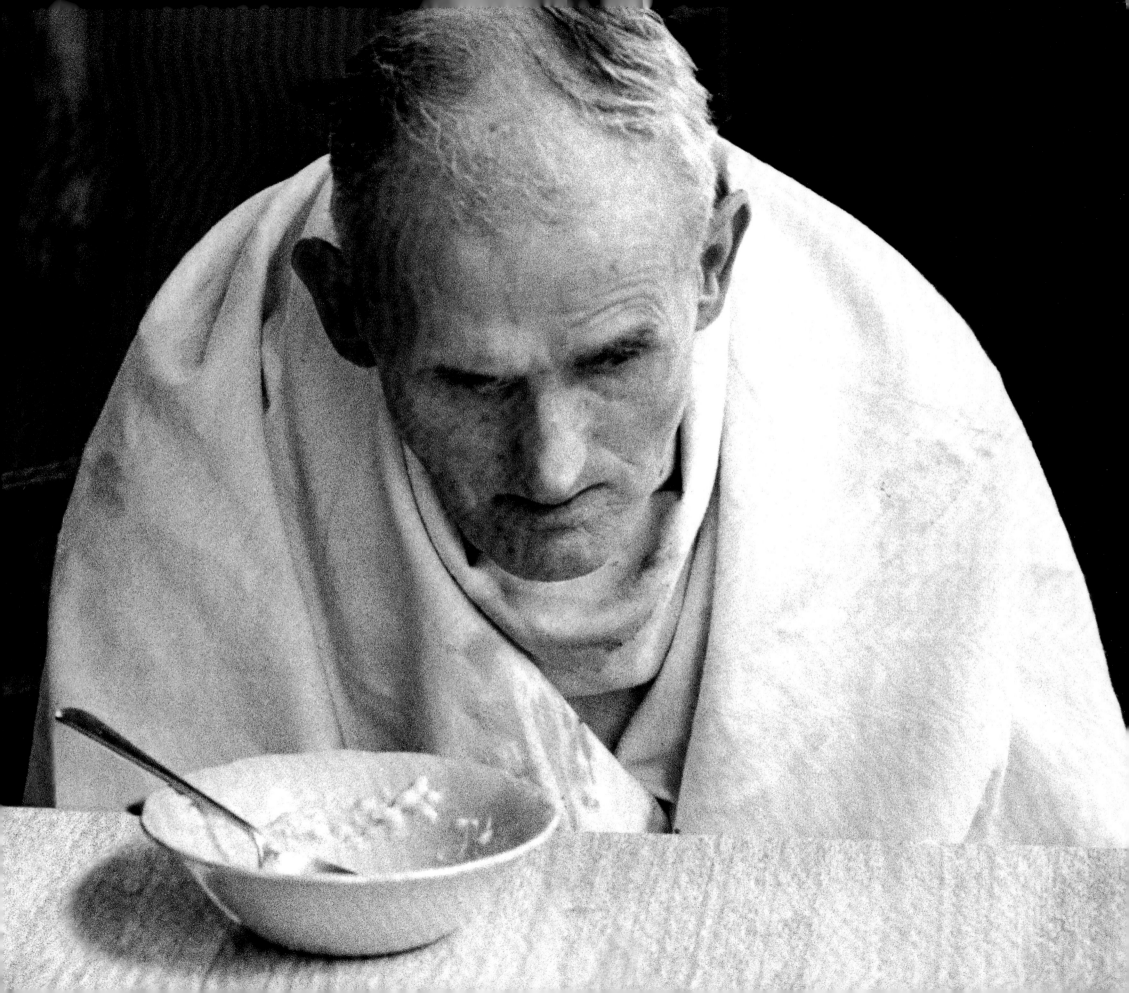

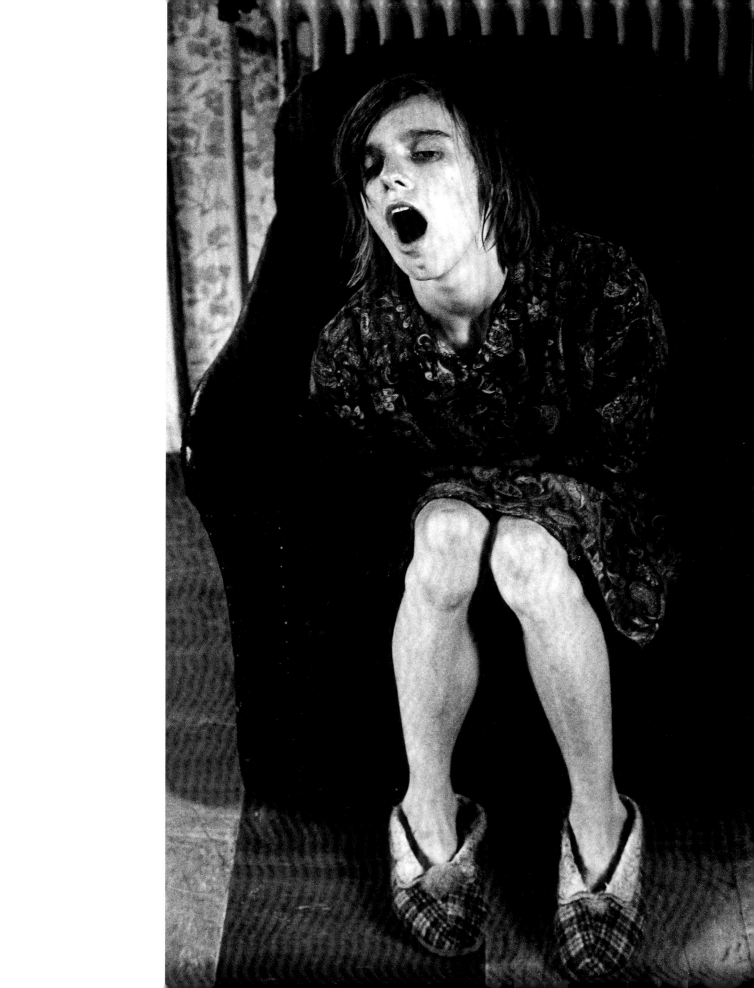

'Mental Hospitals', *Sunday Times* Magazine  1968

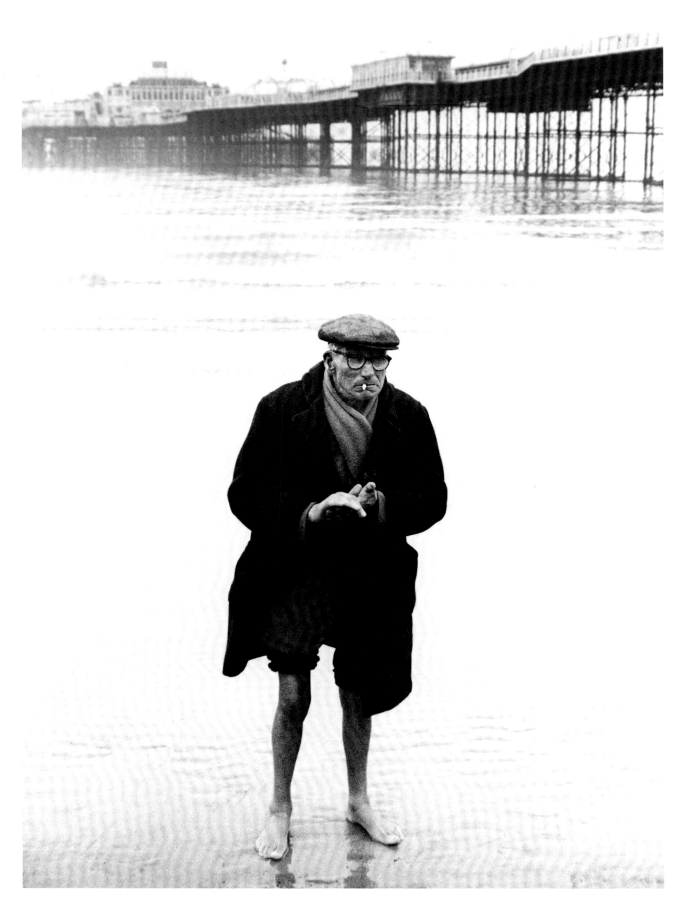

'Loneliness', *Sunday Times* Magazine  1966

'Aspects of Marriage', *Sunday Times* Magazine  1965

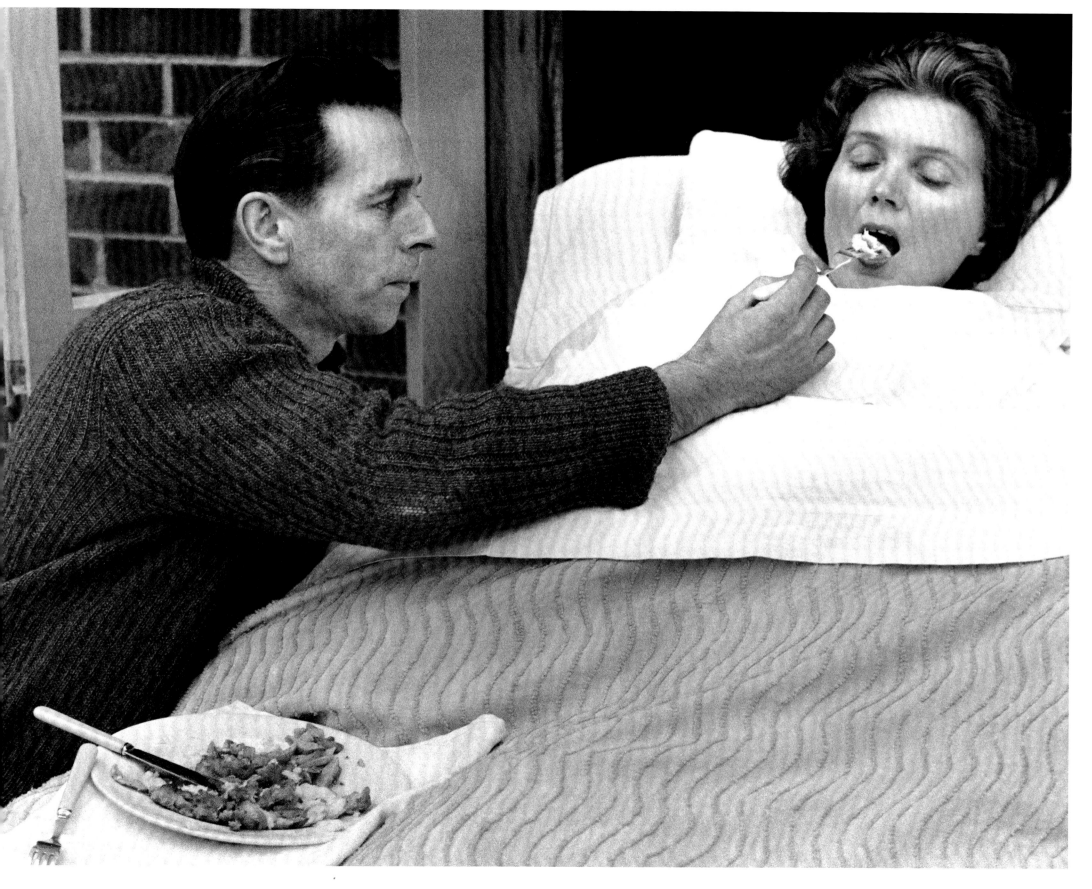

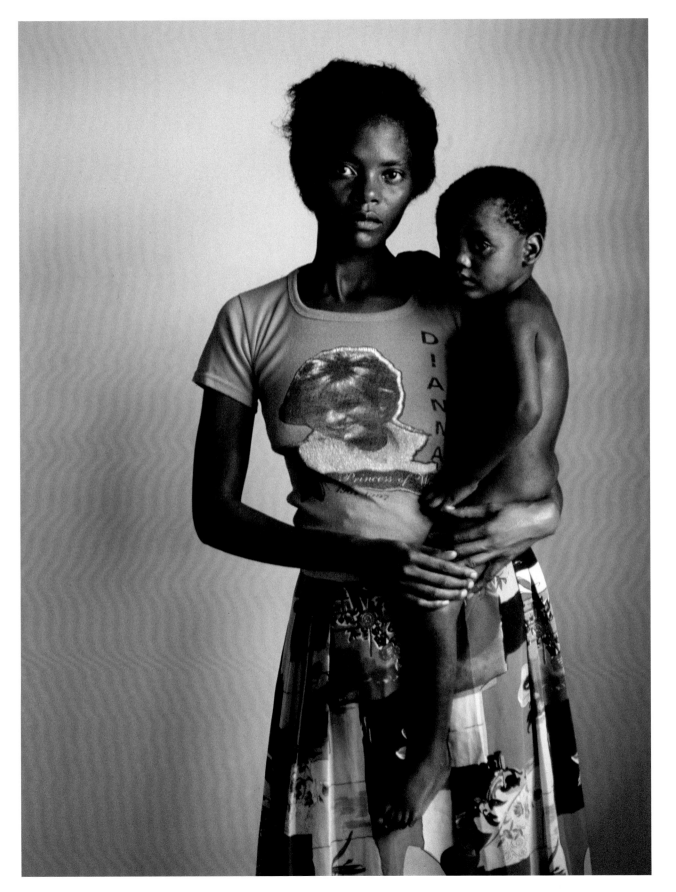

Polio victims, Angola  1999

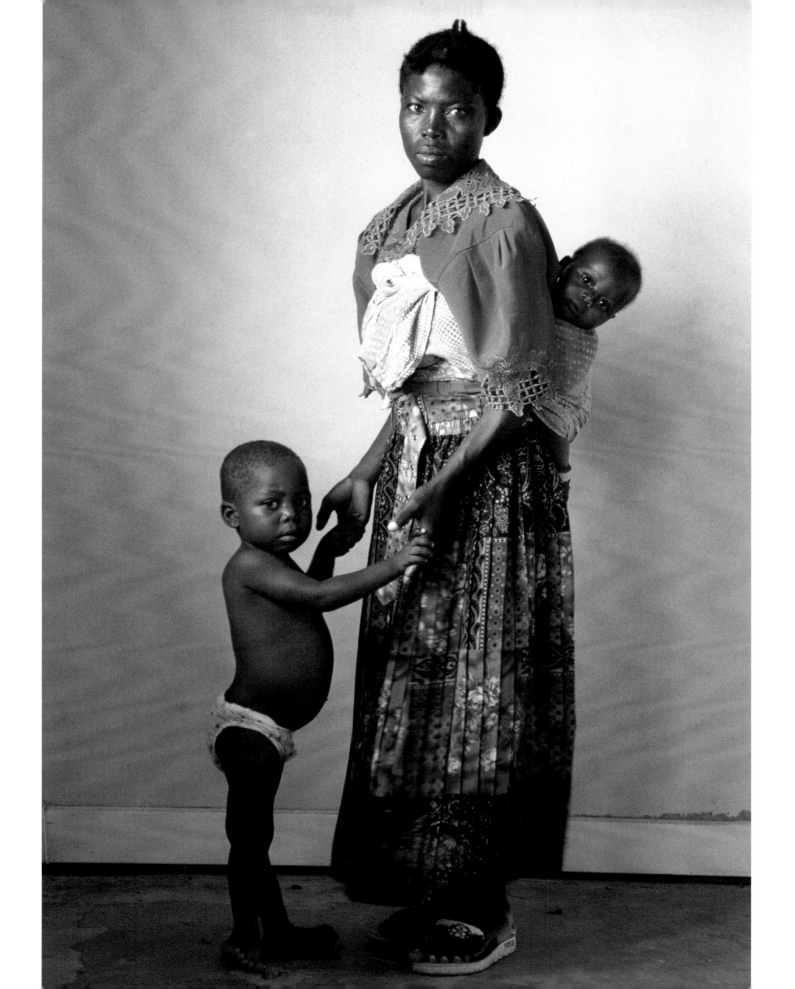

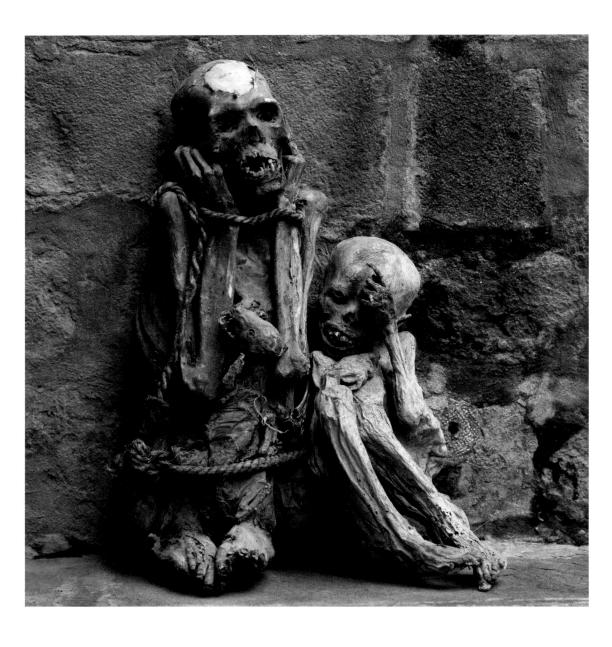

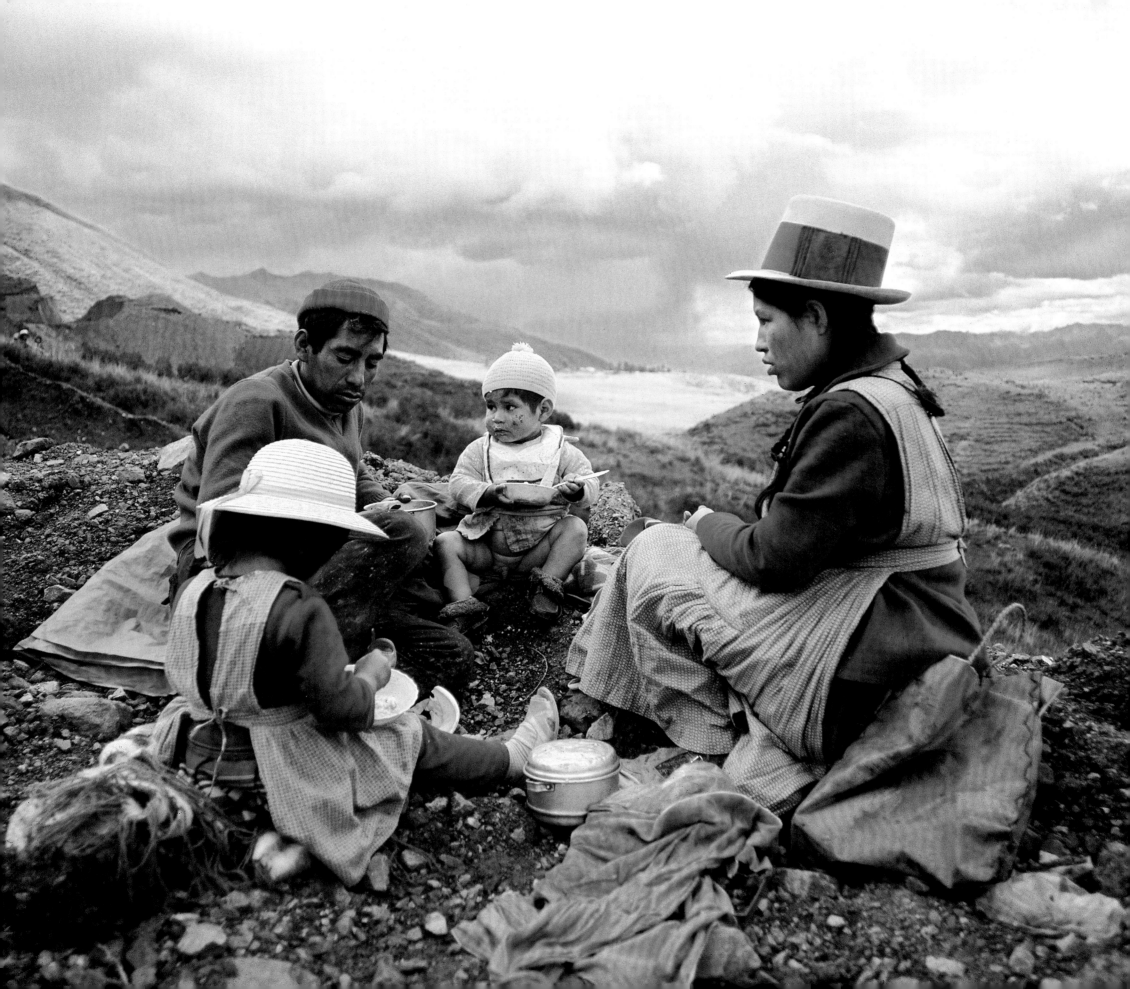

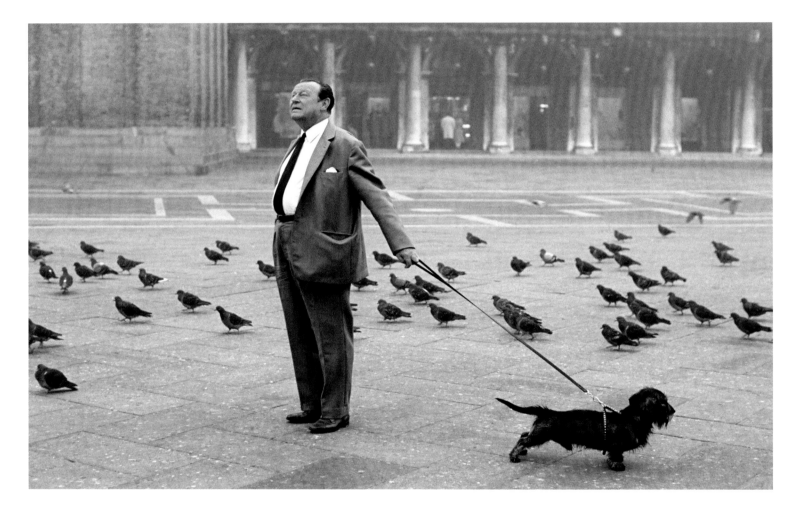

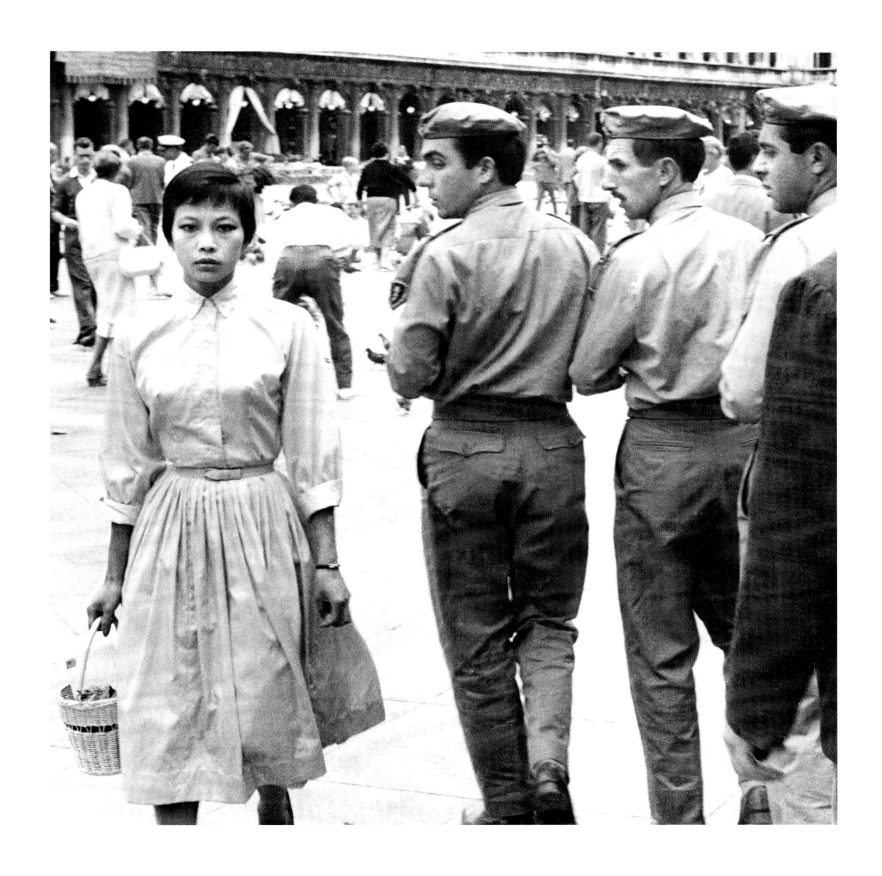

Jacqui Chan,
**Venice** 1956

Overleaf:
**Venice** 1972

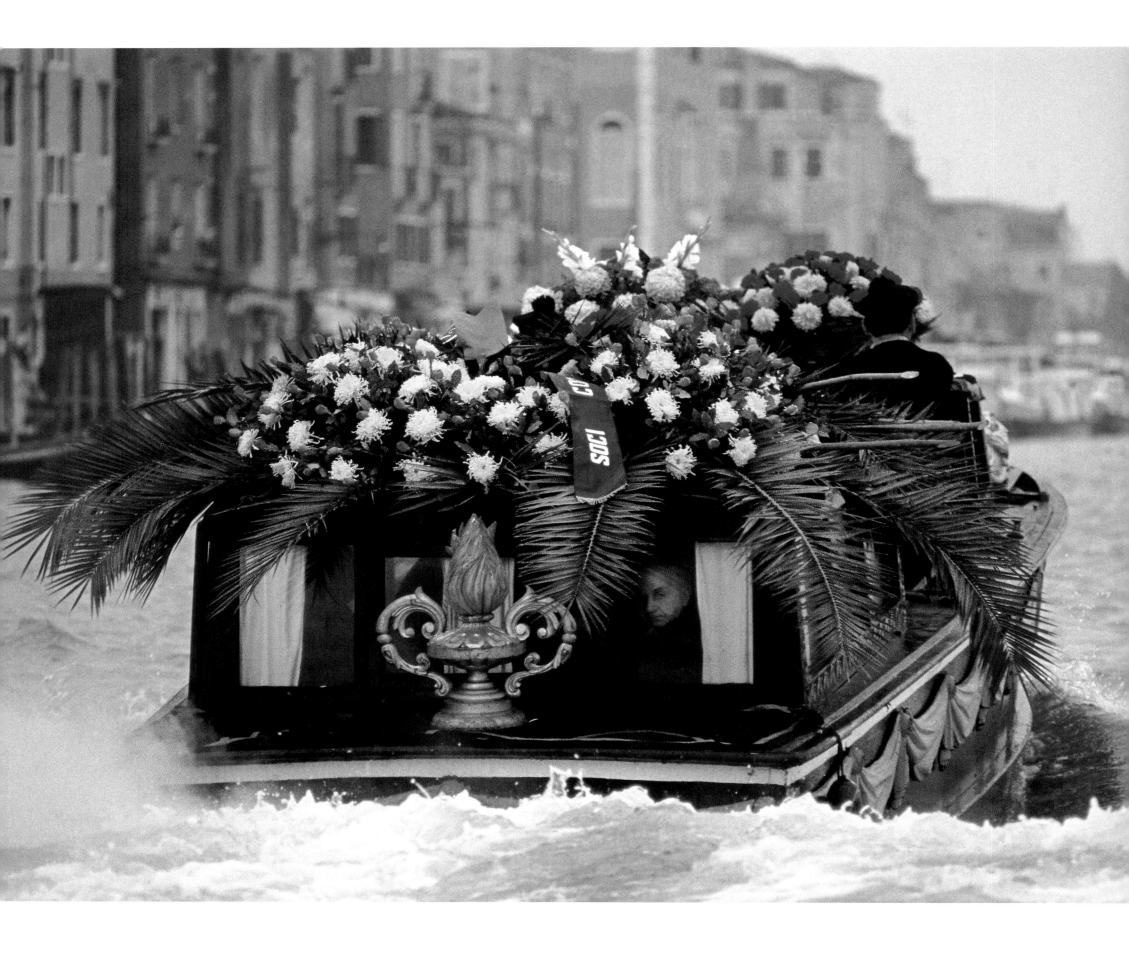

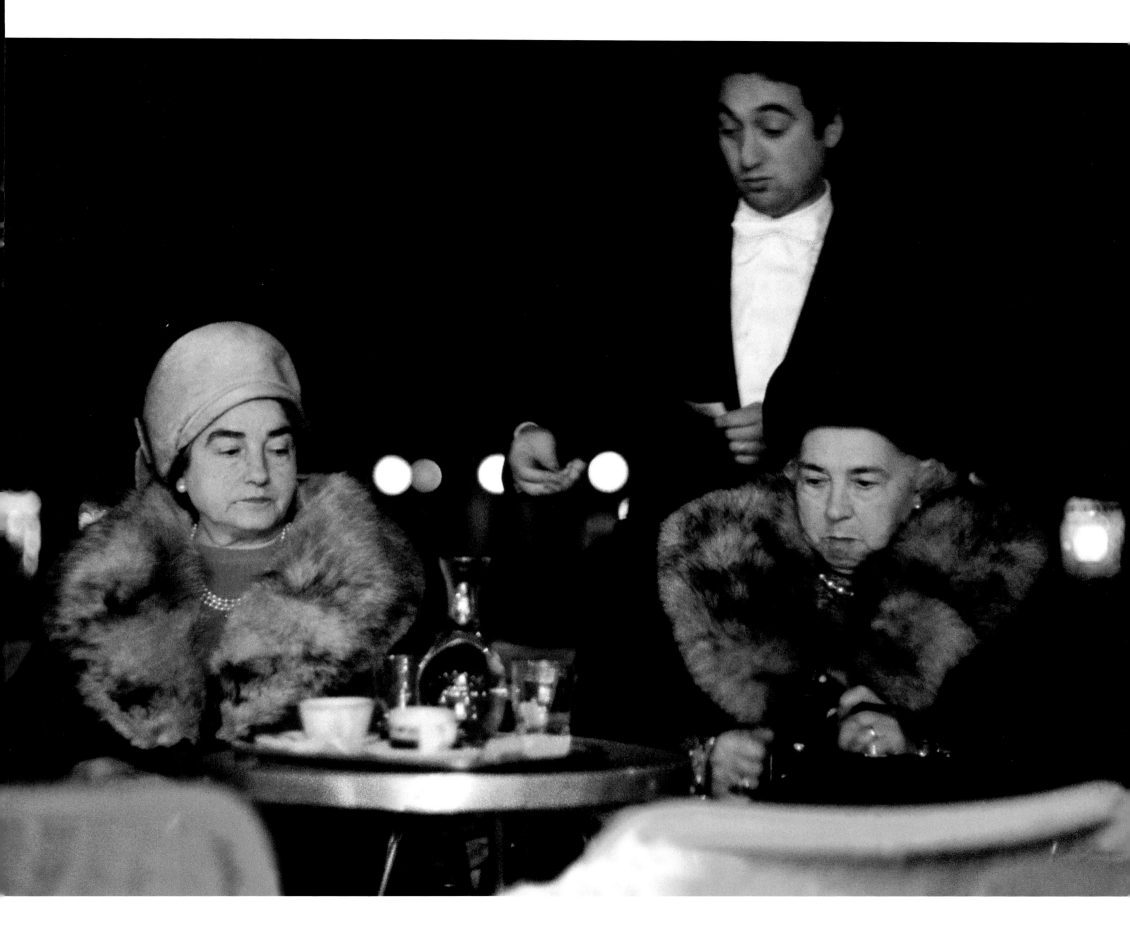

Detroit 1974

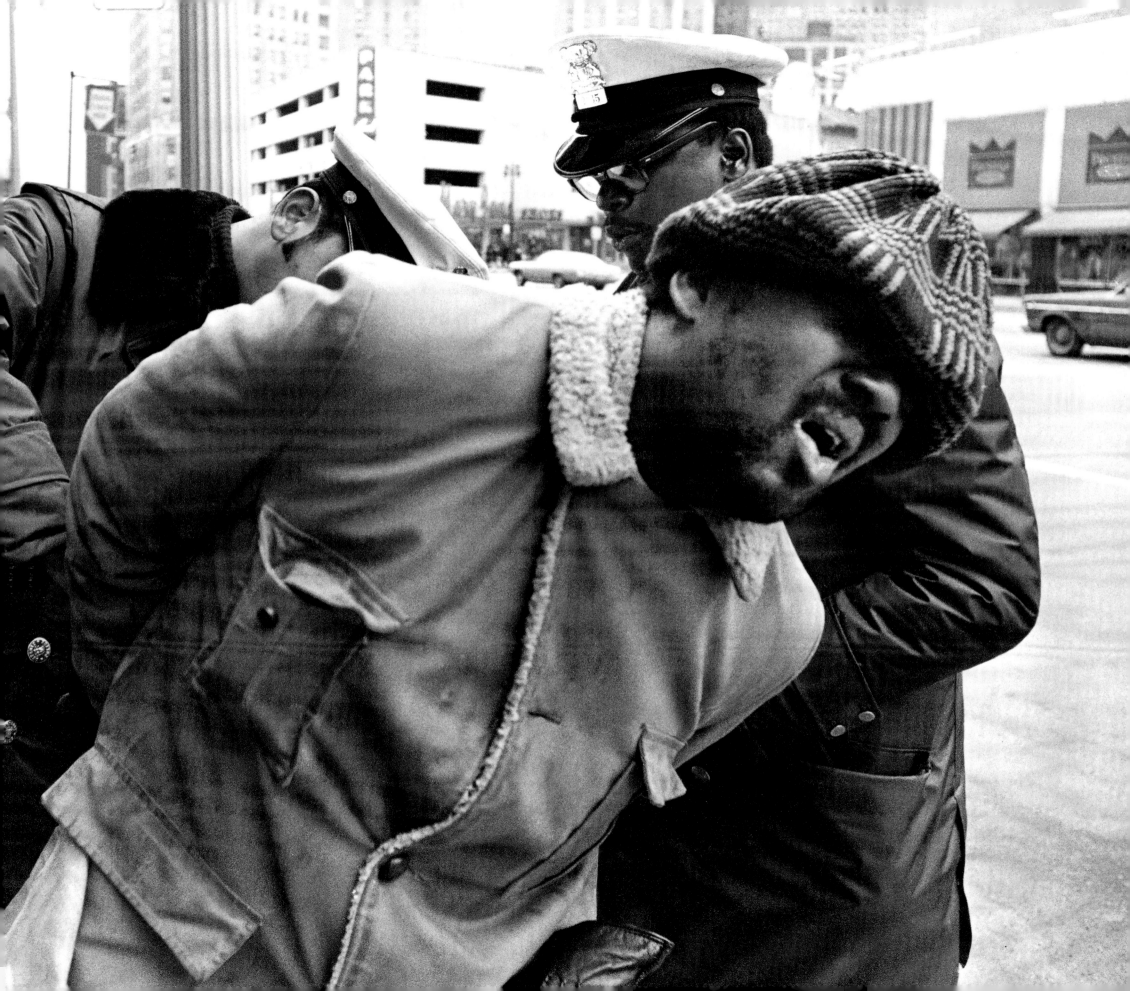

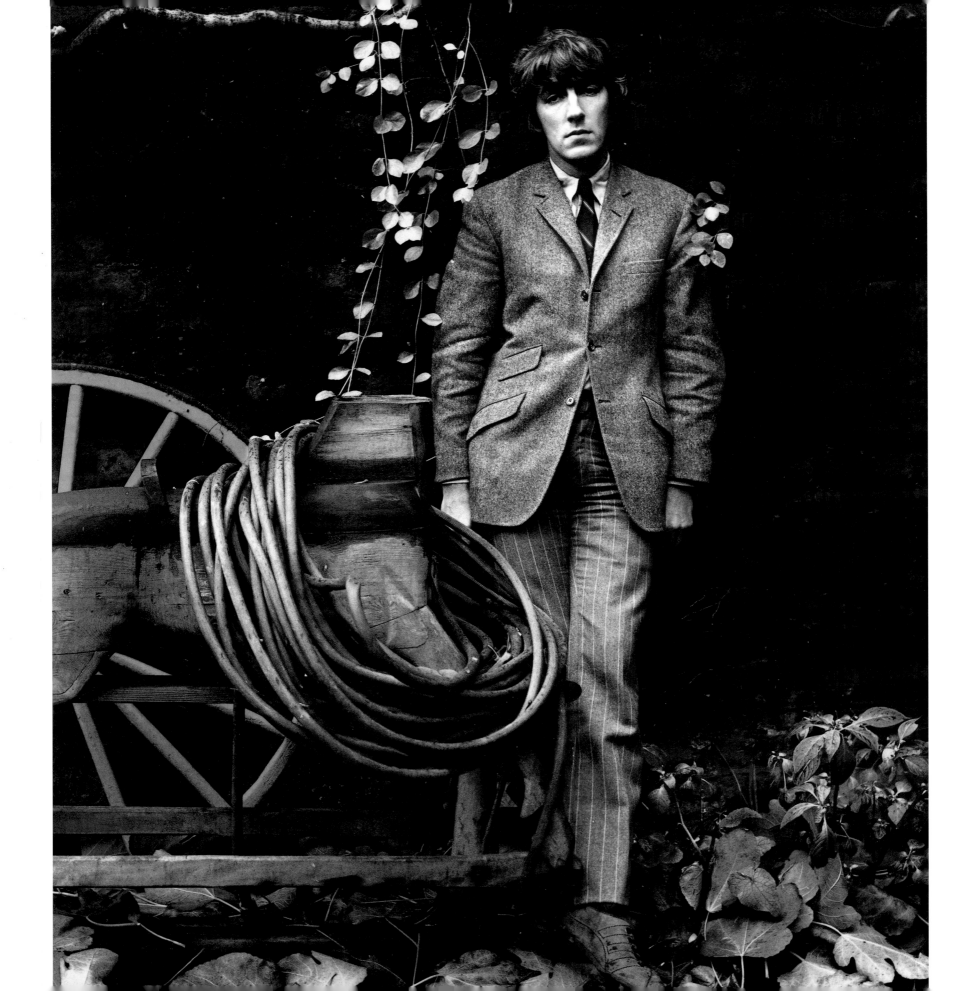

Peter Cook 1968

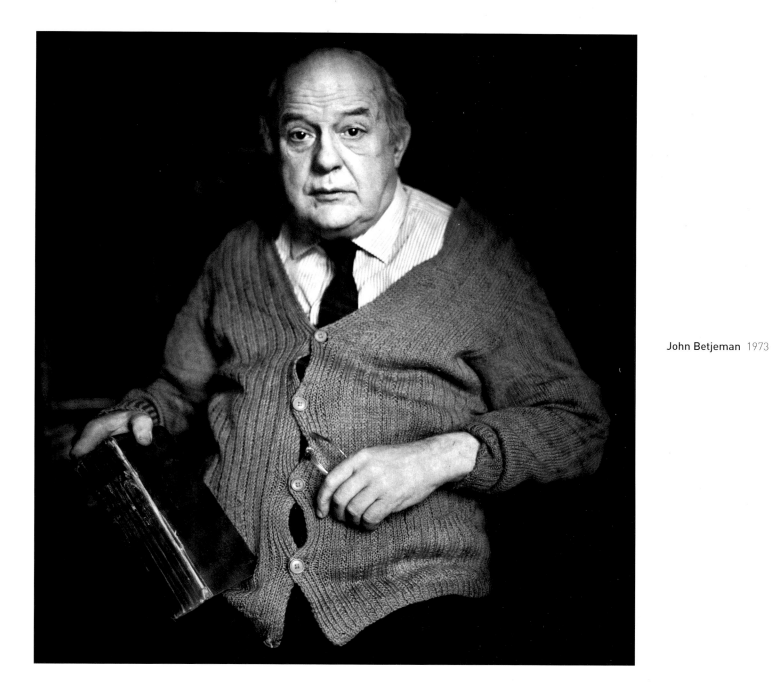

John Betjeman 1973  123

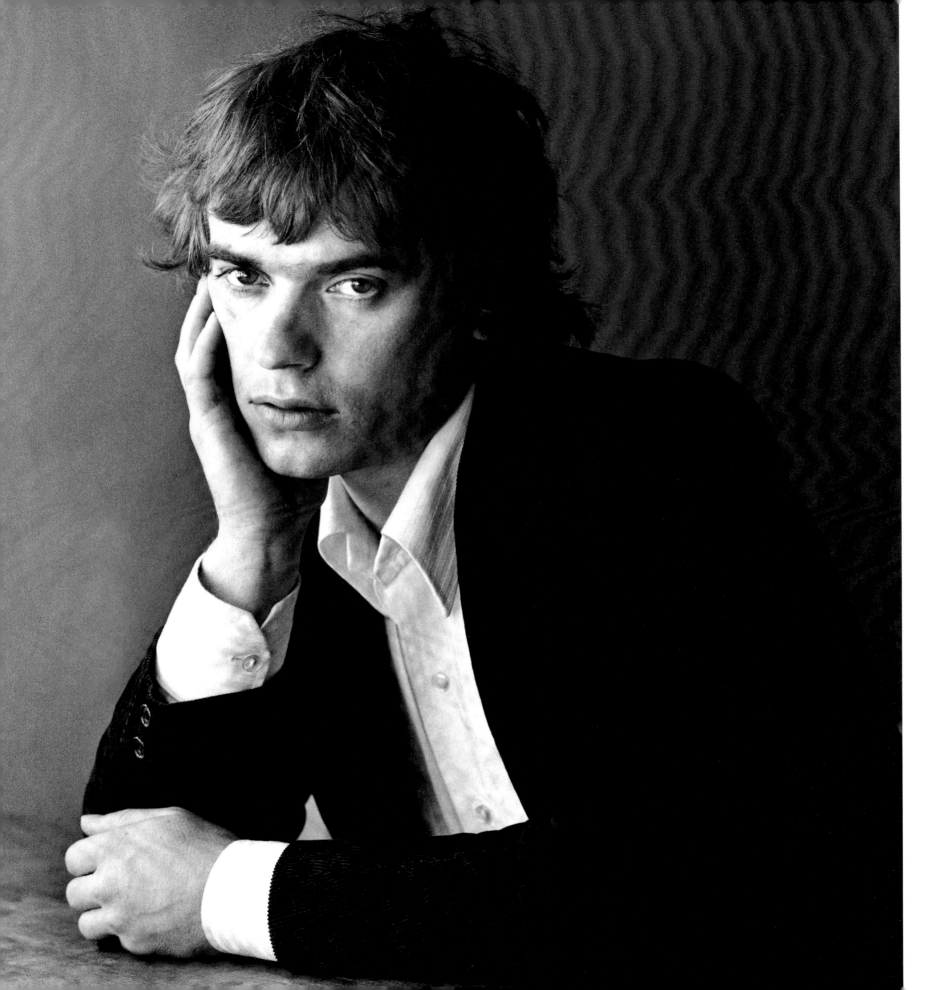

Martin Amis 1978

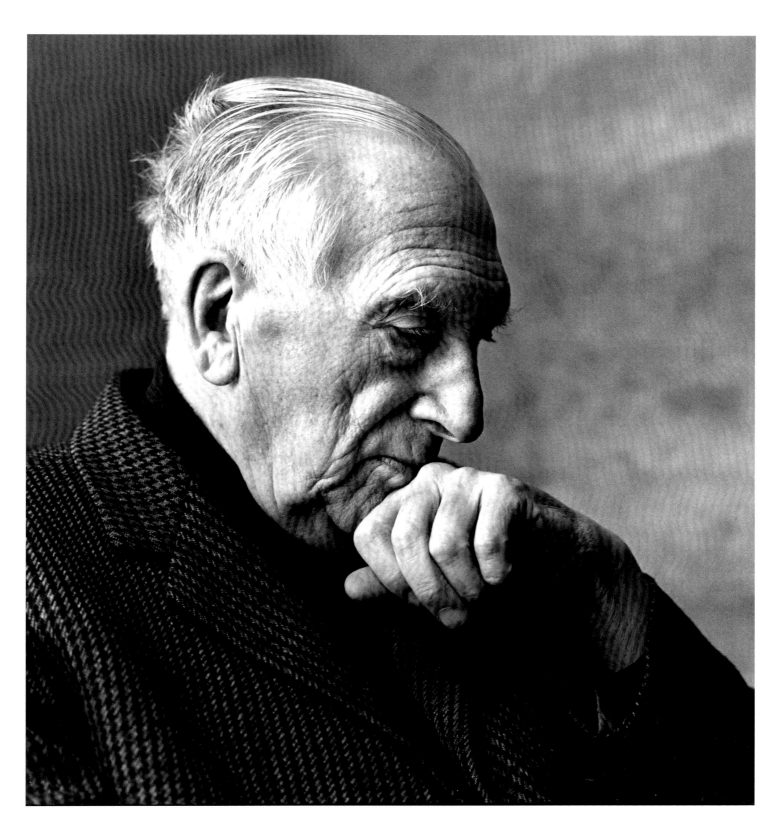

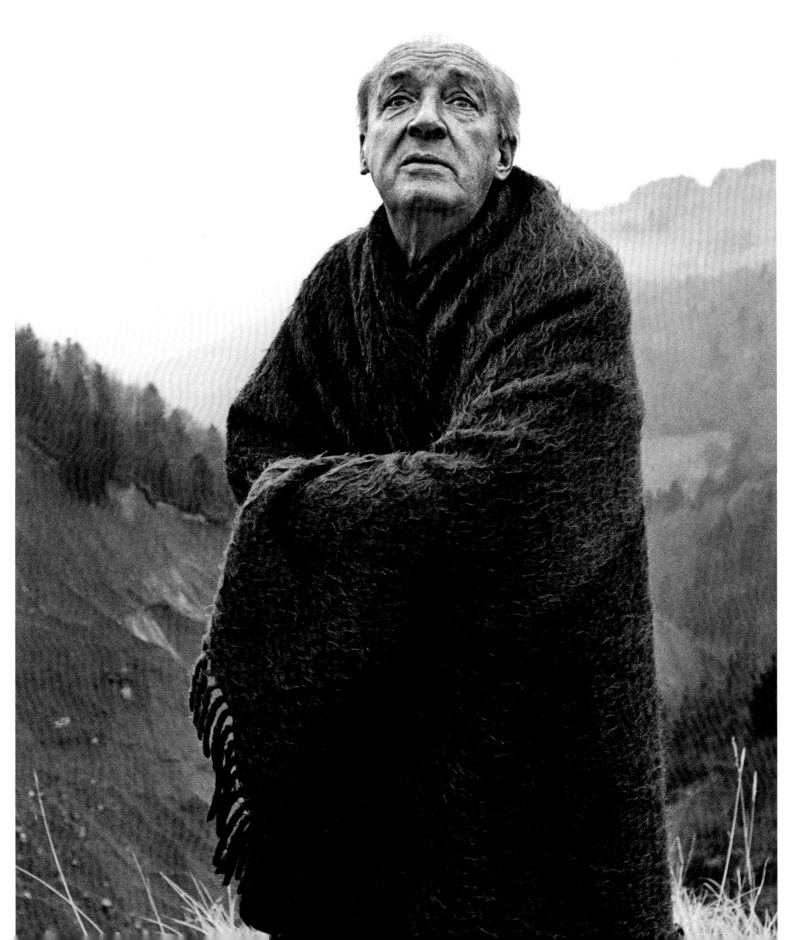

1972

Vladimir Nabokov 1972

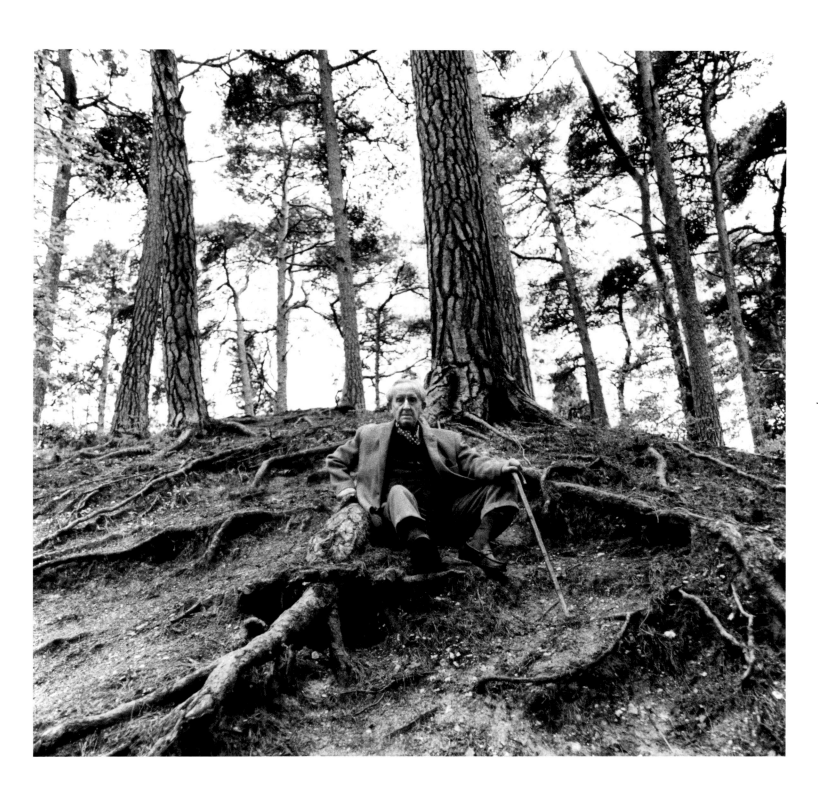

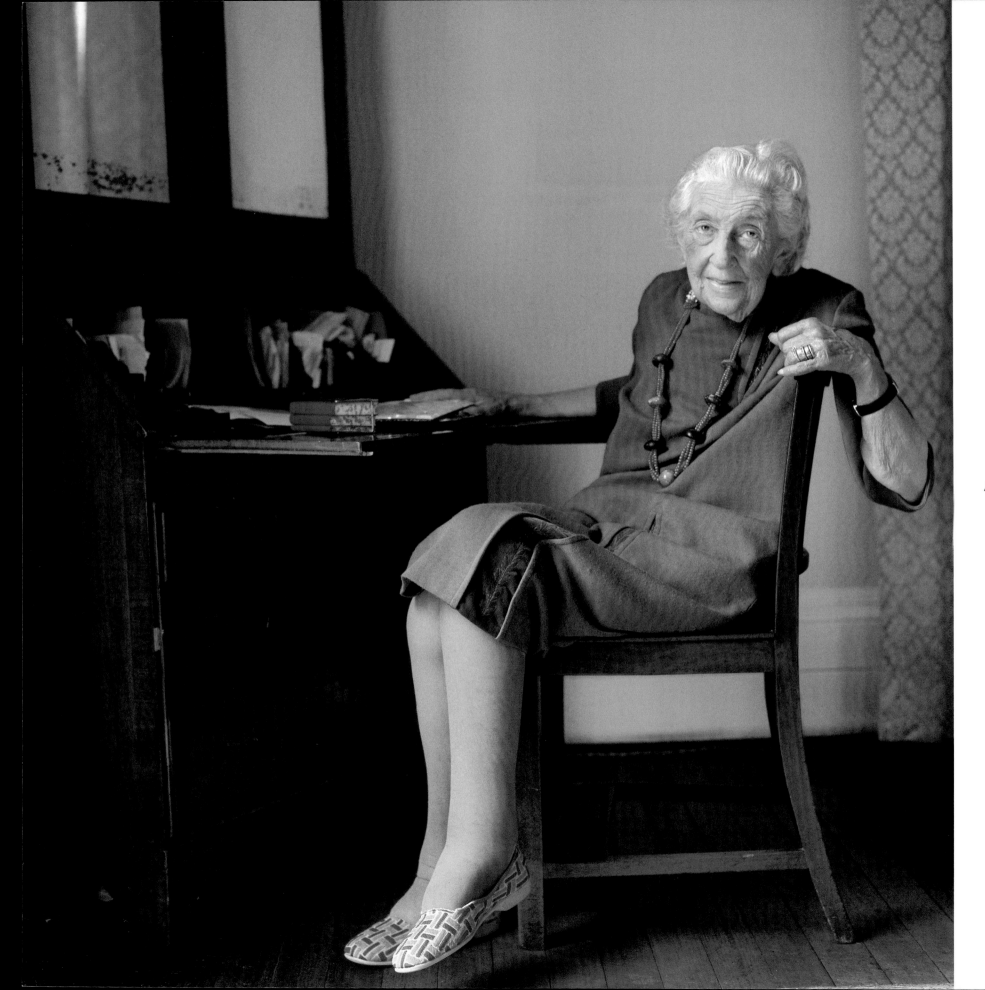

Agatha Christie 1974

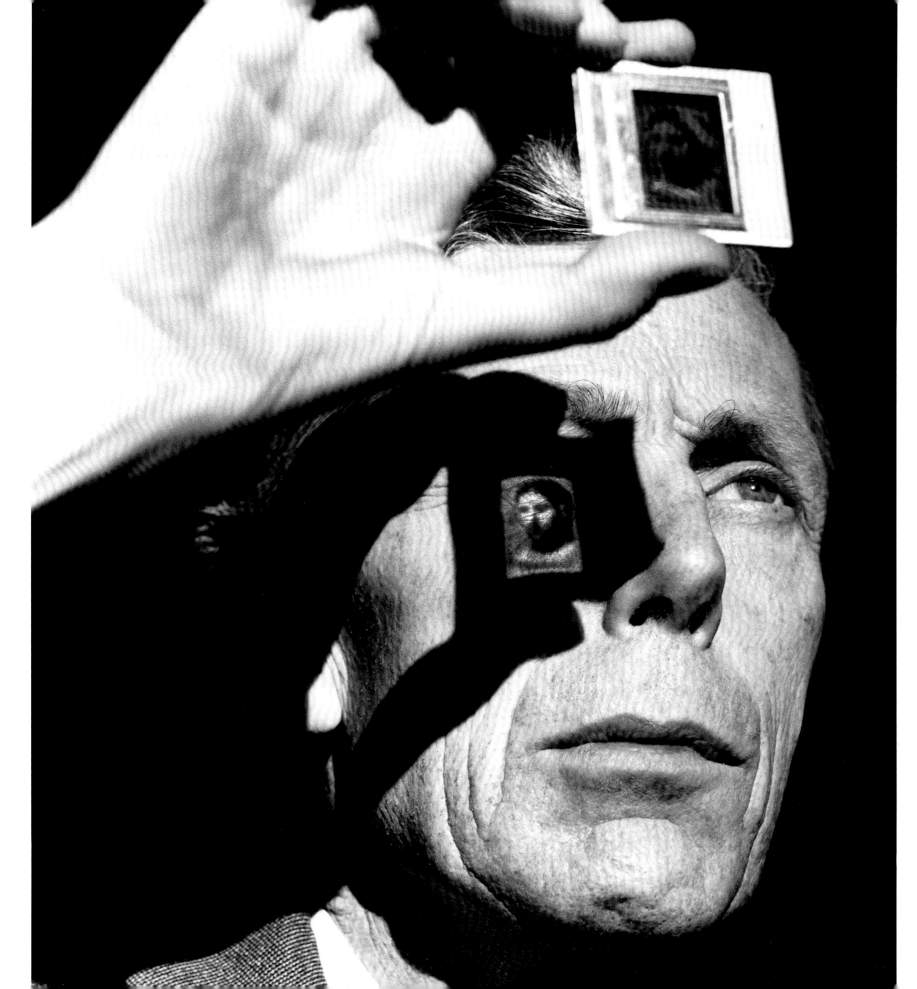

 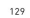

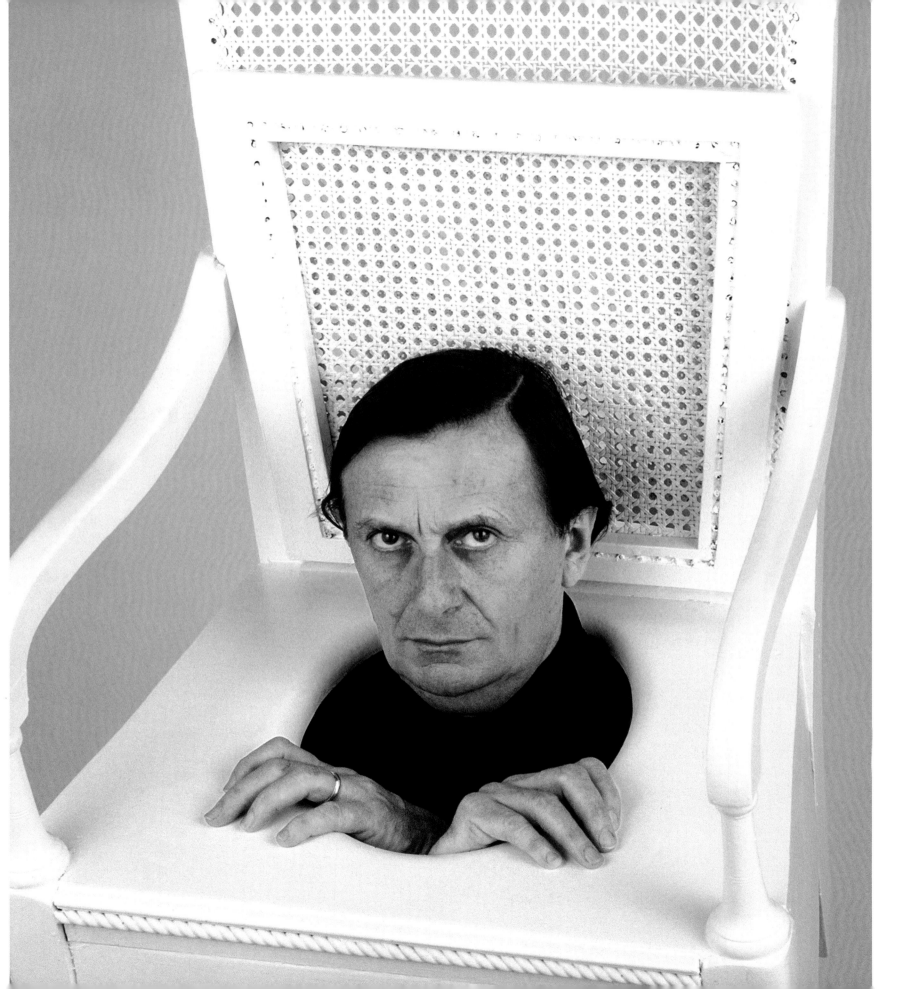

Barry Humphries 1987

# ANTHONY POWELL

SOME forty years ago, during a break in the dress rehearsals for the Benjamin Britten/John Cranko ballet *The Prince of the Pagodas* at the Royal Opera House, when we'd all nipped across the road to the Nag's Head pub, a young man in a faded Levi jacket, carrying a large brown envelope, entered the saloon bar and joined Cranko. The two of them furtively examined the contents of the package under cover of the table top. The photographs (as they turned out to be) then passed from hand to hand under the surrounding tables, without ever quite reaching the seat of the increasingly suspicious official production photographer, who was sitting on the opposite side of the room.

The young man was Tony Armstrong-Jones, who had clearly been smuggled into the darkened auditorium with strict instructions to be as invisible and silent as possible. Certainly, I'd never noticed him. The pictures had a magical capturing-of-the-moment, an immediacy and spontaneity that we'd never seen before. Fast coarse-grain film had been used so that the images had a strongly black-and-white granular quality that gave them an added bite and energy. They were daring, exciting and entirely original.

At the time I felt sympathy for this poor young fellow, whose extraordinary work could not openly be examined and admired, or receive the plaudits it so clearly deserved. I now realise that he probably adored every moment of the cloak and dagger stuff: benign intrigue is meat and drink to him – I've never met anyone with quite such a highly developed sense of mischief and fun. Nor with such a low boredom threshold, which probably goes a long way to explain his tireless energy and constant inventiveness. From his fingers, never idle for more than a few moments, cascade four-poster beds, gothic door canopies, garden follies and jokes – like an endlessly pouring champagne bottle, suspended miraculously in mid-air. I remember his glee in finding a photograph in the catalogue of a grand country-house sale given by one of our senior auction houses, illustrating 'An important three-tier eighteenth-century fountain', which in fact Snowdon himself had cobbled together one weekend whilst staying at the house, out of bits and pieces found lying around in local junk yards, and cement cast in a sand mould.

Less well known is his exploration of aspects of disabled lives whose particular problems no one has yet tackled. I once arrived at his house to see him bowling along the pavement in an elegant Regency armchair that I recognised from his drawing-room, resting on an electronically operated plinth – a veritable *Deus ex machina*. As he approached a parked car, he zapped it with the bleeper in his hand, the back of the car descended to form a ramp, he mounted it in his mobile throne, crossed the empty interior towards the steering wheel, the rear door rose majestically behind him and he swept off. (Sadly the idea proved too expensive to put into mass production.)

His enchanting house in the country was grist to his creative mill. Having started off life as a connected group of four estate-workers' cottages, ranging in period from early Tudor to Regency, in the 1960s the interiors were modishly 'knocked through'. Happily, the internal dividing walls with their traditional wooden-latched doors have now crept back, the moulded plastic has gone and the cosily reinstated warren of little rooms is filled with sunshine, flowers, pretty old jugs and plates, charming old country furniture, rush matting – and of course an Aga. Everything has been restored to what it was – or what it romantically might have been, as it seems a little unlikely that the original occupants would have slept in canopied beds under Oliver Messel's original designs for Margot Fonteyn as Princess Aurora. Equally, one can imagine their surprise on looking out of the kitchen window to see a nobly proportioned lake at the bottom of the valley outside, with its orientally pagoda-ed island surrounded by groves of exotic bamboo and serenely floating white geese ('cheaper than swans and not so much trouble') or, from a bedroom window, the vista of a Gothick pavilion constructed from lacy ironwork discovered at an abandoned race-track, with an Alhambra-inspired watercourse splashing its way merrily towards the back door. All of these dream-fantasies are home-made of course, and all imbued with the sense of style, imagination and wit that one finds in the work of his adored (and equally multi-gifted) Uncle Oliver.

These qualities, and the restlessly questing spirit that animates them, inform everything Tony does, whether on a personal or professional level. What should be understood however is that although intensely cultivated, he is also inexorably chauvinistic, and could have served as a model for the original John Bull prototype. He won't go to see films with subtitles and only really enjoys traditional English nursery food (but with French wine). He is always extraordinarily well-informed about the arts (with the possible exception of music) and world affairs generally, but how is a mystery to me as I have never seen him read a newspaper or pick up a book.

Venice is greatly enjoyed, and for some reason I've never fathomed, doesn't seem to count as Abroad, but is perceived as a romantic outpost of the British Empire: more of a colony really. Paris (and certainly New York) has never made it in the same way. French restaurants in particular hold little allure, either gastronomically or socially. Yesterday I came across an old notebook where he had written, during dinner, 'Don't look now, but the man on your left is a murderer.' However, since his daughter Frances moved to Paris to study at the Sorbonne, I detect a faint softening of attitude, as she has her own apartment where there are shelves to be put up, decorations to be devised and where eggs can satisfactorily be poached. One wonders, however, how many internationally famous photographers, or come to that, peers of the realm, go through the Waterloo Eurostar terminal wearing a suit and carrying two planks and a workman's metal tool-box?

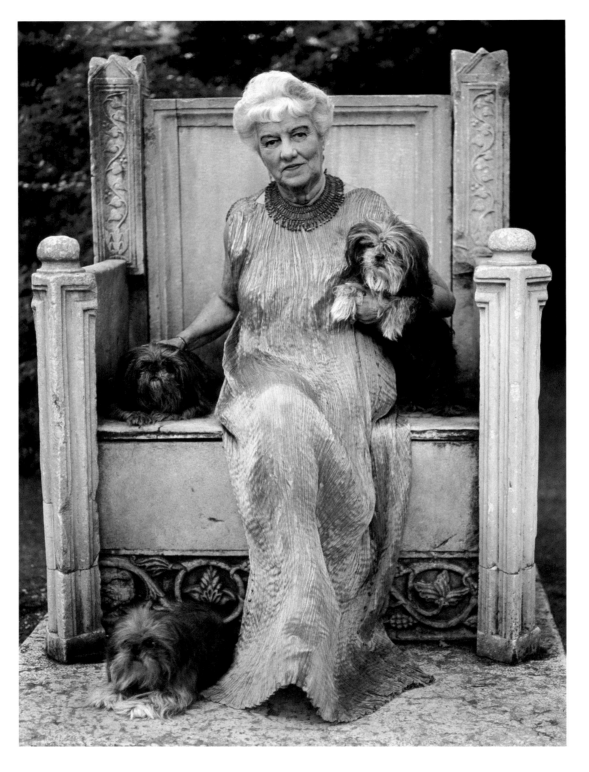

132 Peggy Guggenheim, Venice 1975

Barbara Cartland, Herts. 1988

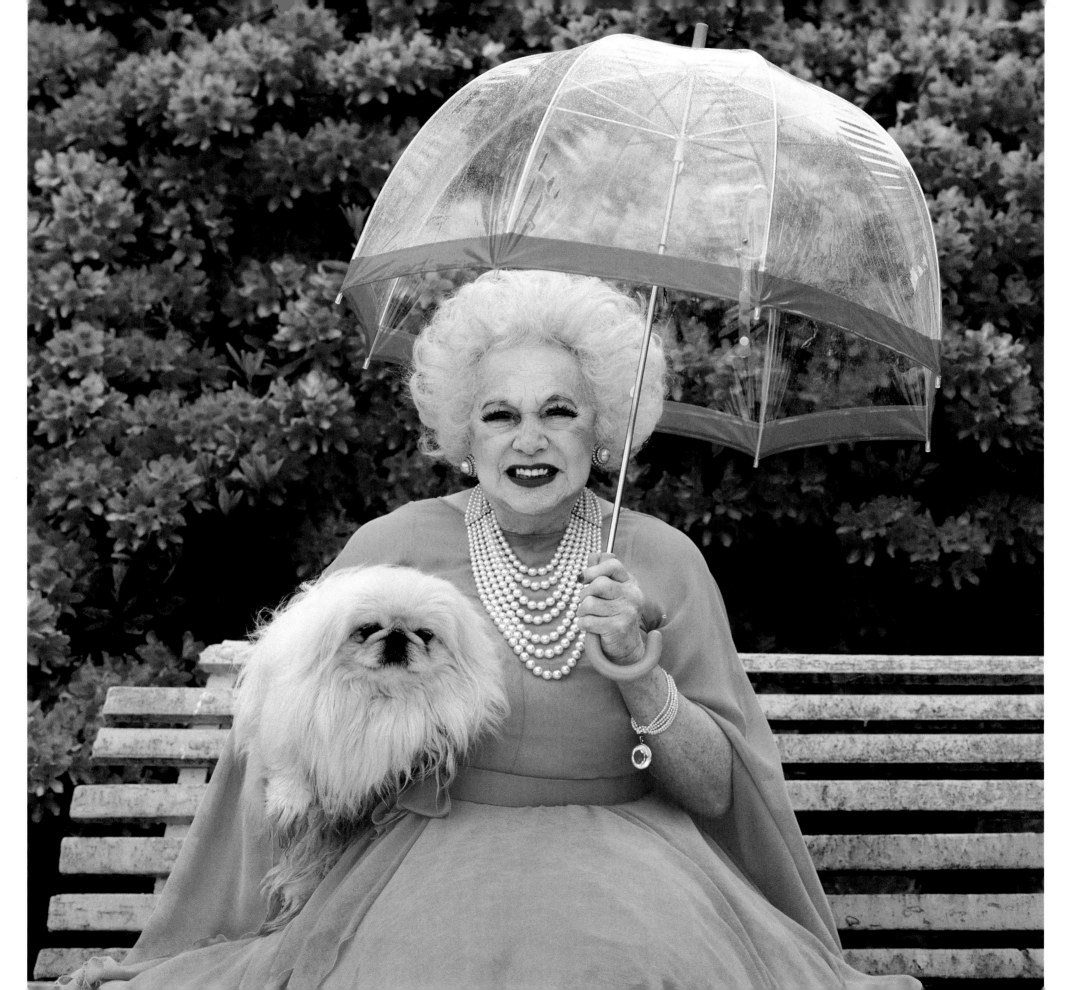

Iris Murdoch 1980

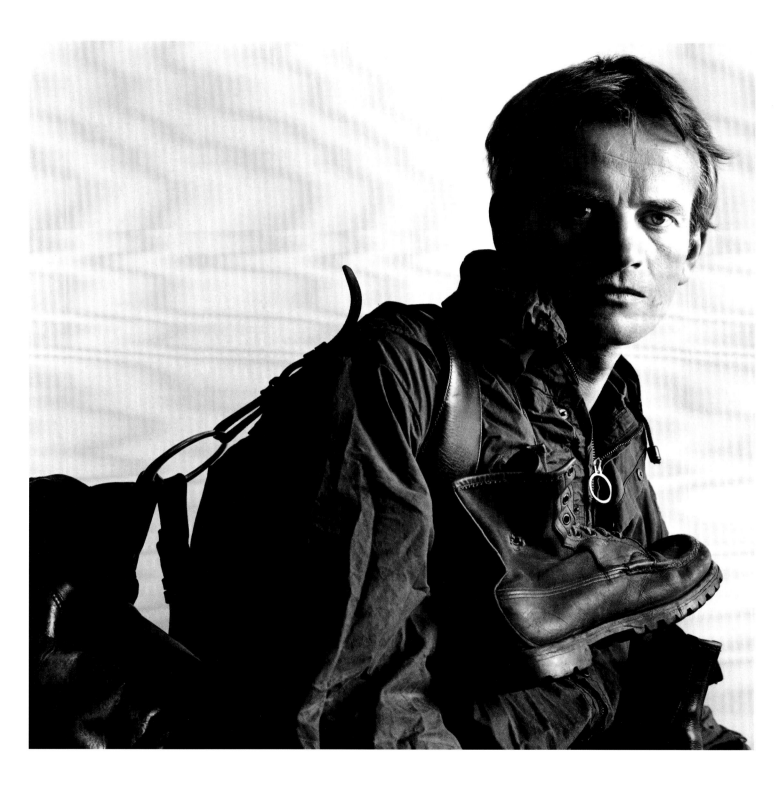

Harold Macmillan 1966

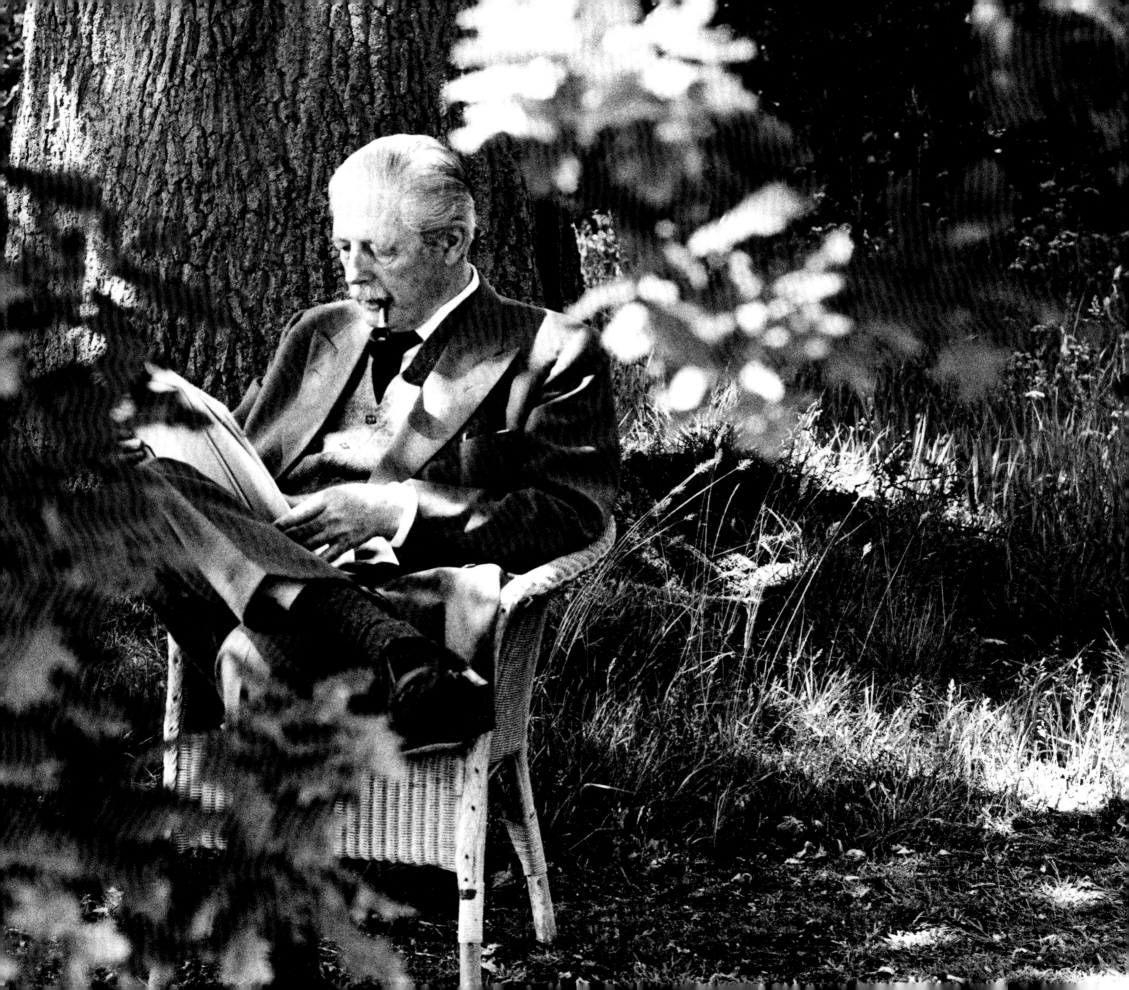

138

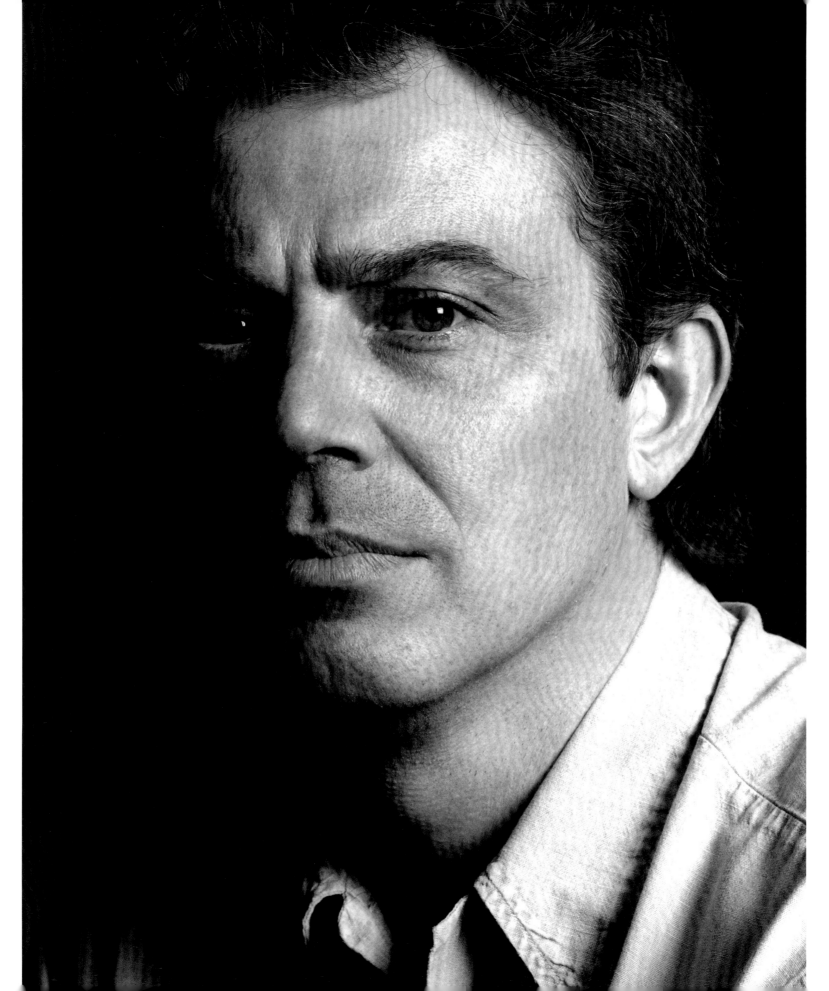

Tony Blair 1995

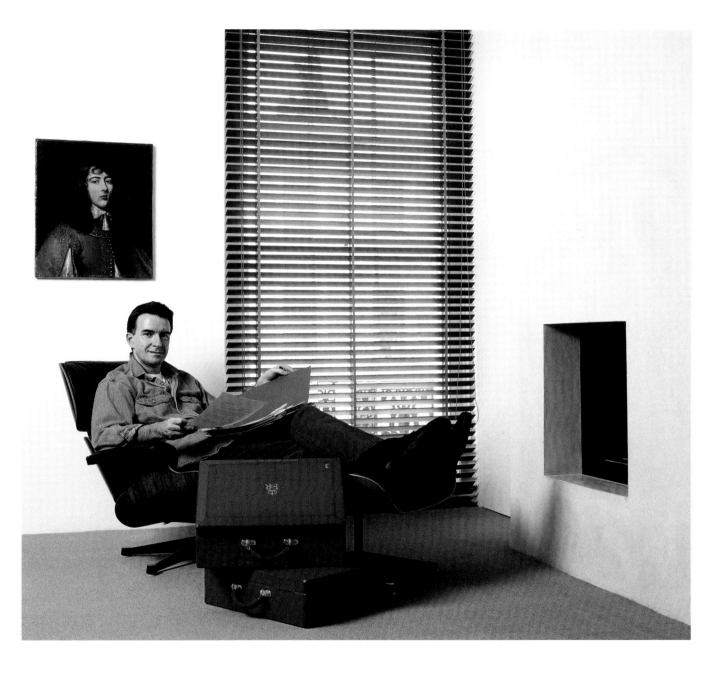

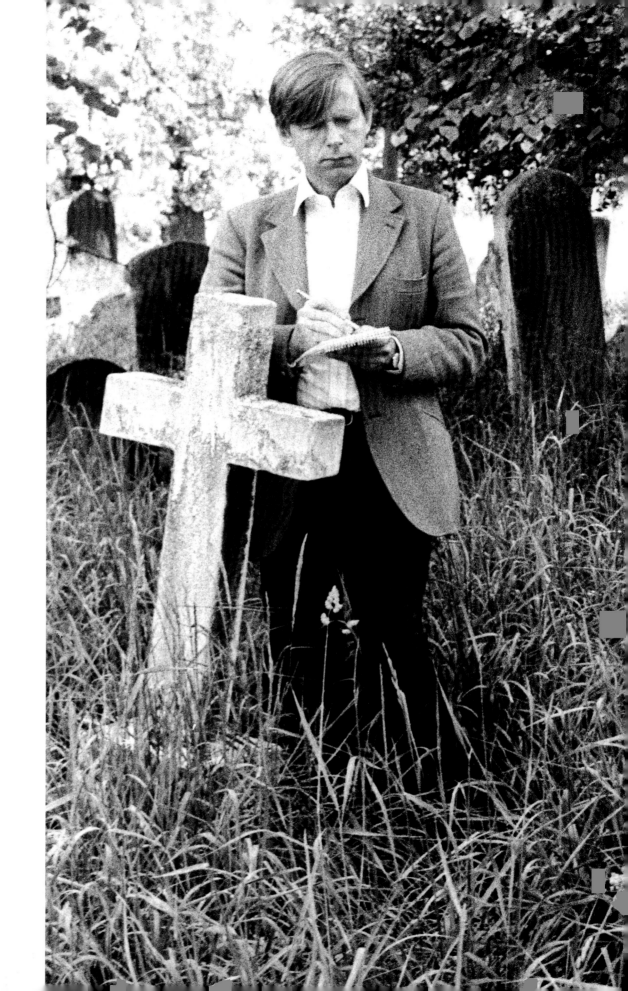

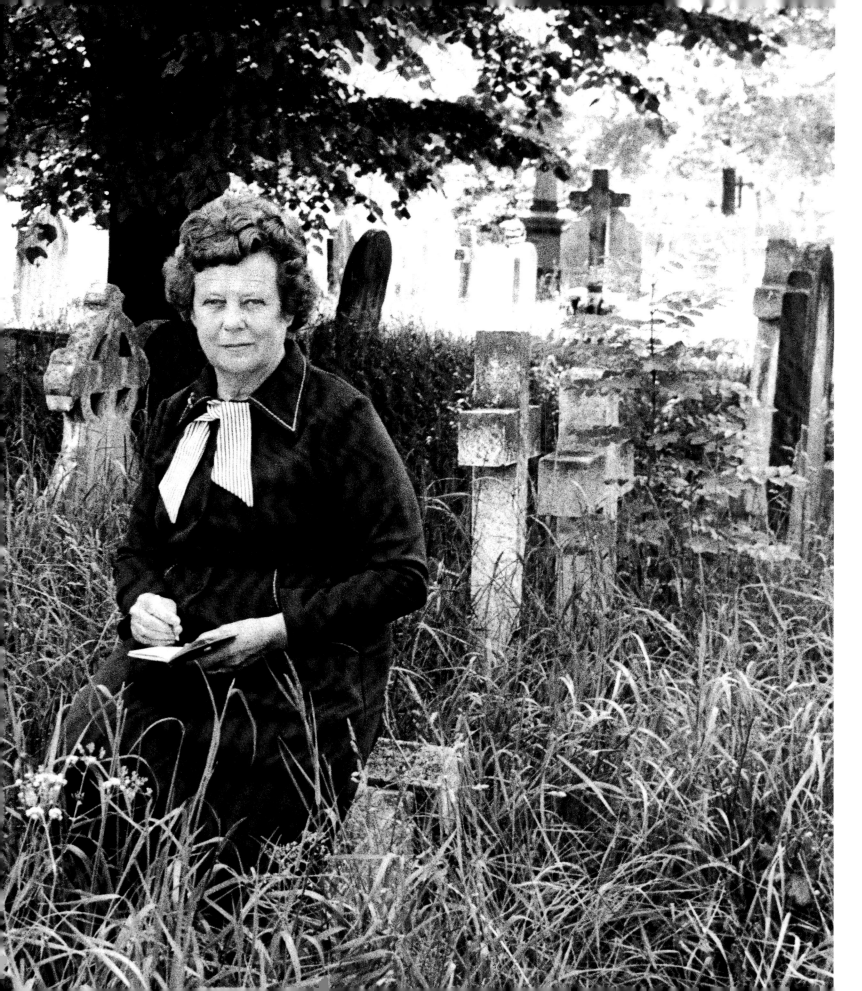

Mary Wilson with John Wells, author of    141
'Mrs Wilson's Diary', for *Private Eye*  1980

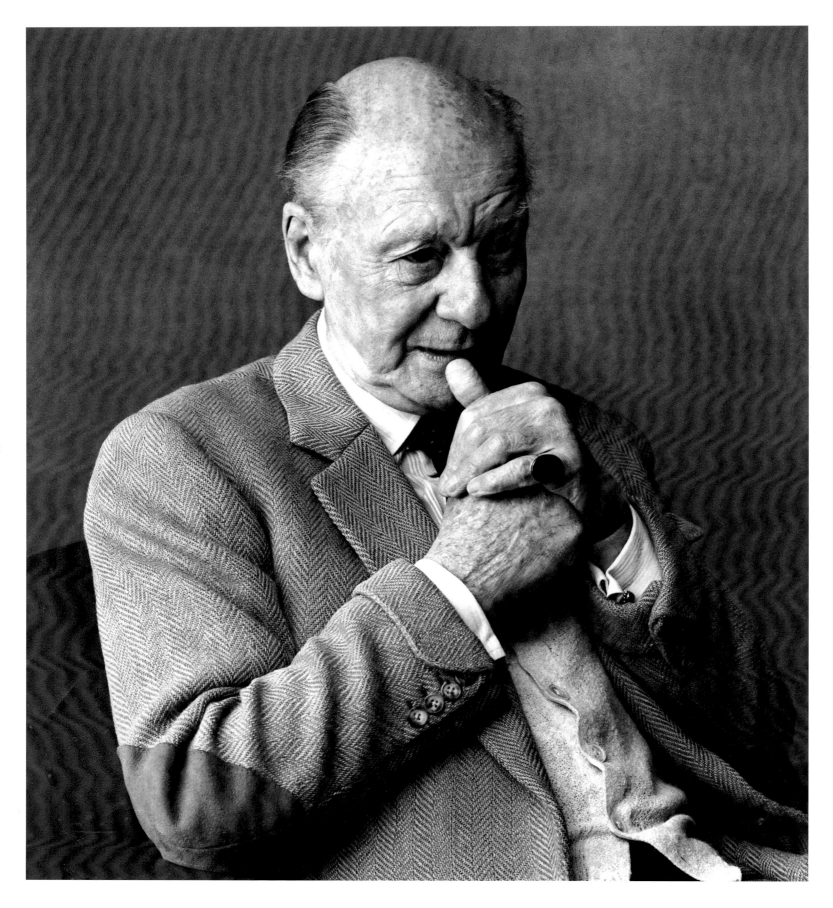

John Gielgud 1982

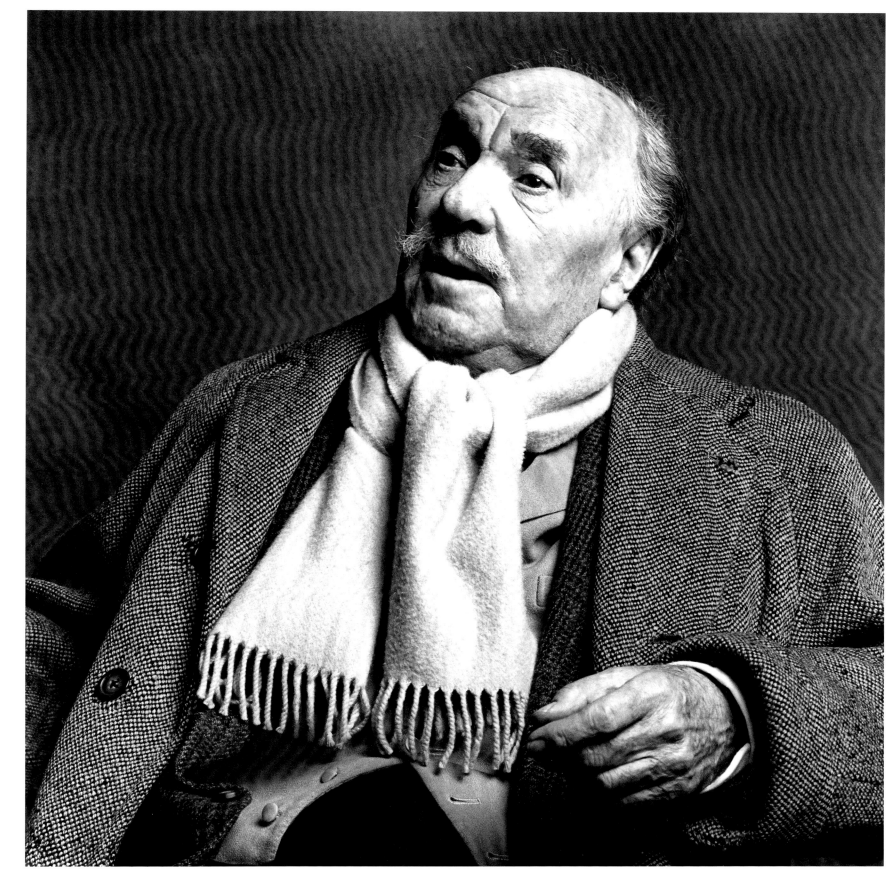

Ralph Richardson 1981

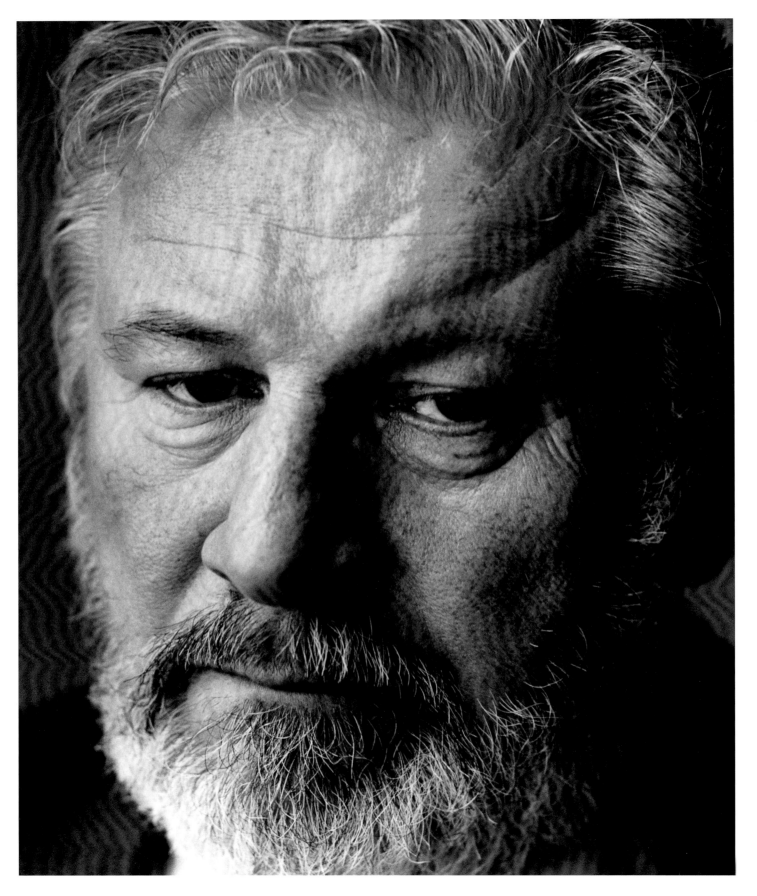

144

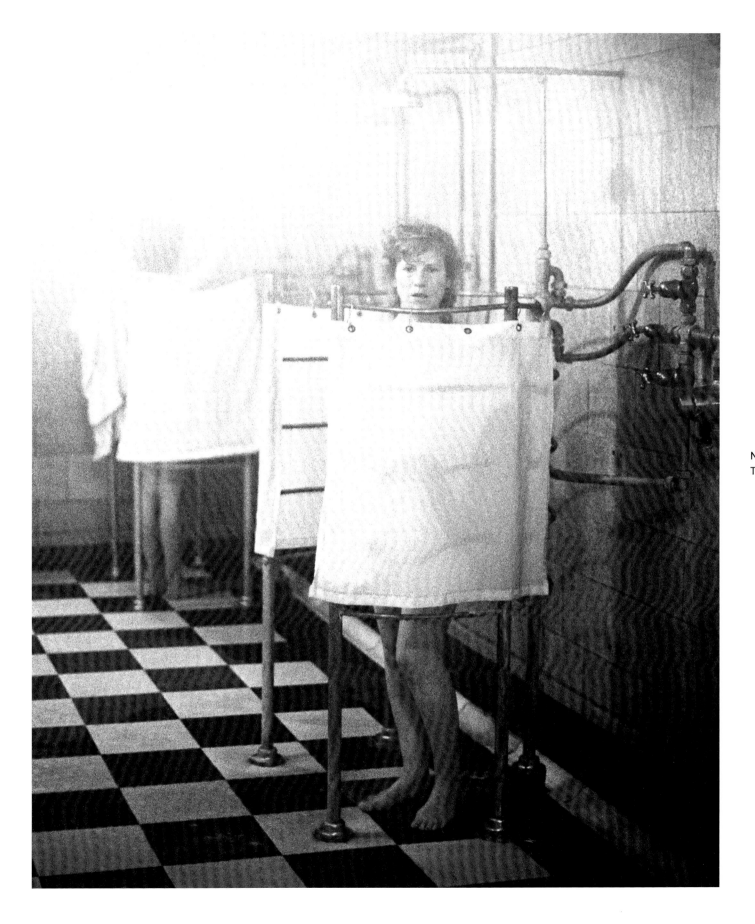

Nell Dunn, Porchester Hall
Turkish Baths 1982

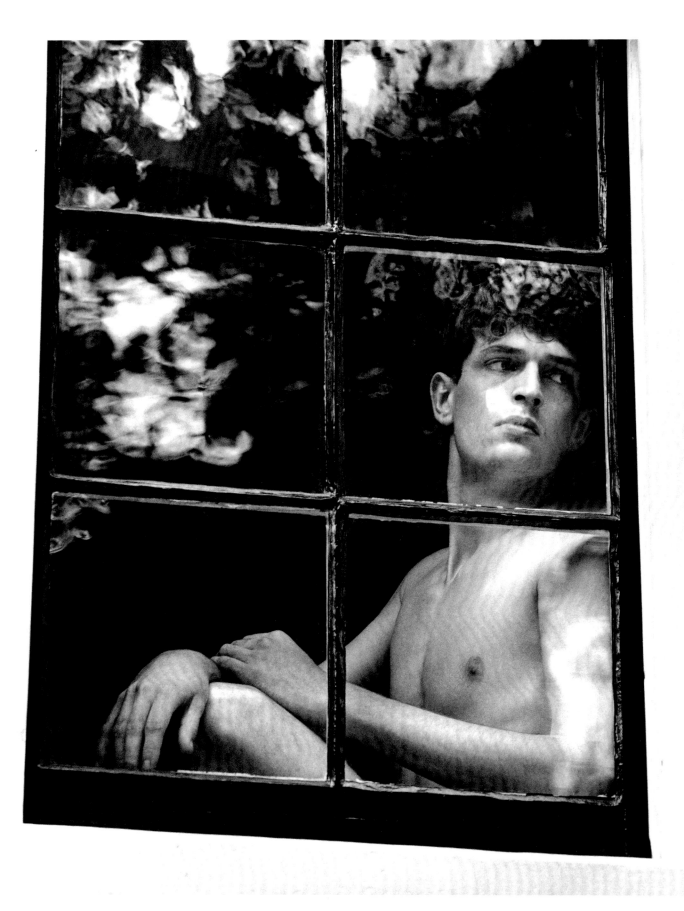

Rupert Everett 1982

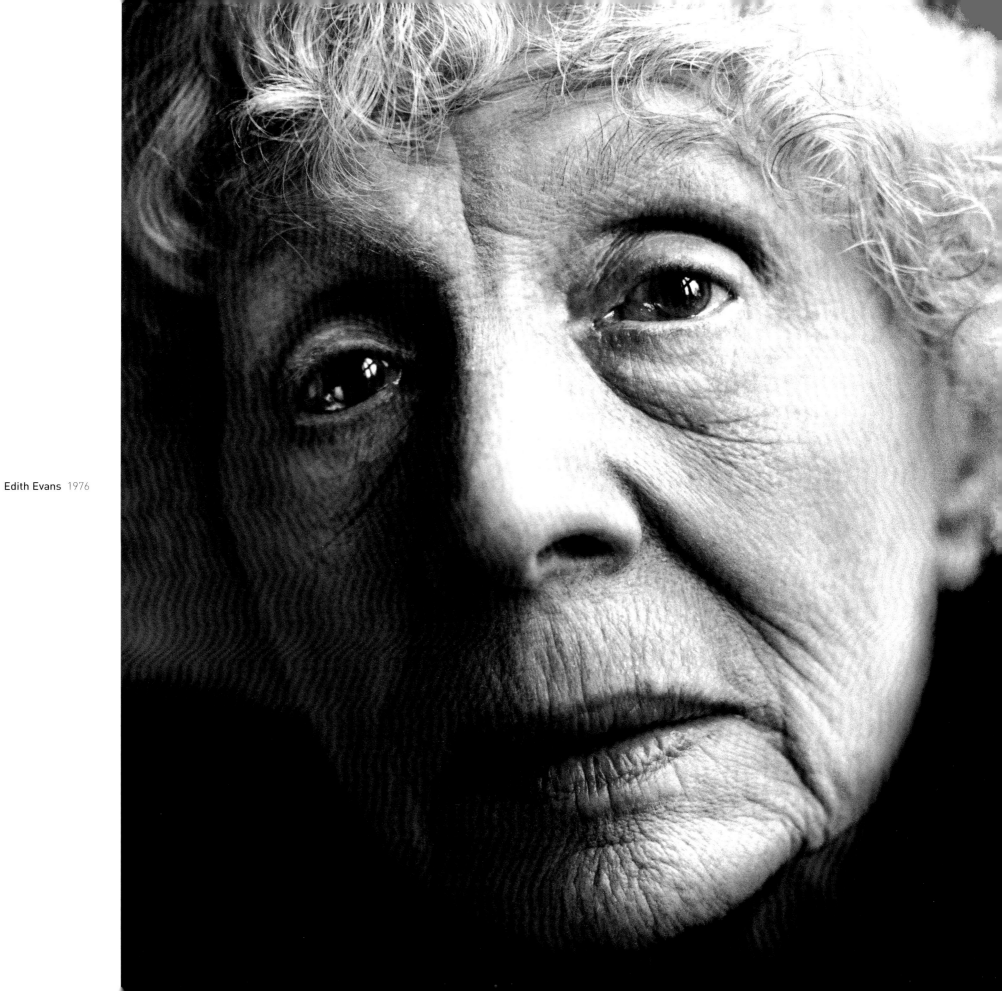

Edith Evans 1976

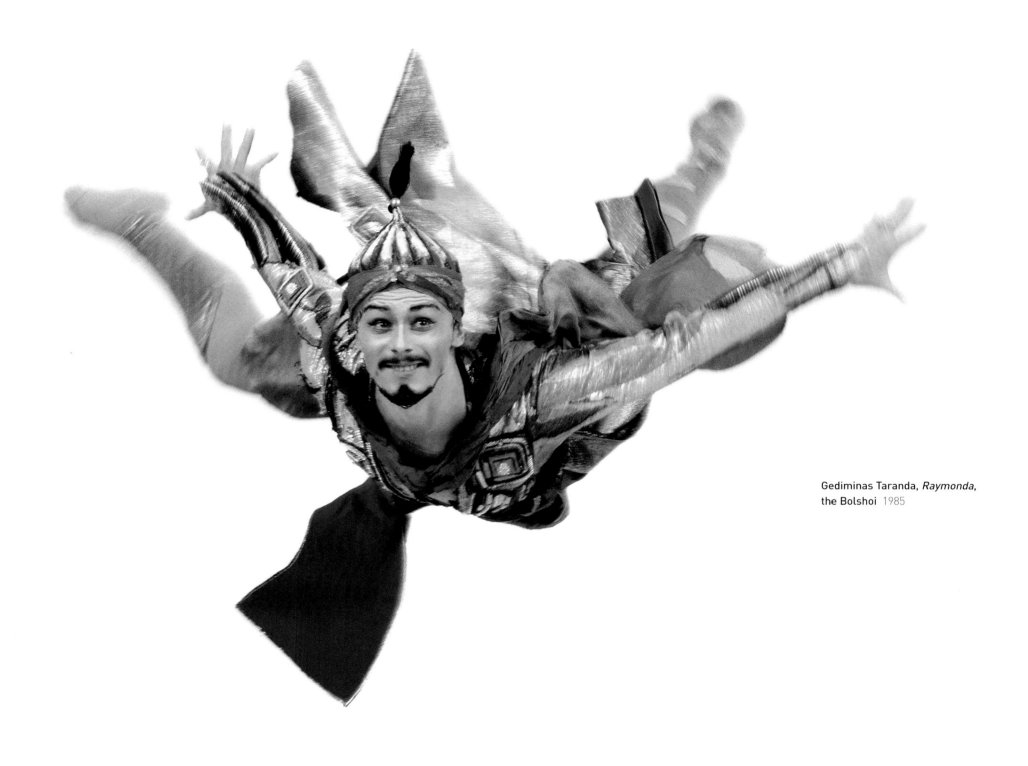

Gediminas Taranda, *Raymonda*,
the Bolshoi 1985

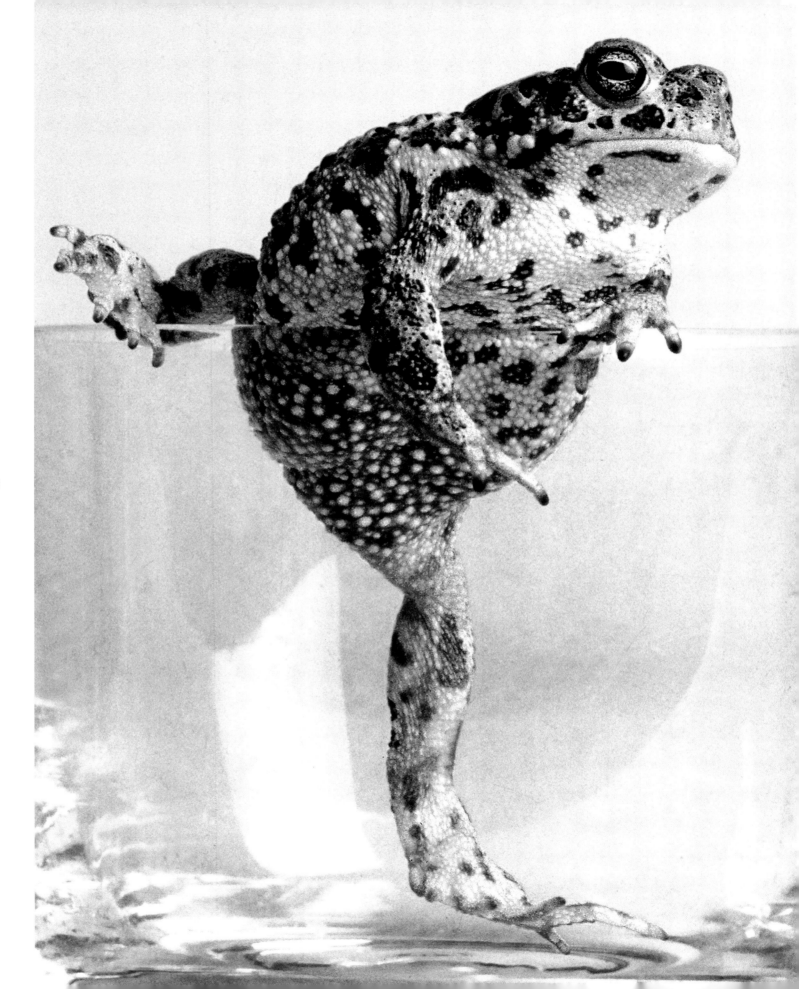

Natterjack toad 1985

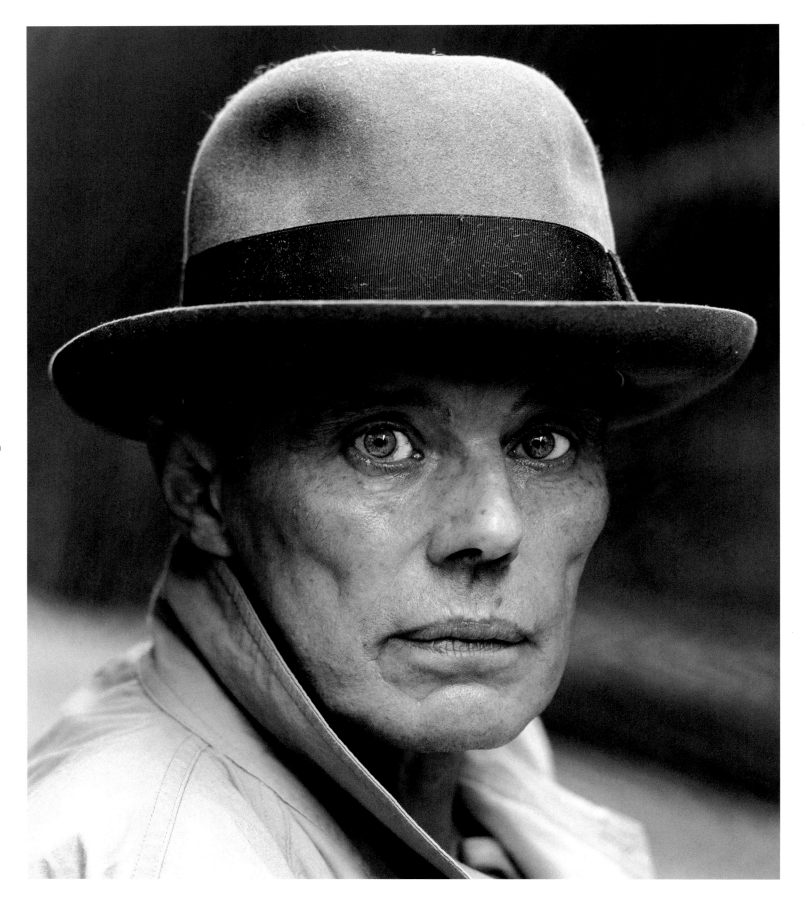

150

Joseph Beuys 1985

Gilbert and George 1981

Overleaf:
**Willem de Kooning** 1986
**Jean Dubuffet** 1970

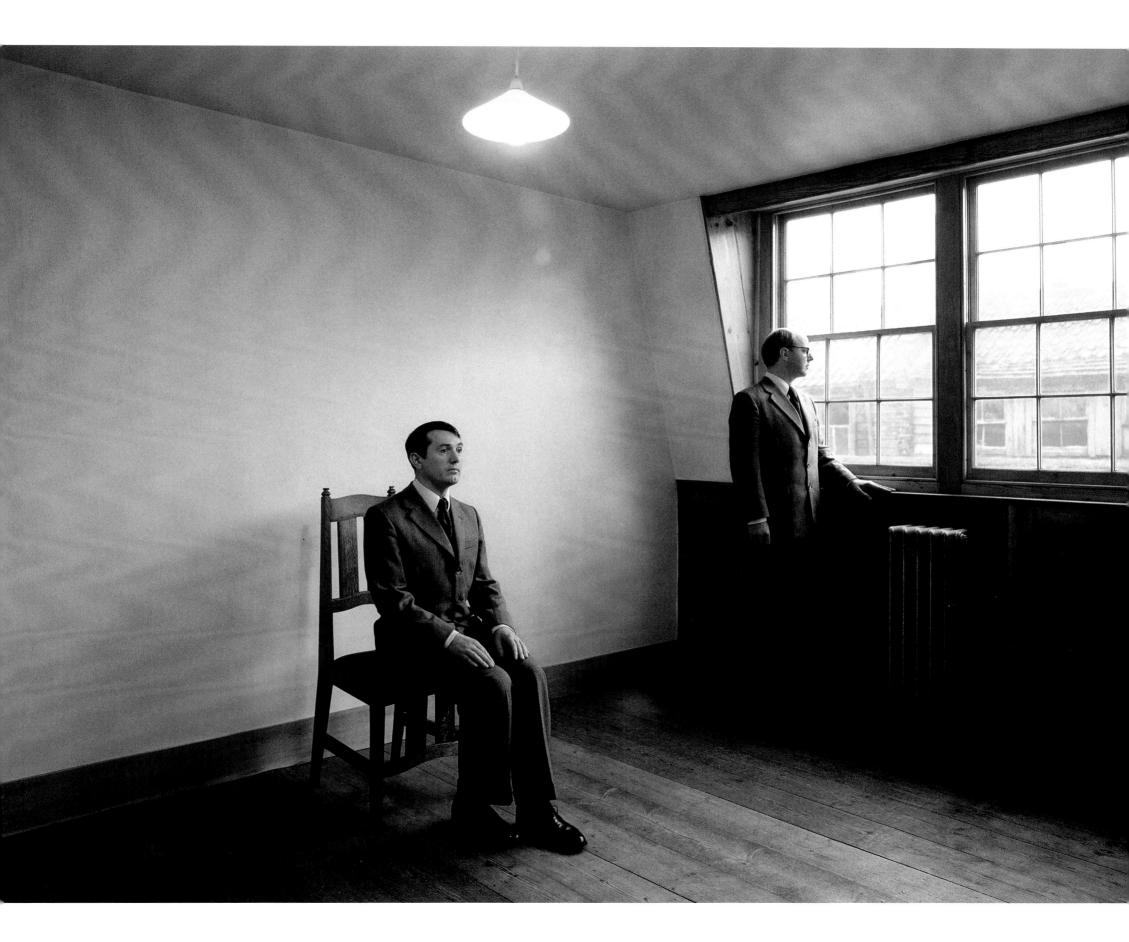

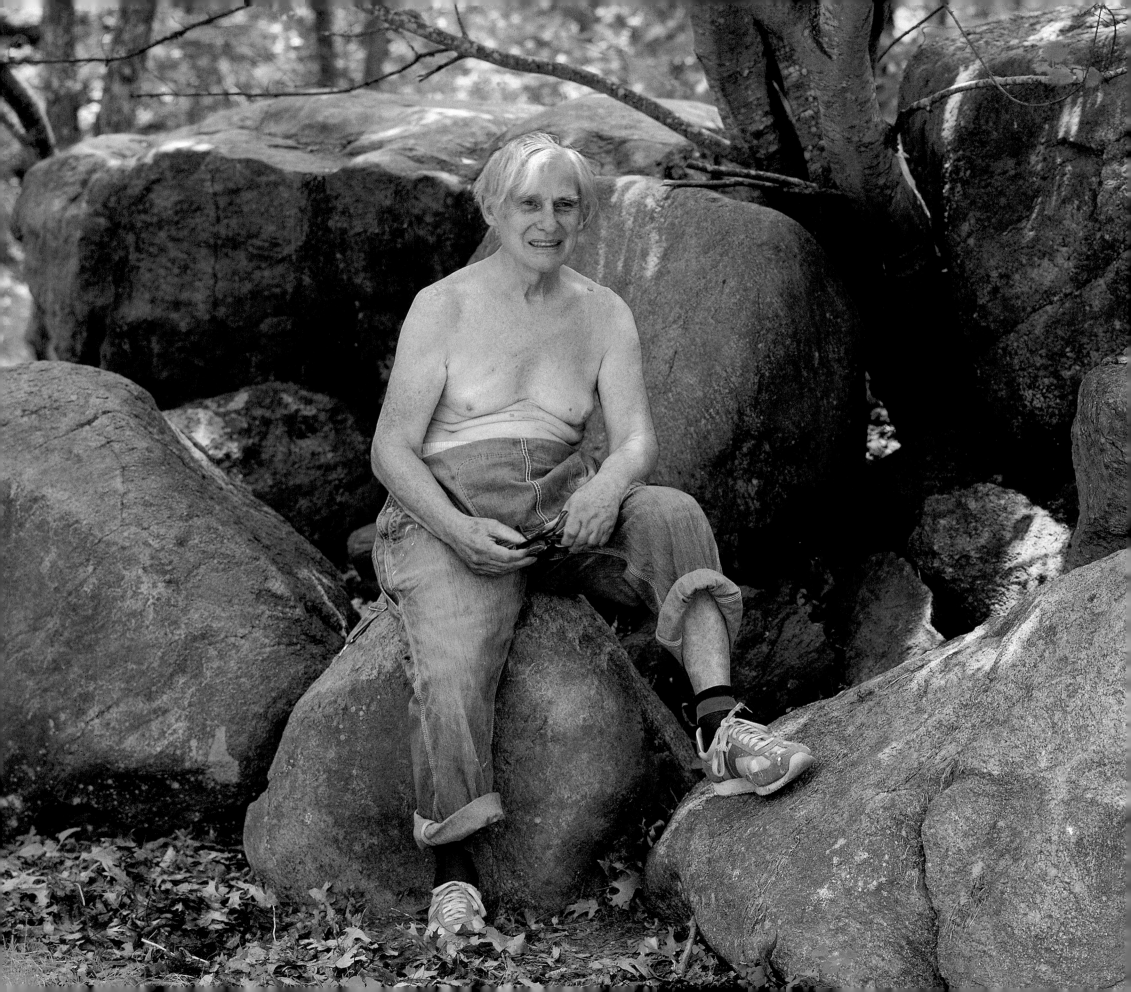

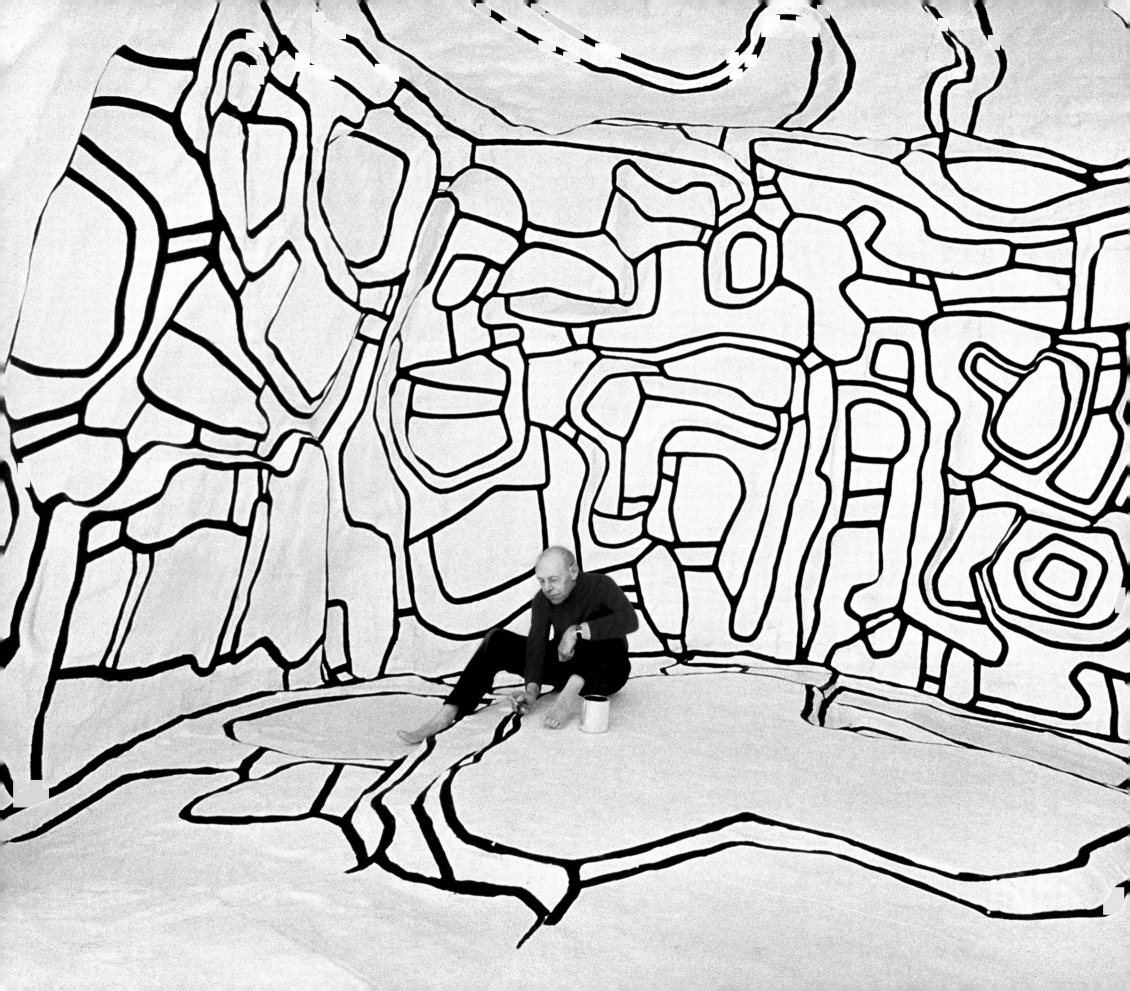

154

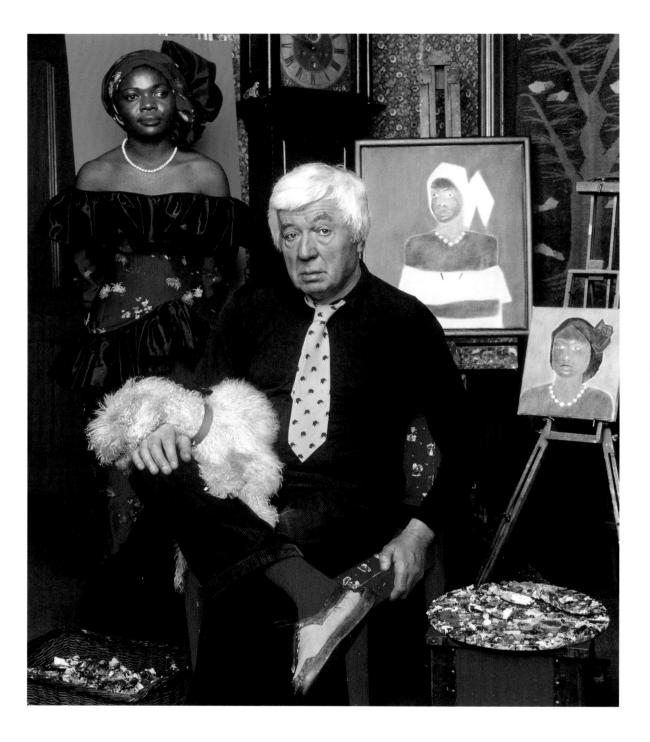

Craigie Aitchison
with Naa Otwa Swayne 1988

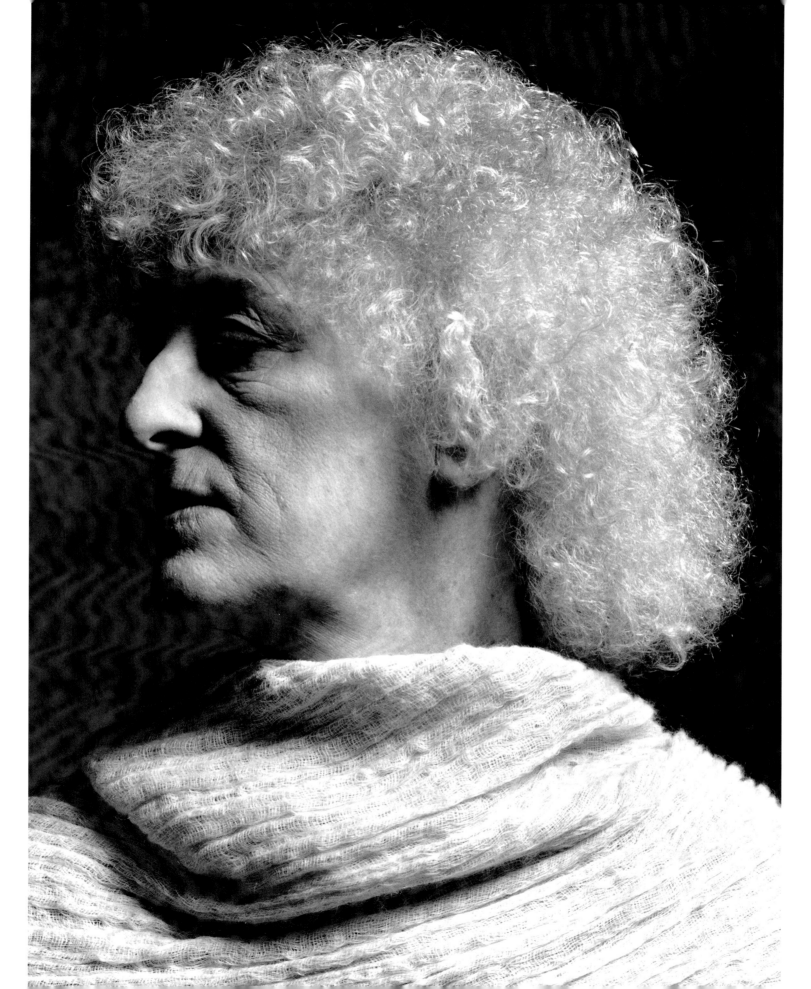

Elisabeth Frink *1986* 155

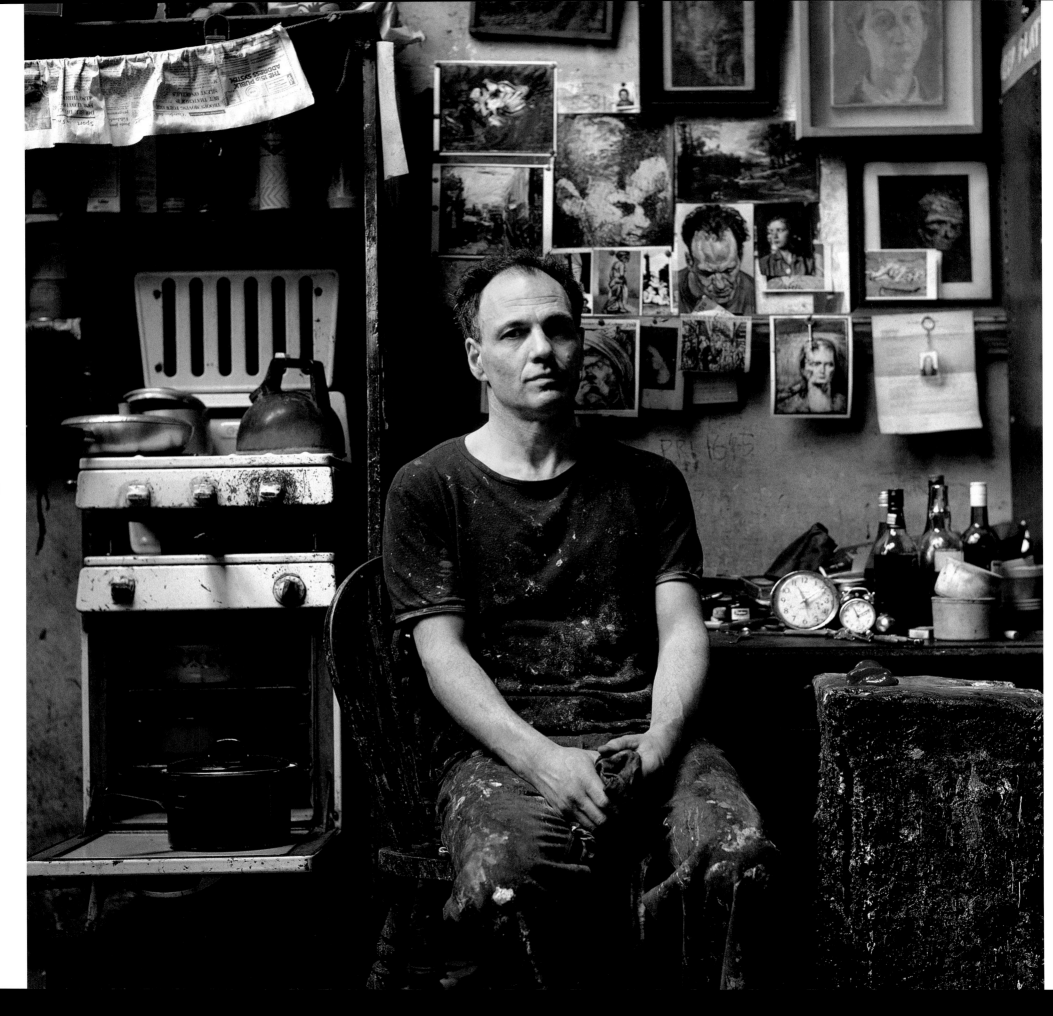

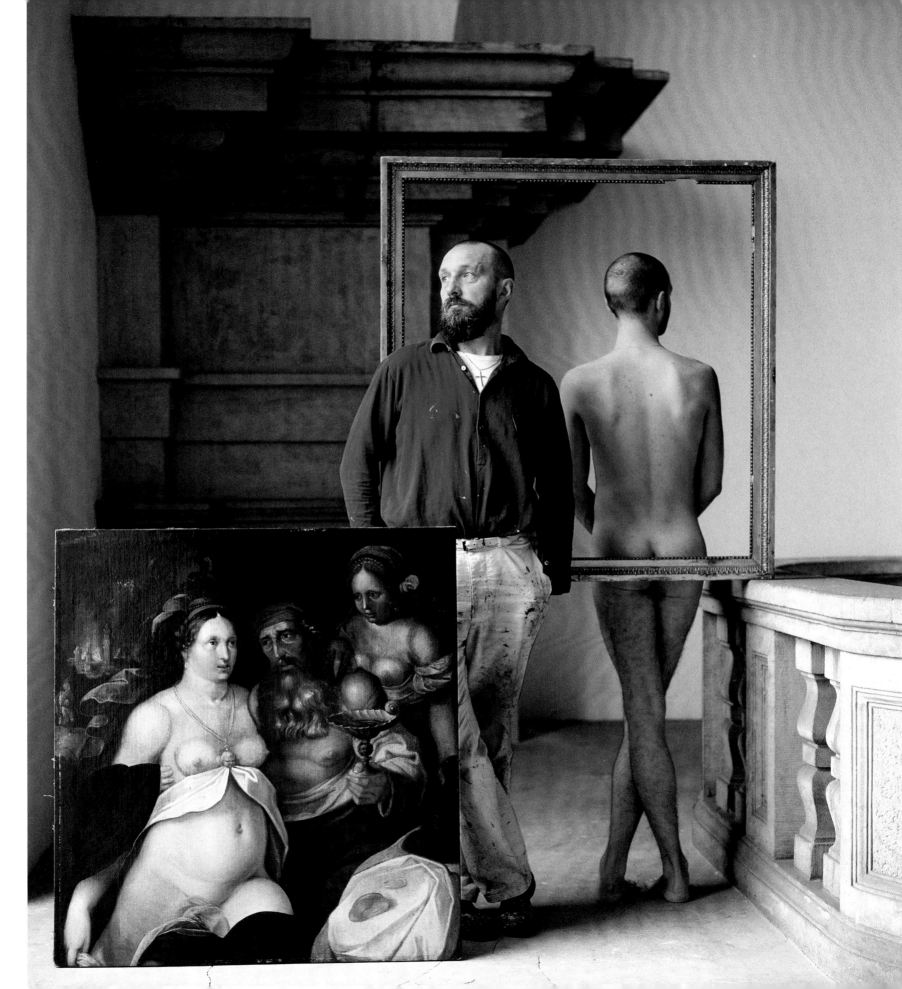

Frank Auerbach 1982

Georg Baselitz
with his son Daniel,
Münster 1984

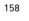

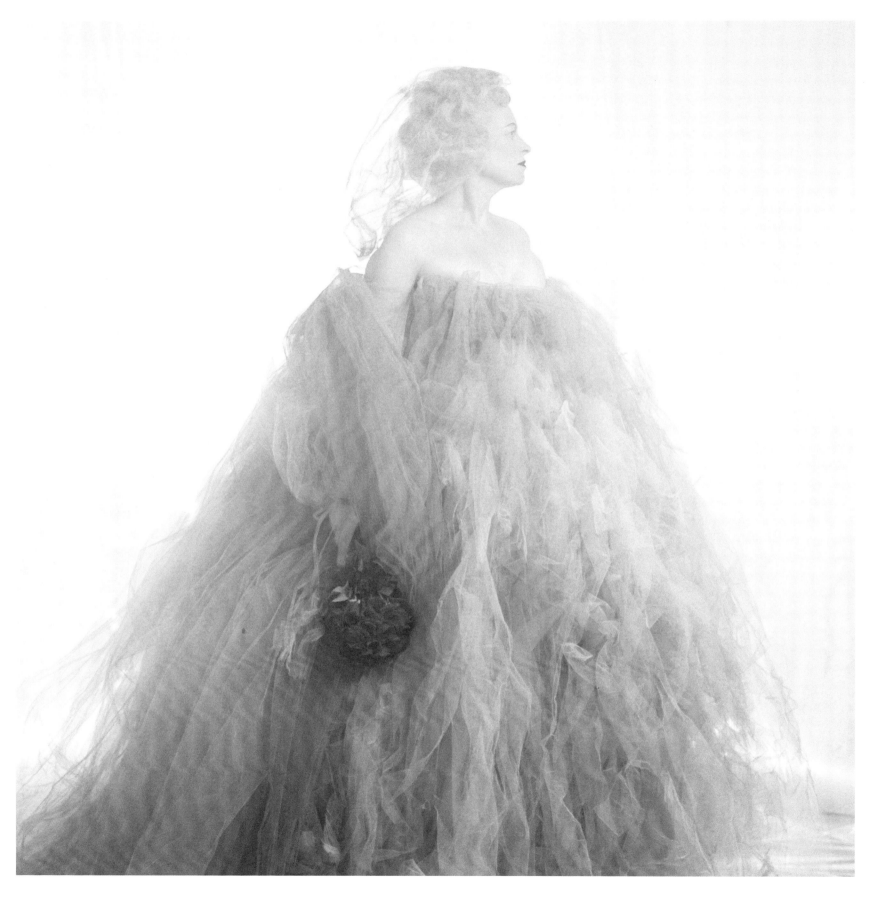

Vivienne Westwood 1992

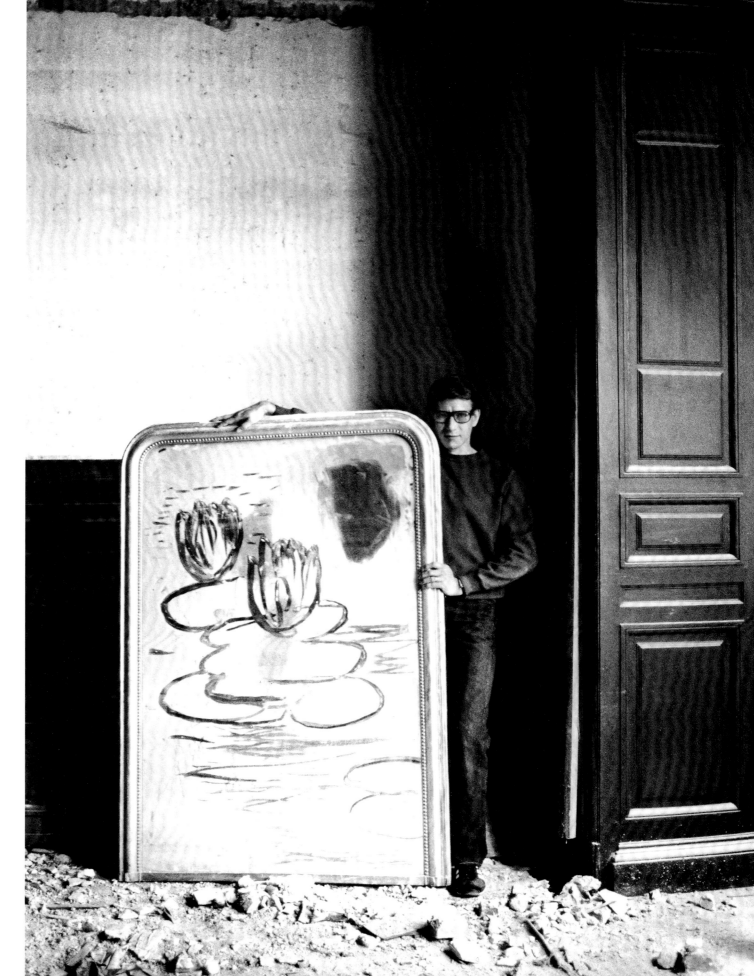

Yves Saint-Laurent, Deauville  1980

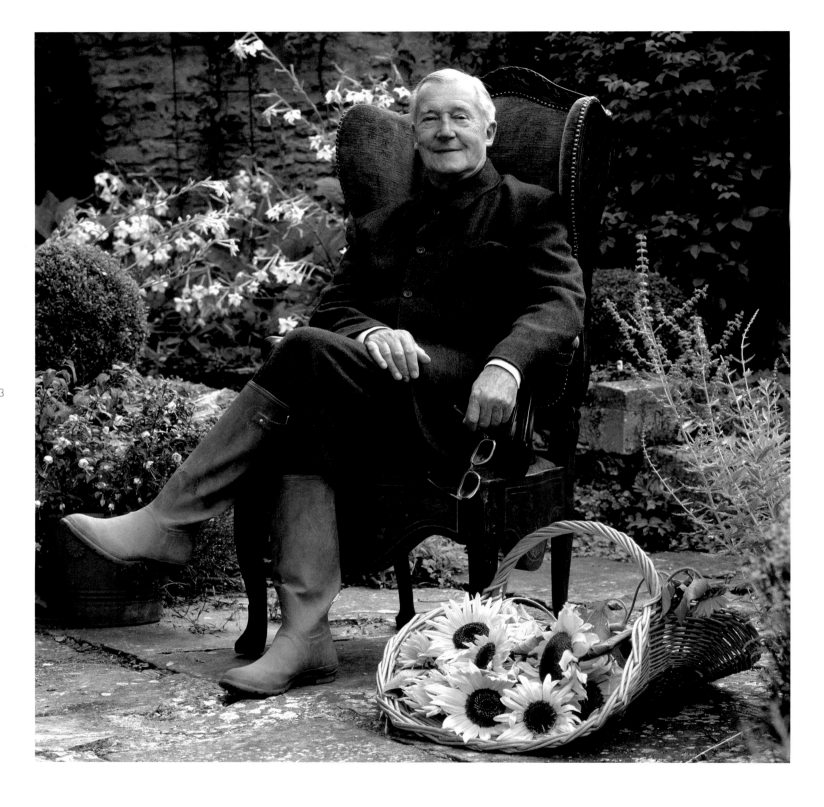

160    **Hardy Amies** 1993

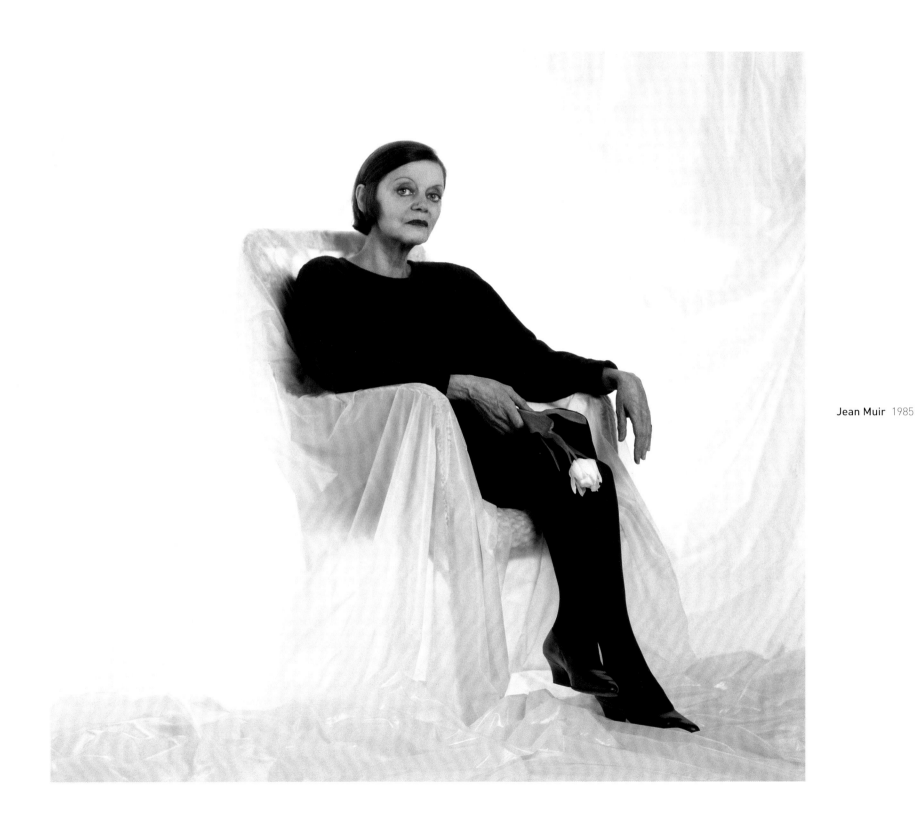

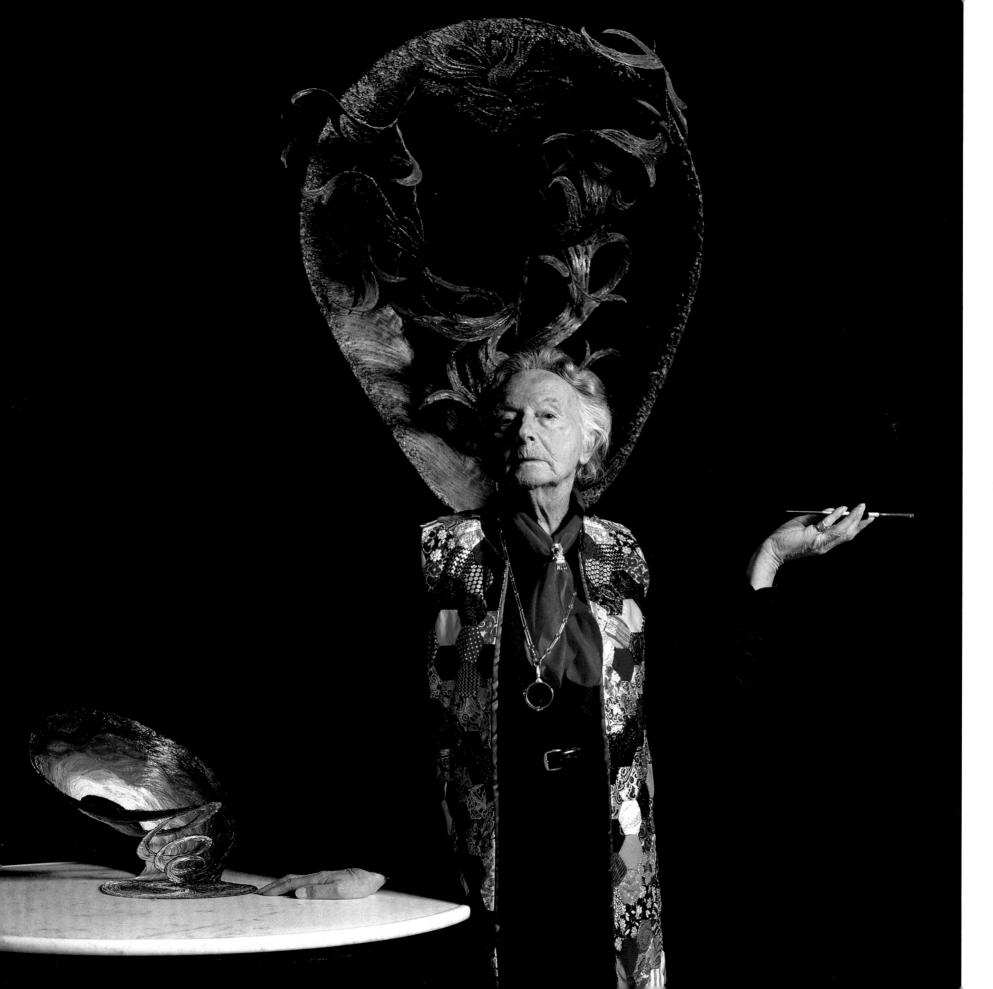

Erté, Paris 1980

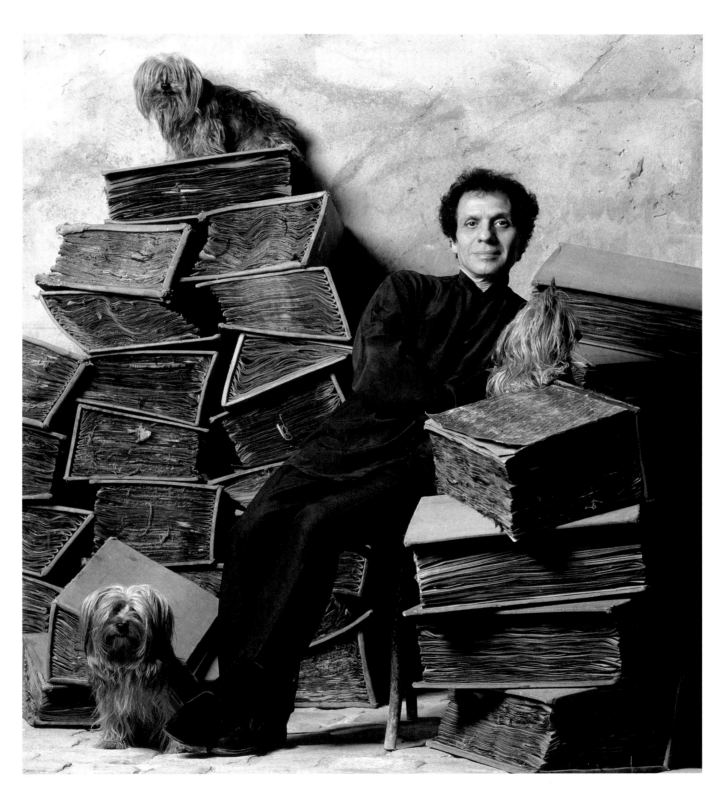

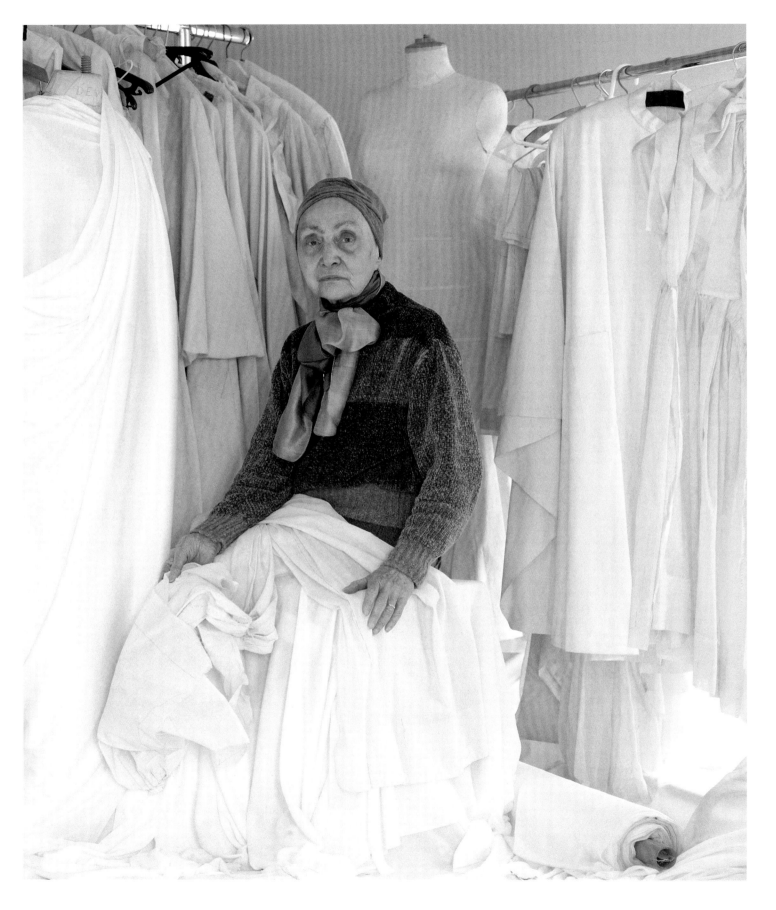

Madame Grès, Paris  1984

Lucie Rie, London  1988

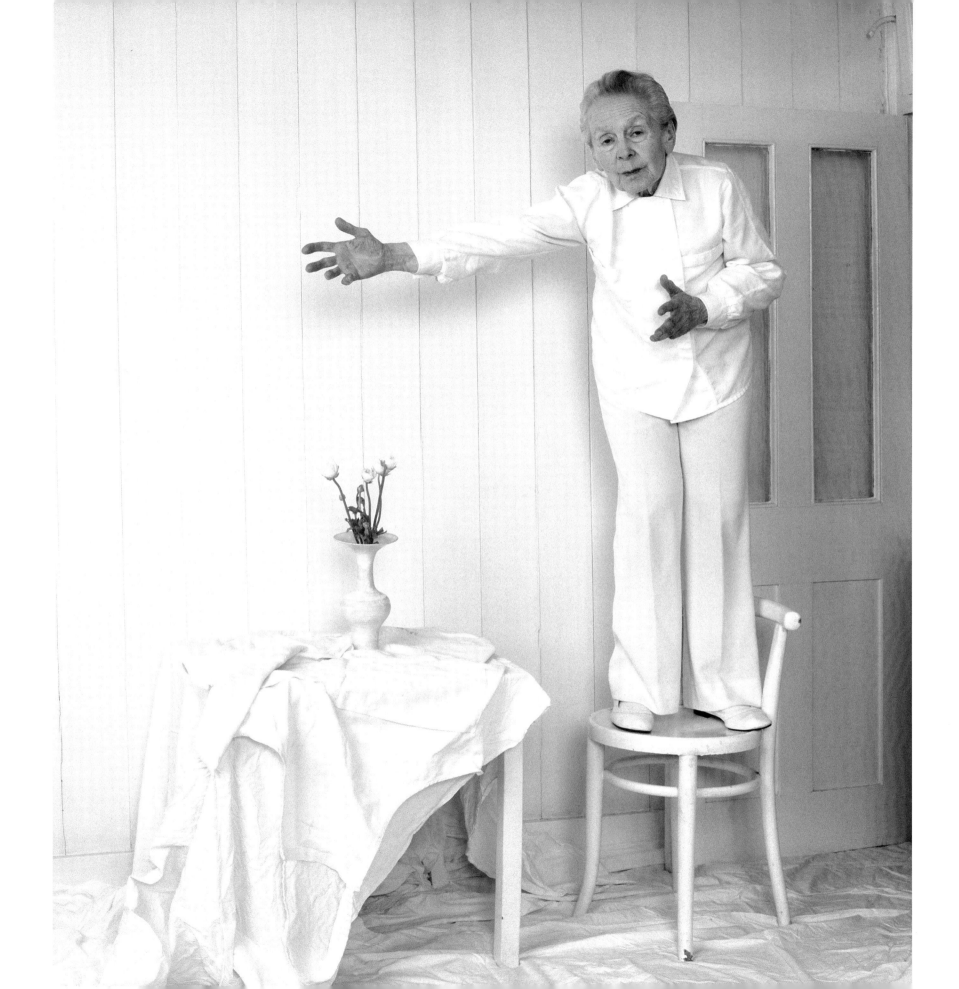

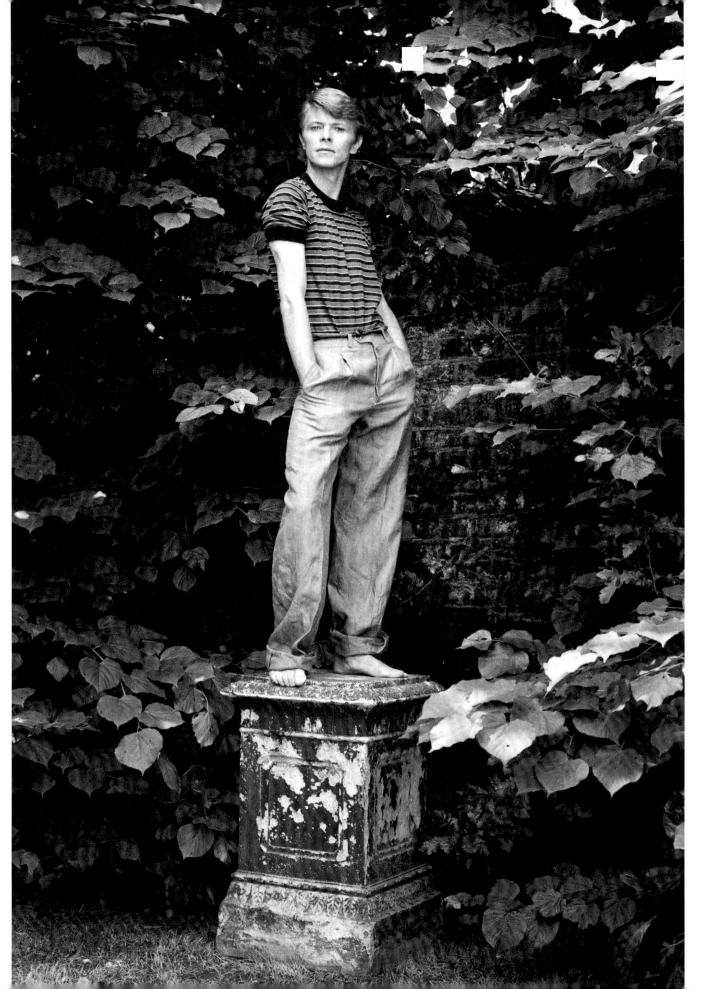

David Bowie 1978

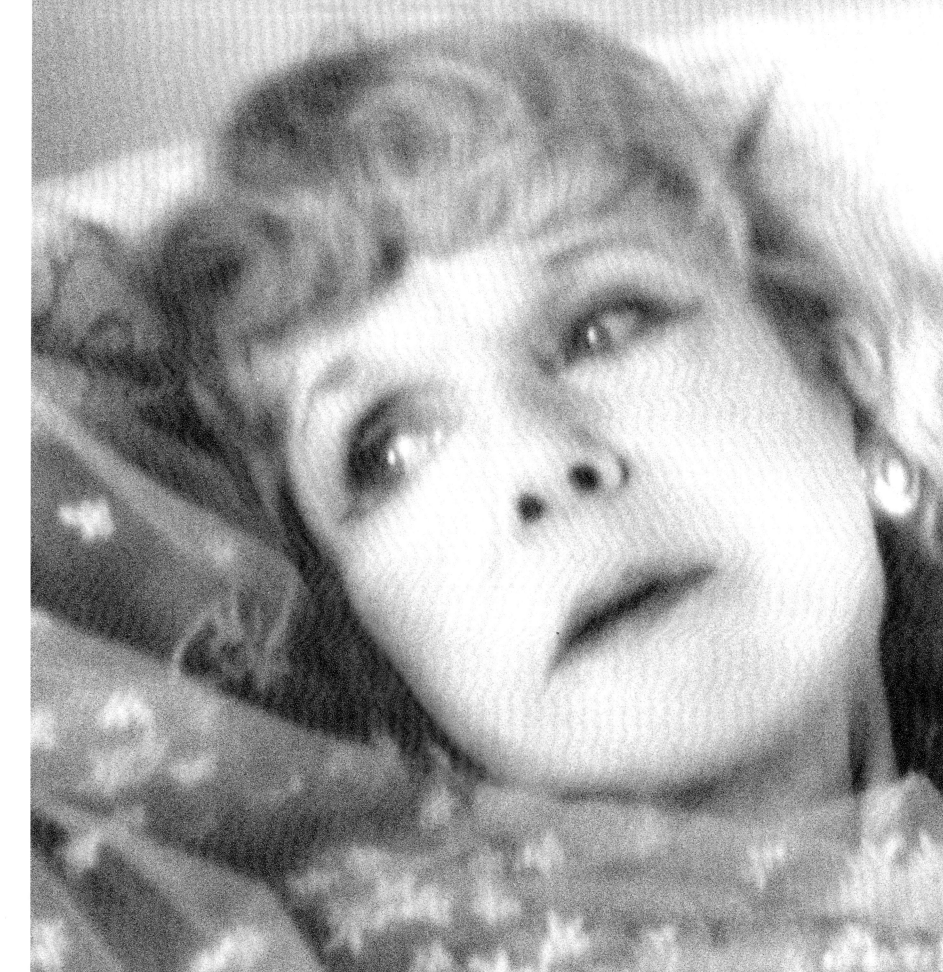

Diana Cooper 1976

168 Igor Stravinsky 1970

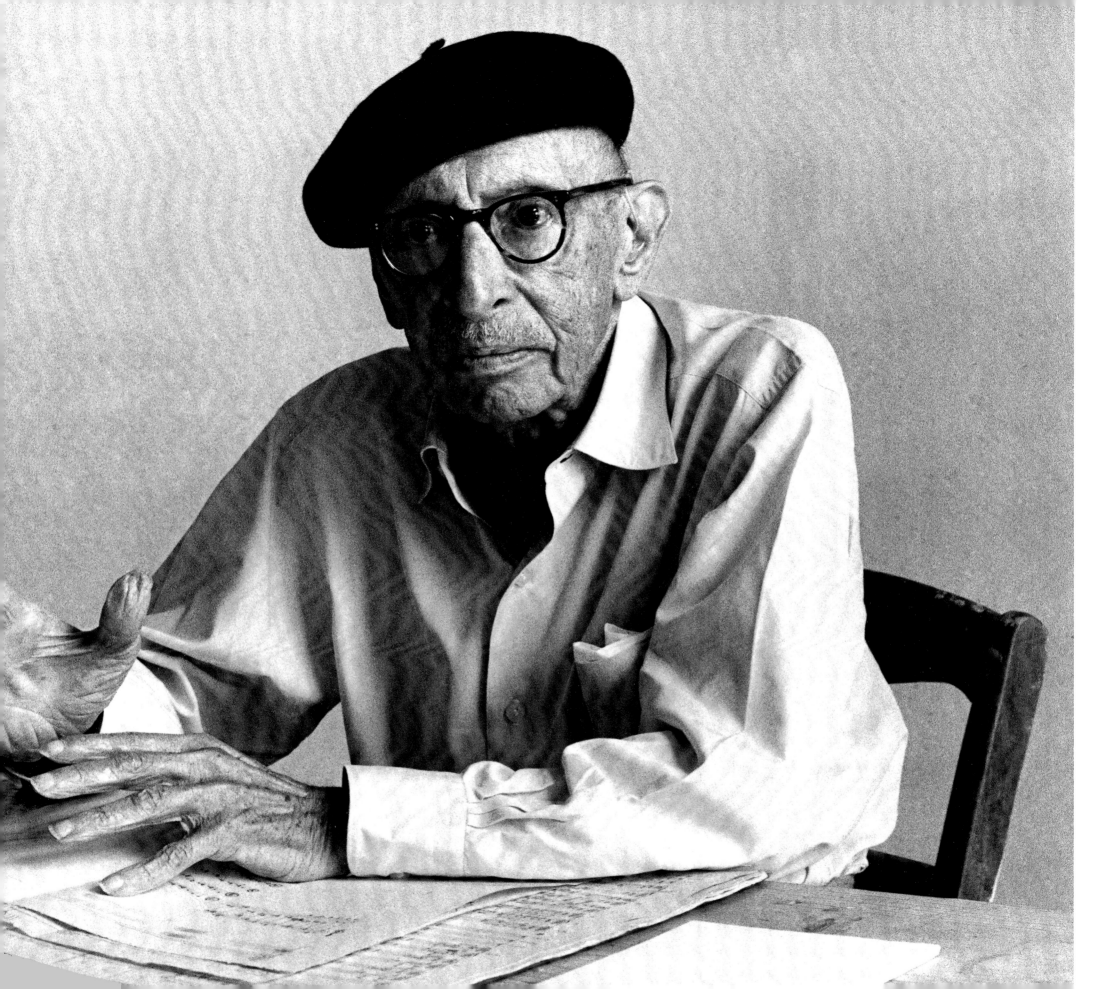

170

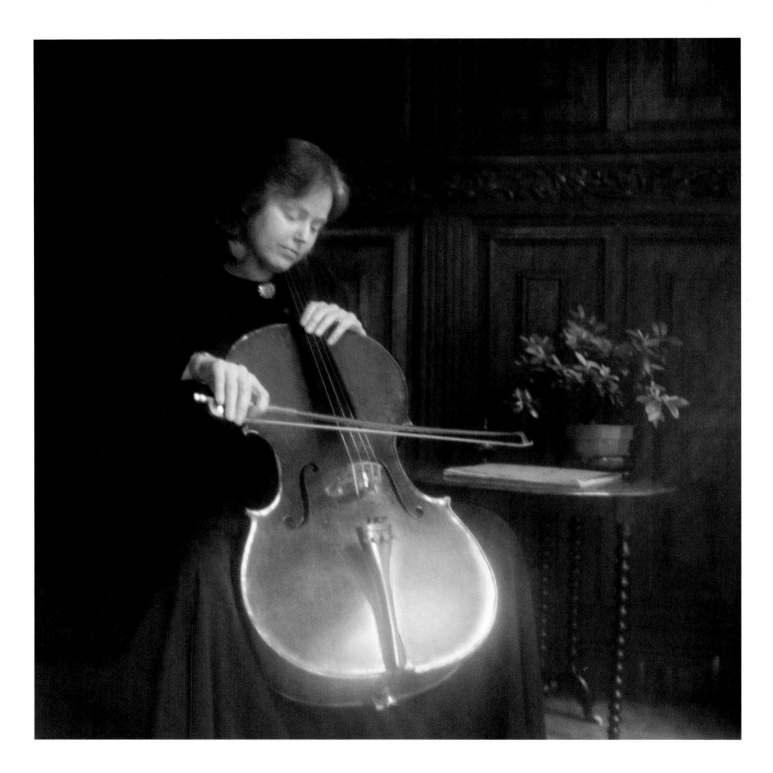

Jacqueline du Pré
1976

WHAT'S the story?' was Tony's first question. Producing pictures for publication has always excited him far more than creating prints for posterity. If anyone as multi-faceted as he has a single aim it seems to be to ward off the boredom of the reader and keep them guessing. No doubt I am particularly conscious of the fact because intermittently and over long years we have worked together on magazine features that tapped his journalistic mind-set.

In black and white or colour, playing it straight or with tricks were all grist to the taking of a good shot. Usually I worked with him on assignments to take pictures of people of interest in the arts but from time to time we did more serious social documentary features together. The general form was for me to propose the person or feature to Snowdon and hope that he would bite. At one period in his career Byzantine-like negotiations surrounded naming him in advance of the shoot as the assigned photographer. It was thought best to keep quiet on the matter which resulted in some surprising reactions, but that's another story. Since his name cleared a pathway to the stars in their courses who might not otherwise have consented to be photographed or interviewed for publication, dropping an advance hint became a great temptation.

My job didn't actually oblige me to work with Tony on the shop floor but from the beginning of our collaboration in the Sixties I chose to whenever I could. I would have the first glimpse of what we were likely to get at the end of the day. I could pour cold water on wild and wonderful schemes out of dread for the cost and consequences: ('Do we *have* to fill St Paul's with pink smoke?') I won't say that I had a lot of control during the shoot, but once trust had been established between us, my suggestions stood an equal chance of being adopted or rejected.

Despite inevitable glitches and the need to survive what his friend of long-standing, the late Carl Toms, has written of elsewhere as Tony's 'quite maddening' ways, a shoot with him was always illuminating and unpredictable. Who else would think of putting the solemn young Oxford maths prodigy, the thirteen-year-old Ruth Lawrence, to the test by asking her a question about shoe laces? ('Did it take up more of the lace to use both ends to cross the string over and under or as a continuing thread?') I recollect that she was caught off guard and said she would need notice of the question.

I asked him recently what my contribution had been on a shoot. 'You were my book and offered reassurance,' was the reply. I also learned I had the sense to hold my horses about talking to any of the subjects when eye-contact with the camera was needed. Since the sitters might well have been prospective interviewees of mine, biting my lip became an occupational hazard. But on other occasions when Snowdon was happy for me to talk, I could make very good use of my time. Being his 'book' was probably important as he feeds off a supply of background information about who or what is up for the next assignment. But you won't catch Tony ploughing through a mass of documentation in the cause. Instead, once armed with some leading facts, he manages to virtually osmose the rest through the pores. He is also adept at extracting information from people to use for his own ends, a skill which doesn't fail when dealing with someone whose co-operation he seeks is mulish on the point.

As a photo-journalist, his efforts were in pursuit of the goal that he shares with Cartier-Bresson, the living photographer he most admires. A moment, *the* moment to commit to film that tells the story. In a likeness, it might be a facial expression, a physical stance, a gait or a gesture or possibly a grimace. He has fully described his way of taking pictures of personalities in his books but he doesn't touch on the effect he himself as the practitioner has on his VIP sitters in this connection. I often wondered whether his public persona didn't in some way hinder the creative process? In my experience he had no trouble with the great artists who responded naturally to a fellow pro. Similarly in the instance of young children, who as subjects usually get on exceedingly well with him. But it was sometimes the case with adults that, in a typically English effort to suppress any hint that they might be influenced or impressed by his connections (scarlet chairs designed by Snowdon for the investiture of the Prince of Wales do a stint in his office), they became effusively over-relaxed. Goodbye to a good shot, unfortunately. Or a few others seemed to make a point of being rigidly indifferent to his efforts and would just sit there, glowering. In the former case, his ruse was to coax the ball back into his court by making sitters feel just slightly uncomfortable as a means of getting at some truth of facial expression.

Ways of resuscitating an atmosphere that goes flat, in which the subject loses his or her concentration, have to be part of a photographer's first-aid kit. Sometimes our man's technique in the studio demanded a pause of silence, or a break for a drink, or a diversionary tour of artefacts in the studio or garden. 'Do you know I made the legs of this table from...?' And thereby hung a baroque D-I-Y tale of statues. skips and found objects that would make any dead eye spring to life.

Not everyone fell in with his practice. For instance, Mrs Thatcher, the Prime Minister, who was photographed post-Falklands, was disinclined to budge one solitary inch once she had taken up her stance on the chair in the studio. It was not for lack of trying. In the event, she was shown as a warrior-queen, proud and resolute and shorn of a politician's ingratiating charm. Incidentally, when it was first published in *Vogue*, opinion held that the then Prime Minister didn't care for the picture but word now suggests that she has more than come round to it.

A series of devices served to produce the effect he was after. Props played a big part. Scarves, hats and berets for framing the face, cardies and waistcoats left as the wearer chose, gaping or unbuttoned, and a series of chairs whistled up from upstairs or the garden aided the composition. Numerous distinguished males who arrived in formal togs to have their picture taken were eventually coaxed into a soft blue linen shirt

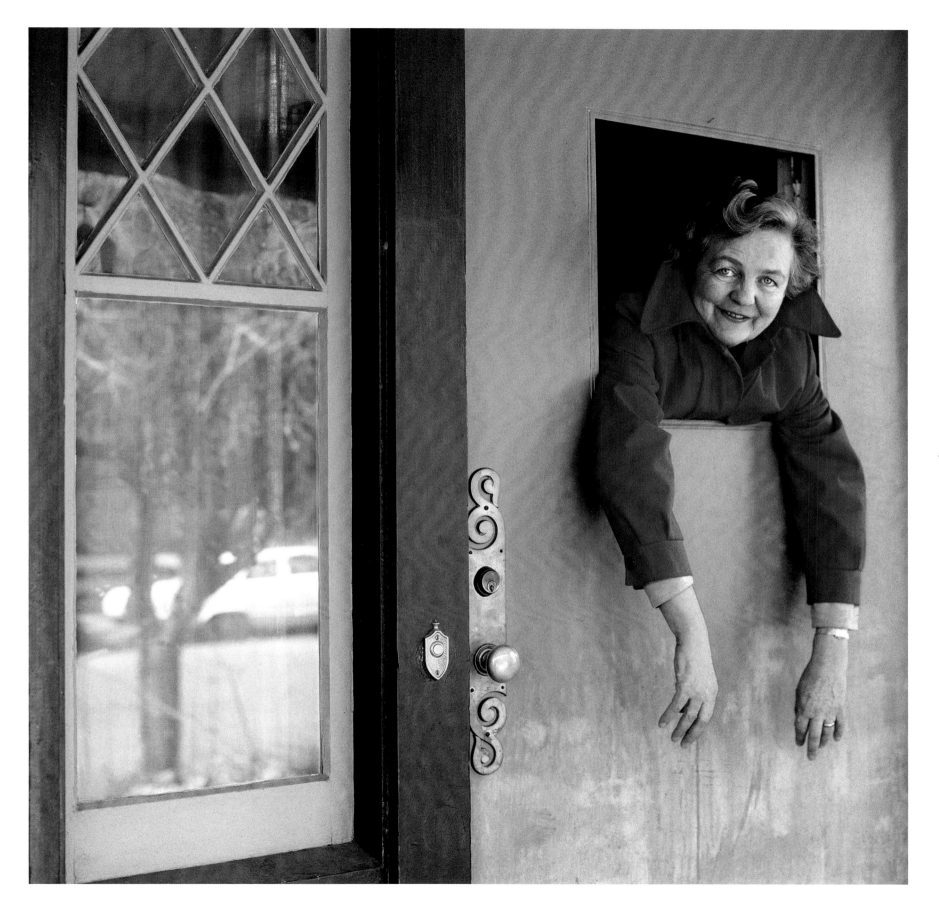

designed by Margaret Howell to be worn open-necked; city slickers thus taking on a new life for a while as romantic bohemians. Then shoes or sandals worn by children who came to be photographed were quickly lost in favour of bared feet.

Inexplicable luck sometimes proved the making of a shot. Tony was on location photographing Mary Wilson, wife of Harold Wilson, the former Prime Minister, with John Wells, author of *Private Eye*'s saucy feature 'Mrs Wilson's Diary'. He asked 'Have you something to hold?'

'No,' came the reply, then, 'Well – I've only got my diary.'

'Oh, that'll do.'

Click. Our shot. Last year, the beautiful young black woman holding her baby, in the issue of the *Telegraph* Magazine carrying Snowdon's coverage of a polio immunisation campaign in Angola, by chance was wearing a T-shirt printed with a life-size head of Diana. Snap. The cover picture secured.

The follow-up to a shoot was generally a bit tense. When time was in hand, I might hive off to the studio to (deep breath) see the results, or otherwise would await the arrival on the art editor's desk of those glossy white boxes. Tony always made a tight edit and omitted material about which he had any doubt. But he was usually prepared to include an image that wasn't in his initial selection if a good case could be made out for it. Sooner than soon he'd be on the line to find out how the photographs had been received. That is, in the rare cases in which the editor of the publication concerned had not already winged congratulations. Anything less than an expression of total rapture tended to send him into a deep gloom, yet paradoxically any criticism that he believed had some validity was examined with almost joyful intensity.

Publication in my view is his finest hour. For Snowdon sits particularly happily on the editorial page within the framework of headlines, standfirsts and text. In addition, his practice of using a medium-format camera results in a square negative which, if he composes the picture effectively, makes it difficult to crop. His pictures thus command not merely one page but a page and a half of space if they are to be done justice. Besides, the illustrative qualities of his pictures marry well with journalism and carry the story forward.

With Tony you have to move on. He's good fun and the best of company on a shiny day. Although he likes to cultivate an air of detachment from worlds that are not his chosen habitat, such as party politics, appearances can be deceptive. He's probably heard the latest news and gossip from the horse's mouth. His sense of hospitality is unfailing and he looks quite crestfallen if people with whom he is amicable can't stay on.

As a pro, Snowdon is a trouper, a point about which there can be no dispute. Whatever personal storm clouds may be blowing up in the headlines or disincentives caused by his fragile state of health, he's on the case never behind time. But he is picky about people he likes to have around him and in my view perhaps too readily allows himself to shut out newcomers who don't toe the line according to his own code of social conduct.

People who know him well will tend to have their own Snowdon. Mine is to be glimpsed in a still-growing portfolio of photographs that give pleasure, and in these few lines from his little volume *Wild Flowers* '…I bent stalks and leaves slightly as one would flatter a sitter. Occasionally I let the flowers wilt a little so they drooped into the geometric or romantic shapes I wanted. Always with the simplest possible light…'

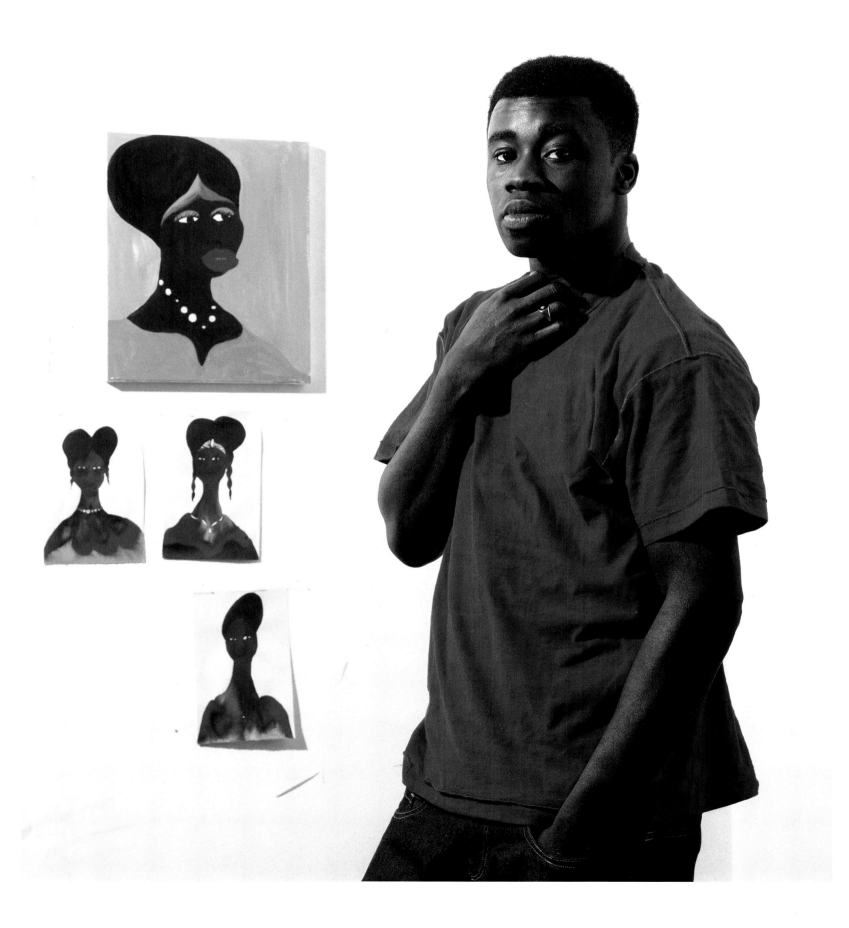

176          David Hockney 1978

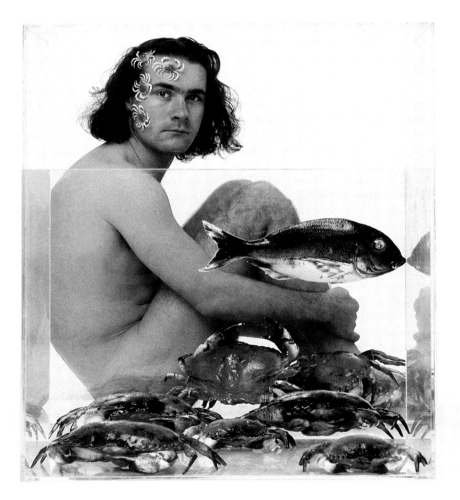

Damien Hirst 1991

178    Eduardo Paolozzi 1988

John Bellany 1992

180     Nicola Roberts and Jonathan Howells,
        *The Tales of Beatrix Potter*, the Royal Ballet  1992

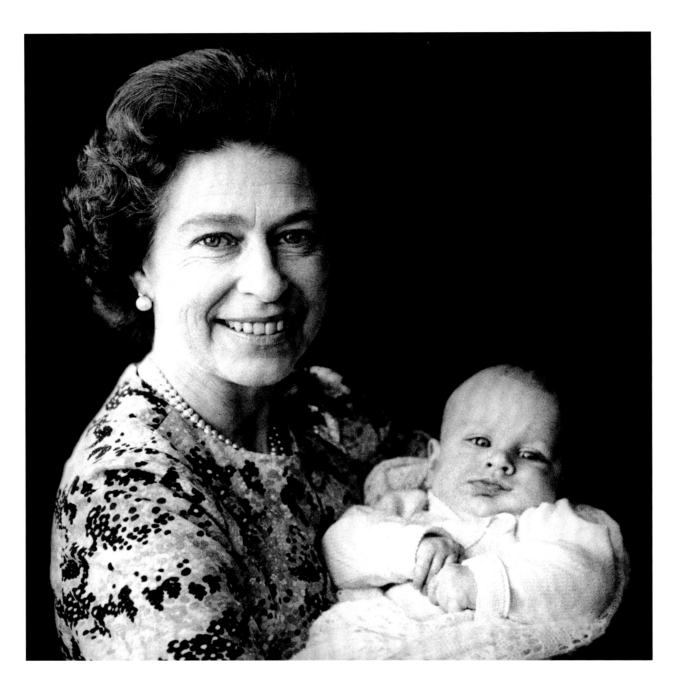

The Queen and Peter Phillips 1978

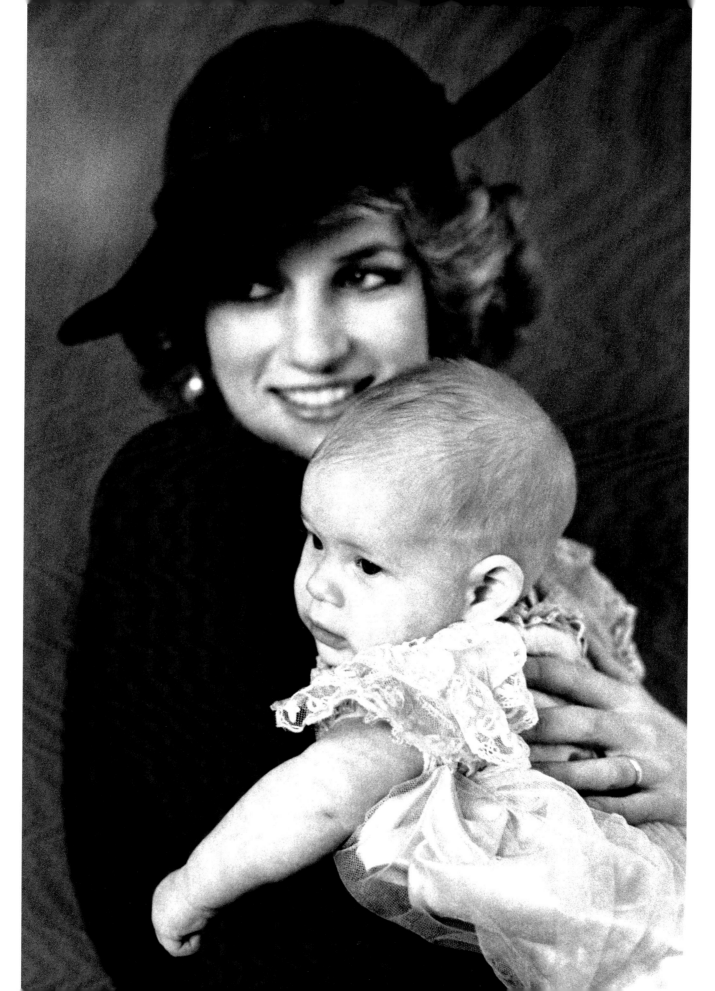

The Princess of Wales 183
and Prince Henry 1984

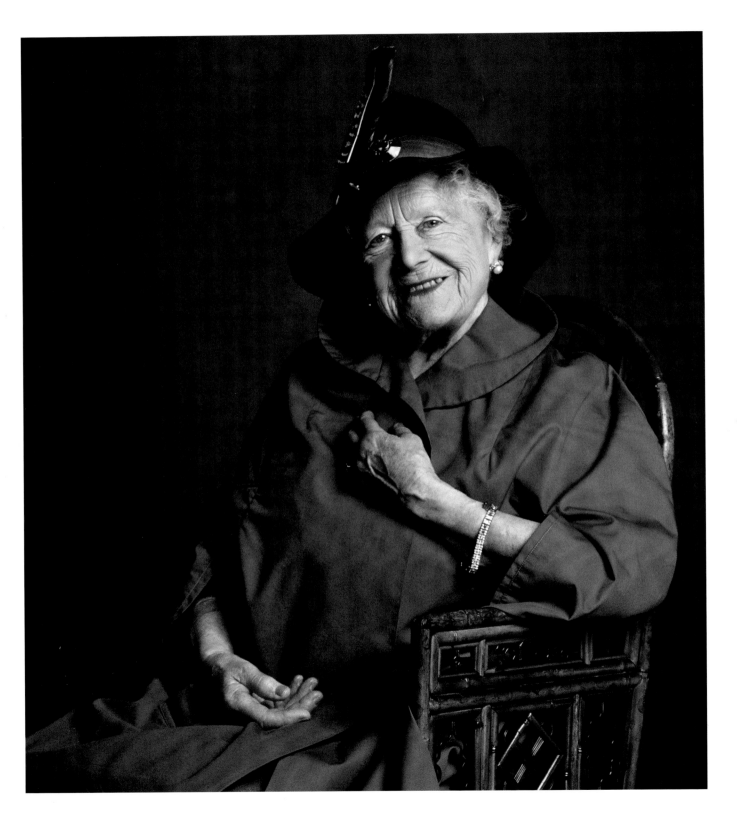

Queen Elizabeth,
the Queen Mother 1997

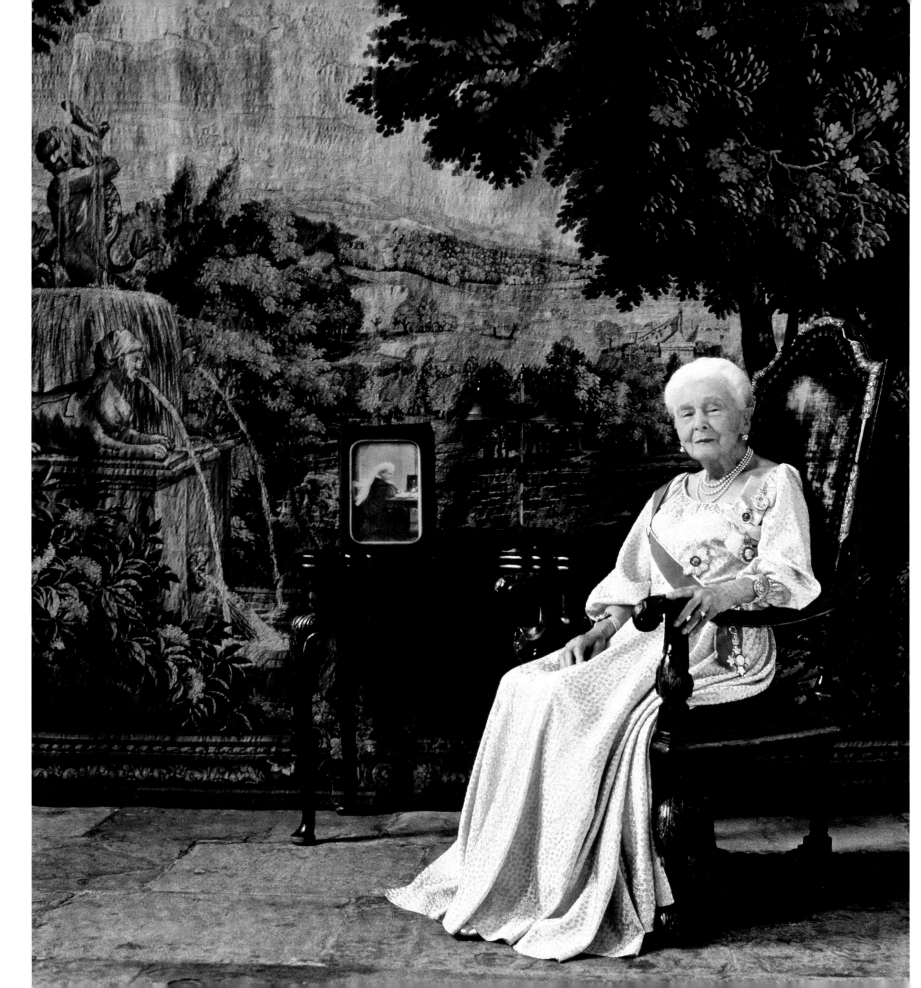

Princess Alice,
granddaughter of
Queen Victoria  1978

186    The Prince and Princess of Wales with Princes William and Henry, Highgrove  1991

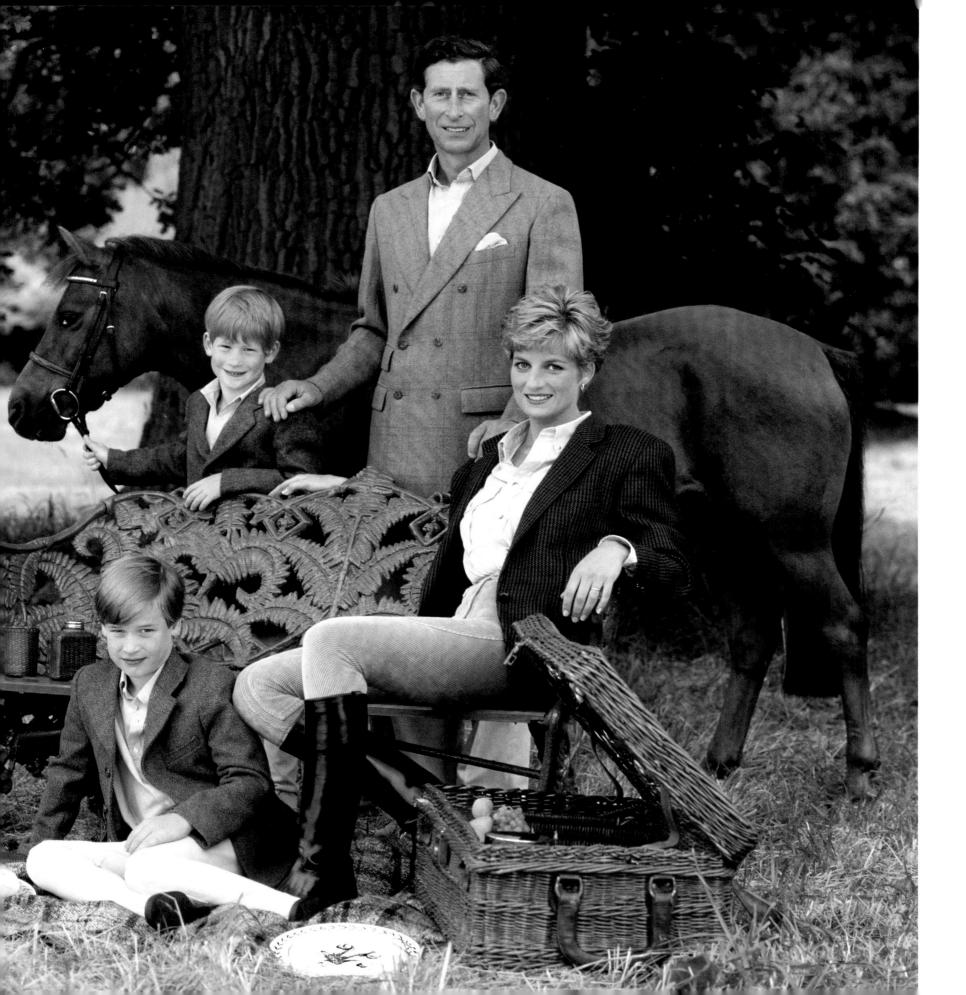

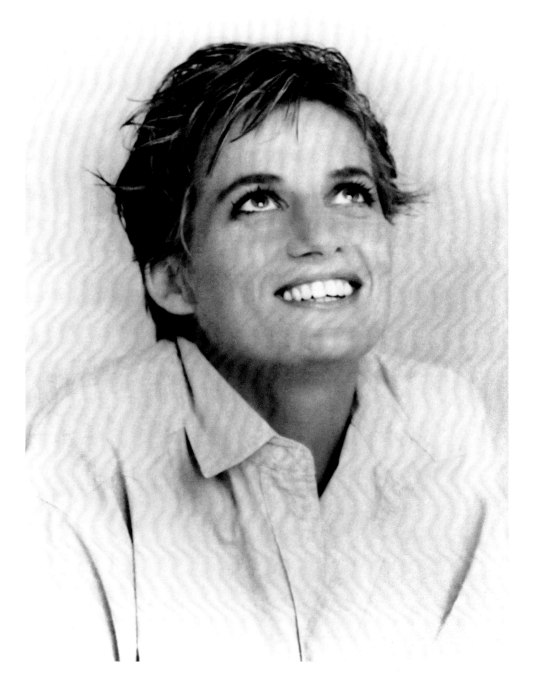

188     **The Princess of Wales**  1991                                                                  **Princes William and Henry**  1991

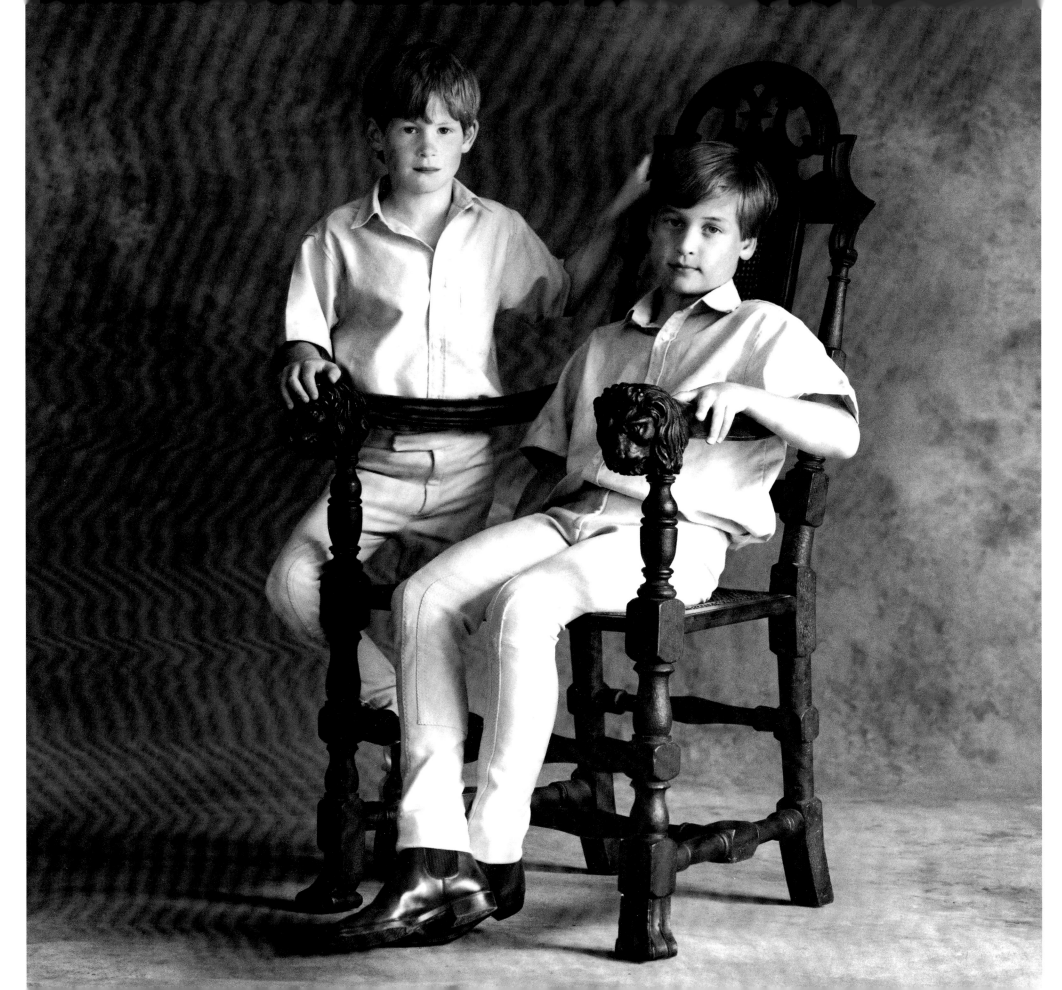

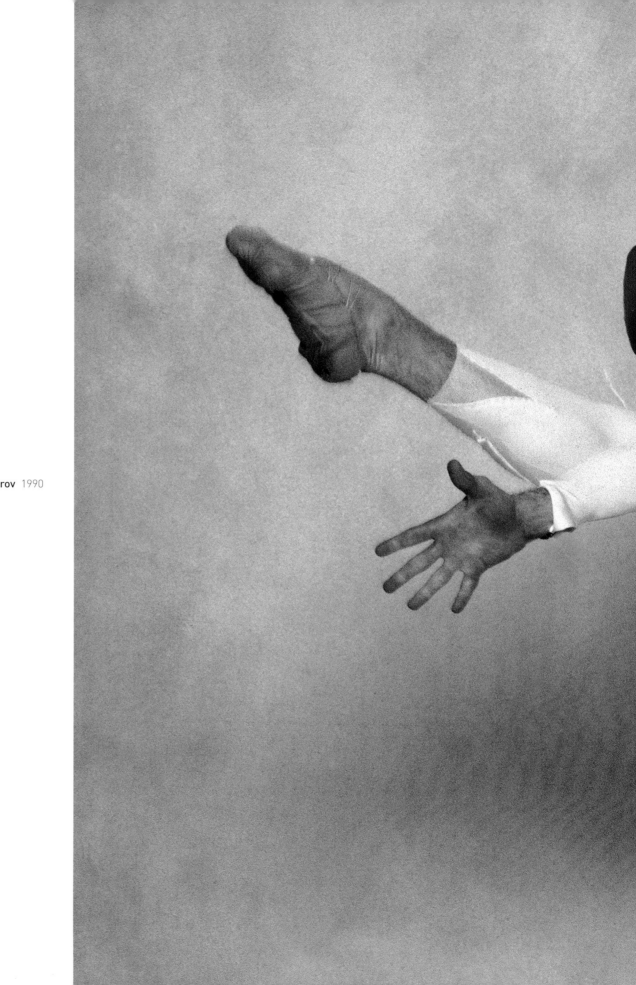

190      Andris Liepa, *Petrushka*, the Kirov 1990

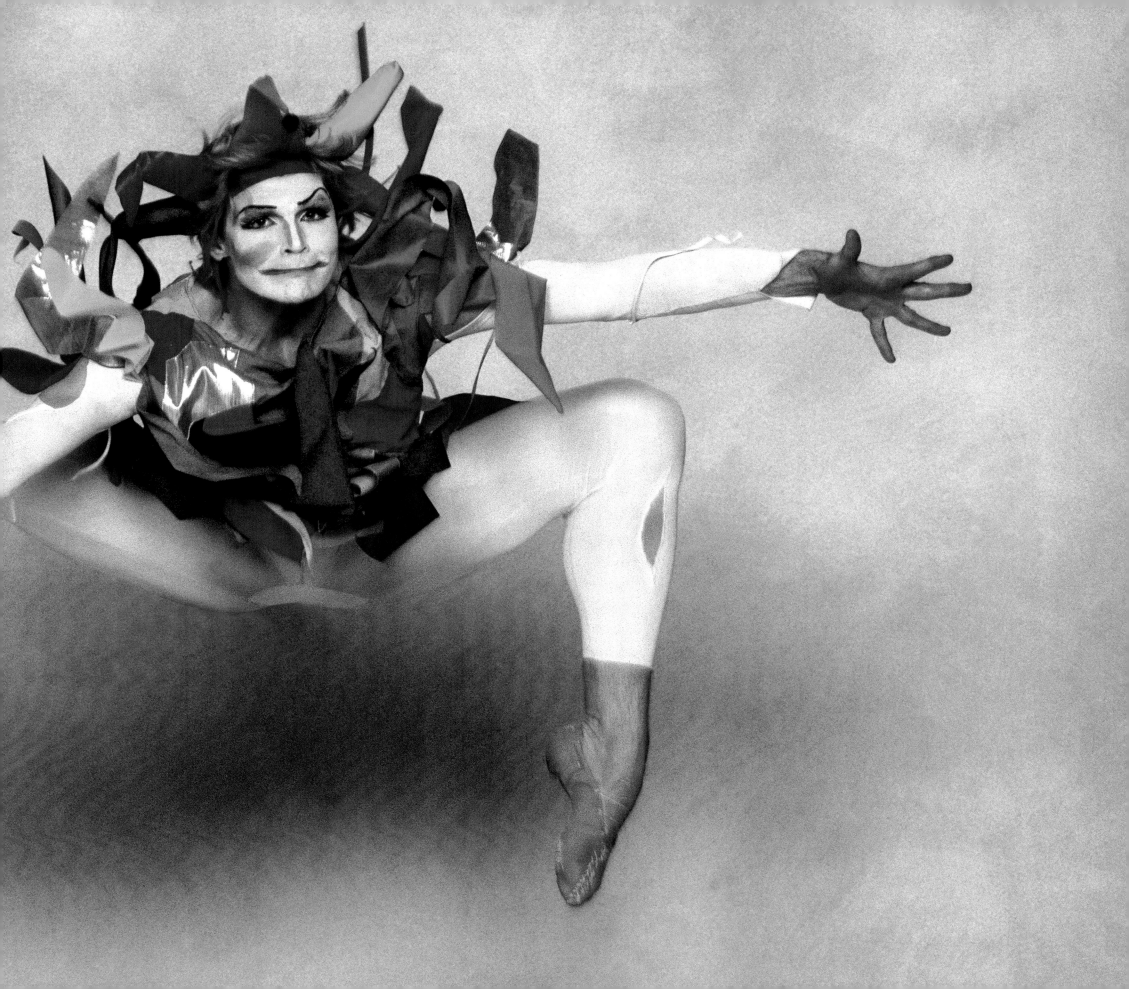

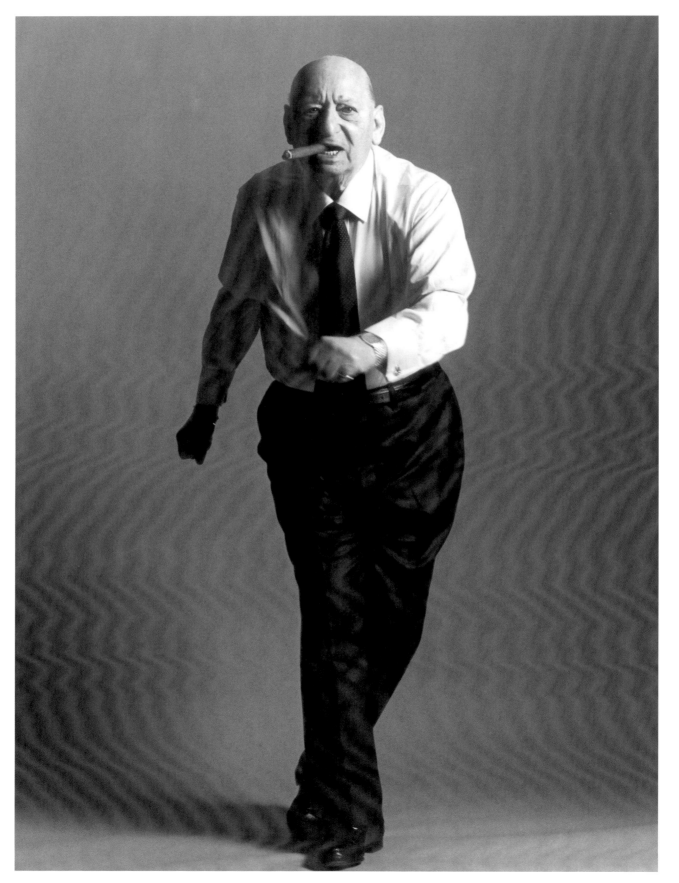

Lew Grade 1998

Faroukh Ruzimatov, the Kirov 1990

194    White-Crested Blue
       Poland Hen 1992

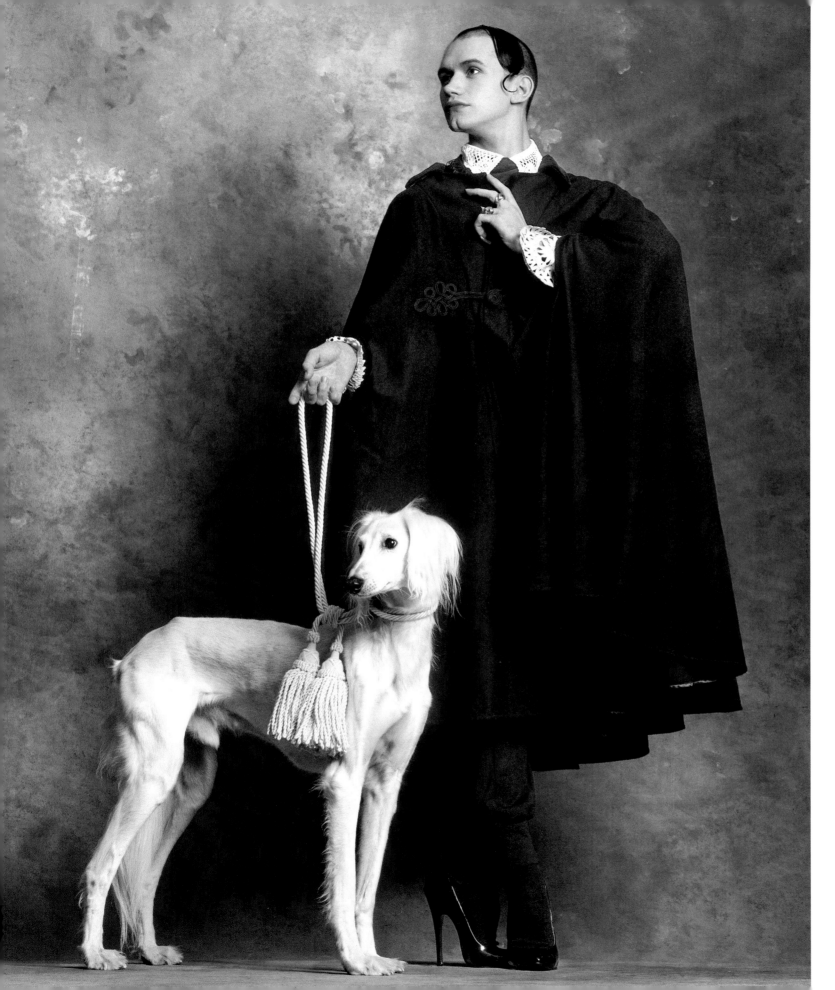

Michael Clark  1987

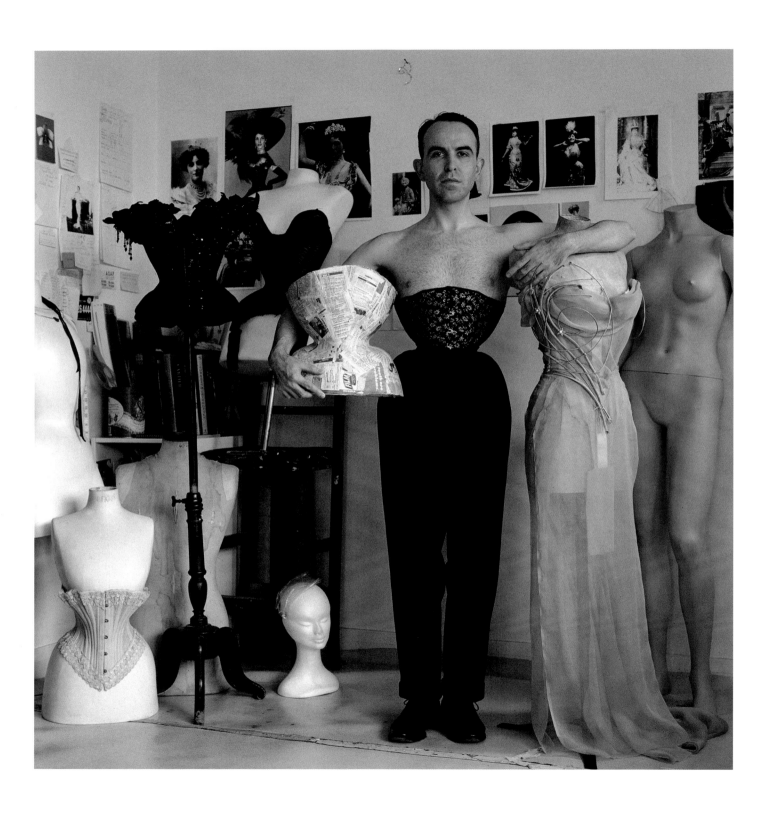

Mr Pearl 1998

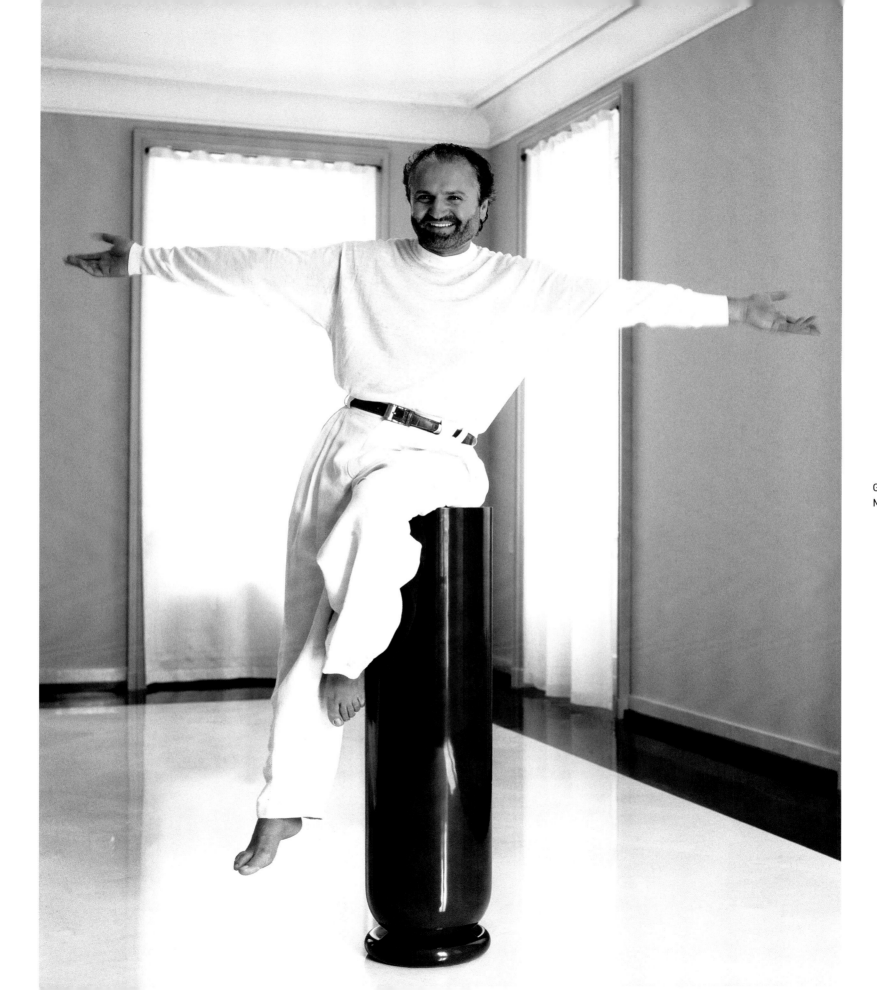

Gianni Versace,      197
Milan 1990

Wolfgang Joop, Monte Carlo *1999*

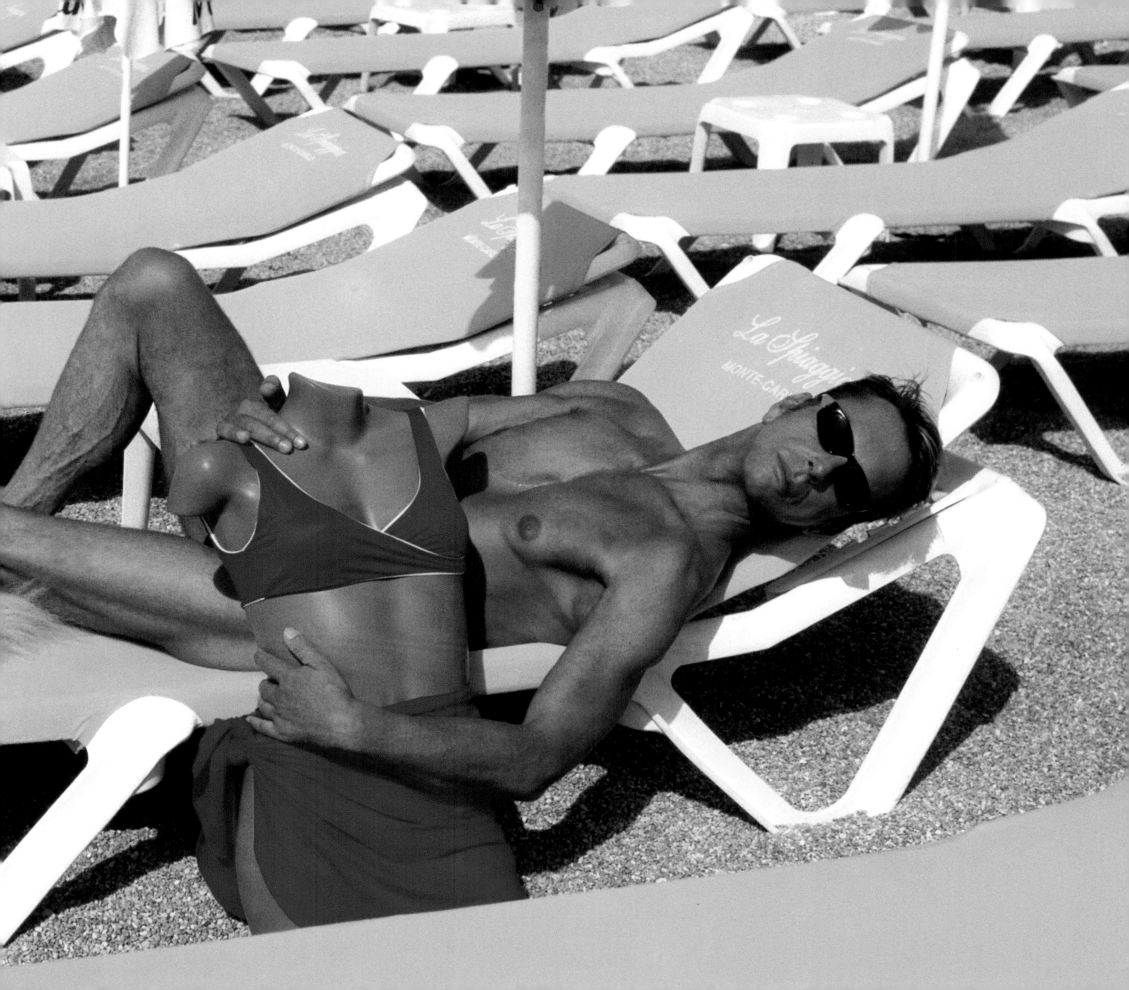

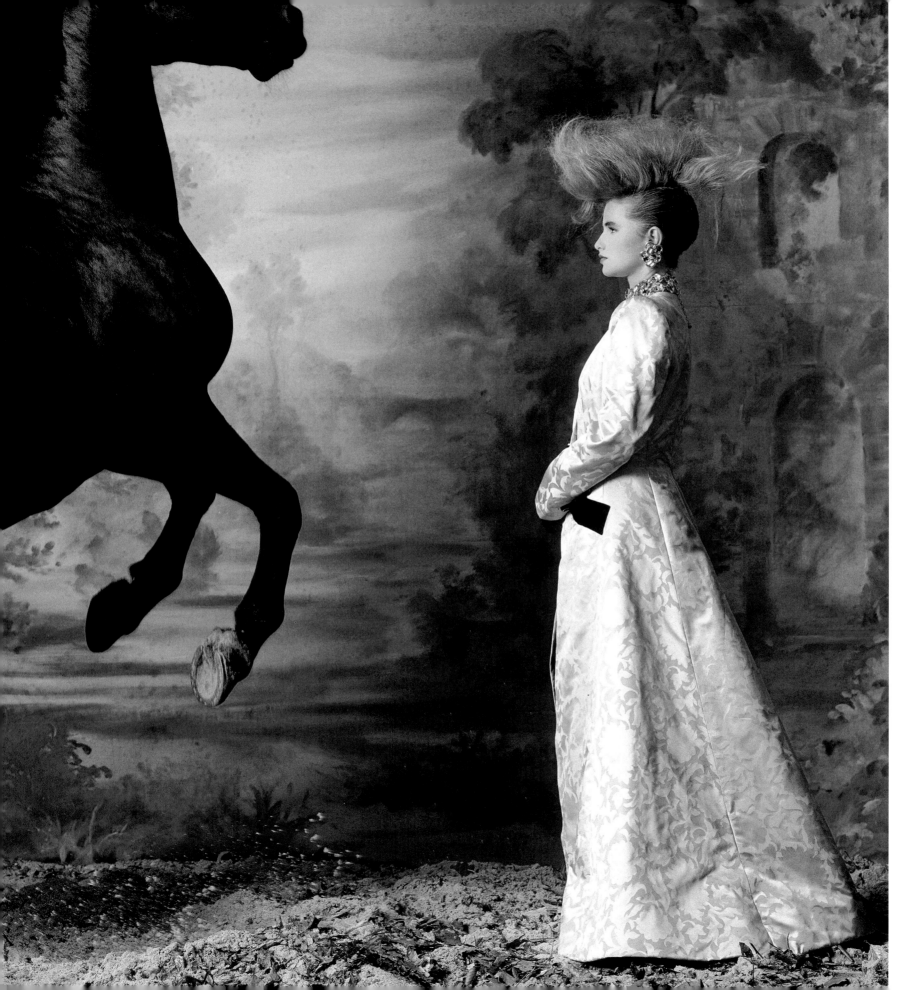

Isabelle Pascoe, the Paris
collections for *Vogue* 1985

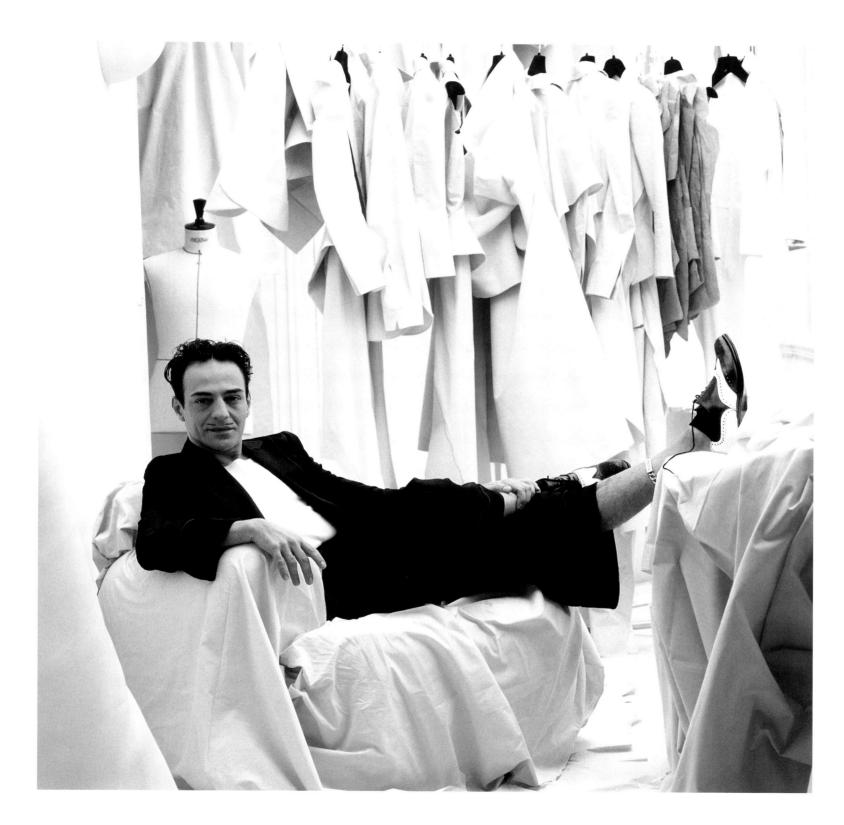

John Galliano, 201
Paris 1994

Simon Callow 1995

# SIMON CALLOW

I WAS just thirty years old, cock-o'-the-walk, fresh from the Fringe and insane with joy to be rehearsing the part of Mozart in the original production of Peter Shaffer's *Amadeus* at the National Theatre, when the press office informed me that I was to be photographed by Snowdon for *Vogue*. I was suddenly filled with terror infinitely greater than any I had felt at the prospect of creating a sensational part in a new play by Britain's most successful post-war dramatist, opposite Paul Scofield, directed by Peter Hall. In that I would be somebody else, but in front of Snowdon's lens, I would be me, and he would be sure to see straight through me. This was the man, after all, who had photographed Marlene Dietrich and Noël Coward, to say nothing of every actor of any account during the previous twenty-five years. I squirmed at the very thought of it, but obediently went along to Launceston Place like a condemned man going to the scaffold.

I don't know quite what I expected, but I remember being surprised and relaxed by the urbanity and instant intimacy of the slight, dapper man who to my surprise greeted me himself at the door. He seemed to know me already, not from anything he said but from the complicity of his look, and the teasing tone of his voice. But there was challenge too, an elfin authority which I realised I had better obey. He ushered me into the part of his house which he had adapted into a studio. He explained the large pieces of transparent milky plastic at the windows: they had come from a hardware shop in Brixton, but proved to be perfect filters for the natural light which was the only light in which he was then prepared to shoot. He pooh-poohed the technology of photography, claiming to know nothing about it and nothing about cameras. He talked about how he had started in the Fifties, about the happy accident of his pioneering style of *photo-vérité*, about some of the famous wits and geniuses whom he had, in his favoured word, *snapped*.

As he talked, he kept clicking the shutter and every time he did, I tensed further, developing a sixth sense about when he would press the button. Uncannily, the smiles, laughs and fascinated expressions he so readily provoked froze nano-seconds before the shutter opened. He changed tack, again and again: first amusing, then intriguing, then moving me, but my zygomatic muscles were always one step ahead of him, forming themselves into a ghastly rictus the moment photography was in the offing. Snowdon began to be reproving, a little cross: 'You keep seizing up.' 'I know,' I said, helplessly, my worst fears fulfilled. 'It's very strange, isn't it,' he suddenly said, 'that you should have been given this part of Mozart. I mean it's a very important part, a wonderful part. What right have you to play it? Why, out of all the brilliant young actors in this country, have you been chosen? They could have had *anyone*. And you're acting opposite Paul Scofield, a really great actor. How did that happen? I simply don't understand. Can you explain it?' This time the rictus never came. I was so completely astonished at the full-frontal assault that I quite forgot to be self-conscious as he took twenty short snaps in rapid succession. 'That's better,' he said, all smiles and naughty charm again, 'we're

finished now.' I reeled away, more stunned than grateful; that came later, when I saw the photographs: the first time, I can honestly say, in my entire life up to that point when I had stood in front of a camera – as myself – without smirking. And it cracked it for me, the whole ghastly business of being photographed. Like a Zen master, Snowdon had bashed me over the head and I had got enlightenment. I was never self-conscious in front of a camera again.

Whenever we met after that – at social events – he twinkled at me, remembering the lesson he'd given me. Later, he photographed me again, and it was delicious – and hard work. Whatever he'd like you to believe, there's nothing of the dilettante about Tony. He has no intention of wasting your time or his: every picture – *snap* – is a chance of something special. He has evolved his style unrecognisably from that of the young Turk who shocked the photographic establishment with his grainy and purposely blurred images, his sense of catching life and art (especially the art of the theatre) on the wing. Now he arranges life into conscious compositions. The quest is the same – truth – but the method is utterly different. He can be quite a bully, in his adorable way. Once he's found the pose and the expression that he wants, he expects you to bloody well hold it. 'Don't go dead on me!' he cries. 'You've gone dead!' then, with great solicitude: 'Is it awfully tiring?' 'Well, yes.' 'Tough!' he crows, triumphantly.

A couple of years ago, Tony left messages for me (in a number of different voices; his gifts of mimicry are dazzling: had he so desired, he could have given Mike Yarwood a run for his money) telling me that I was to write the introduction to a book of his theatre photographs. He told me; he didn't ask me. I was properly honoured, mindful that his work for the stage is, along with Angus McBean's, the most revealing photographic account of the theatre in our times. I have no idea why he chose me, nor did I ask him, for fear of getting a wicked, mocking answer back. I simply enquired what it should be like. 'Fun!' he said, absolutely typically, 'light and amusing and – fun.' I questioned him further. What sort of information did he want it to contain? 'It's very simple, really,' he said airily, 'you just have to say what's happened since Suez.' I took him at his word, at least as far as the history of the theatre was concerned, and instead of being daunted by it he was enchanted by the massive and perhaps rather earnest essay that I duly penned. It was, I hoped, a number of things, but fun was not really one of them; notwithstanding, his enthusiasm for it knew no bounds. Working with him on the book was fun all right, wicked, slightly tipsy fun, as he and his assistants pulled out box after box of breathtaking shots, many accompanied by scurrilous background anecdotage. A mere fraction of the contents of that Aladdin's cave found its way into the book, but to peruse it at close quarters with the photographer himself was to see the theatre of an epoch come to life – performers and performances caught in the act, their impulses made flesh as Snowdon's shutter unerringly blinked, pinning them down as certainly as any lepidopterist's pin.

Les Dawson 1991

Griff Rhys Jones,
*The Wind in the Willows*
1991

205

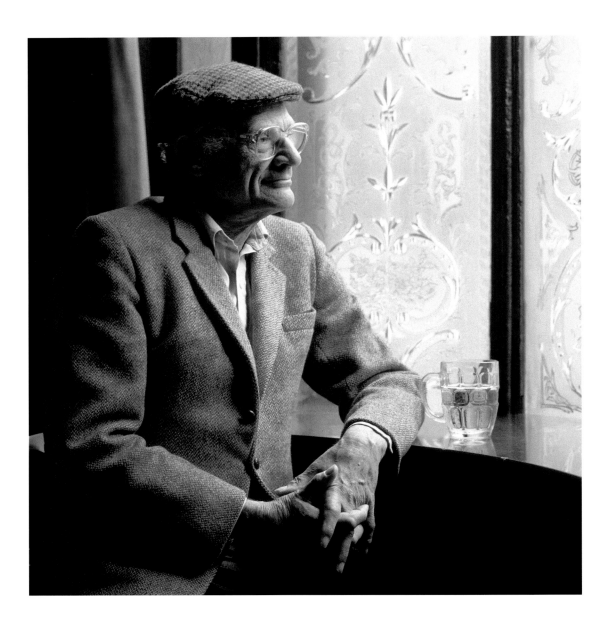

Arthur Miller, the Salisbury,
St Martin's Lane, 1991

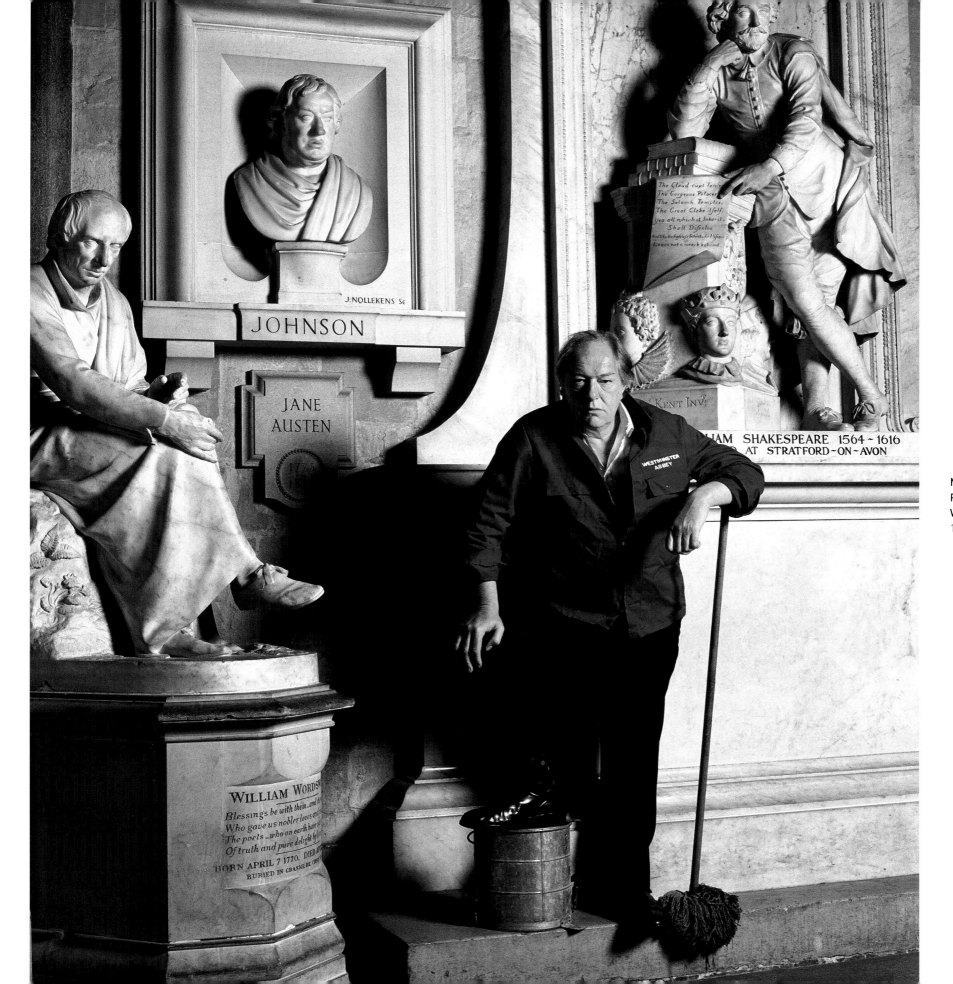

Michael Gambon,
Poet's Corner,
Westminster Abbey
1995

Kenneth Branagh 1995

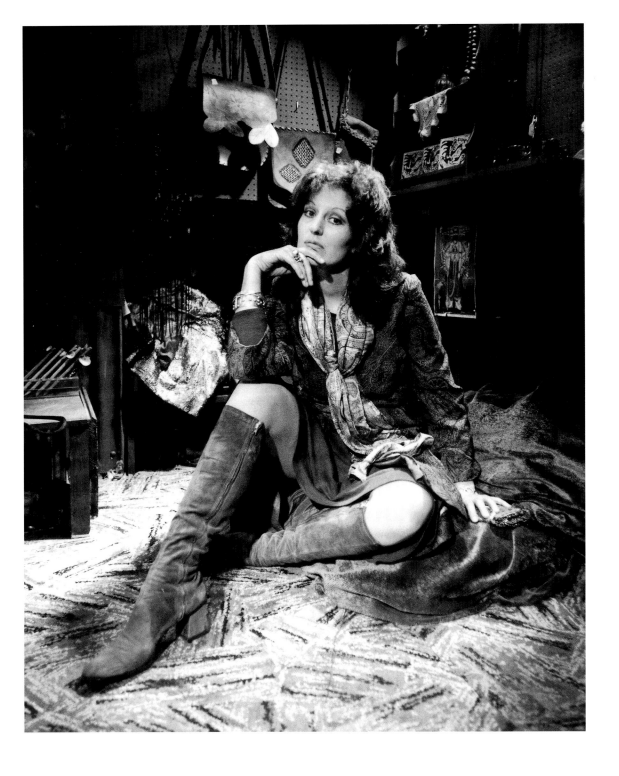

**Germaine Greer** 1971                              **Helen Mirren** 1995

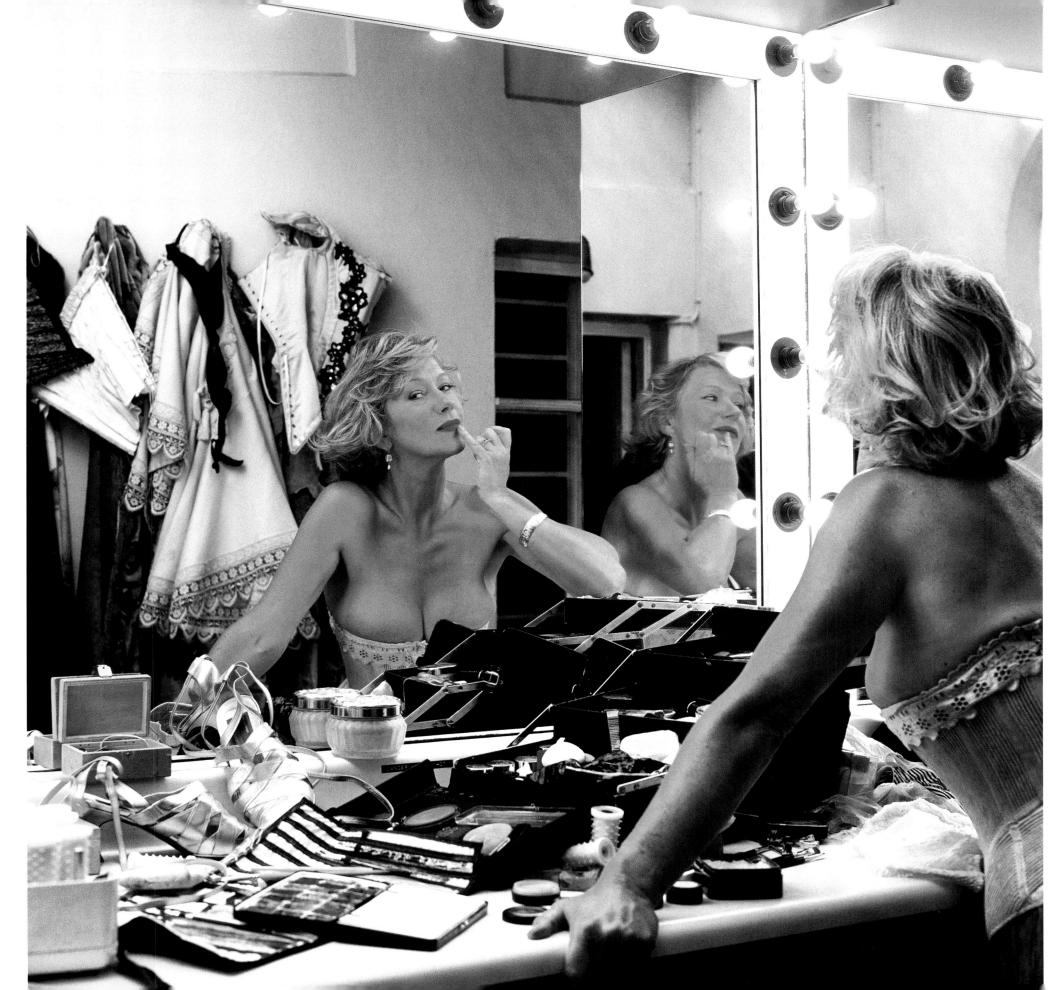

Emma Thompson 1993

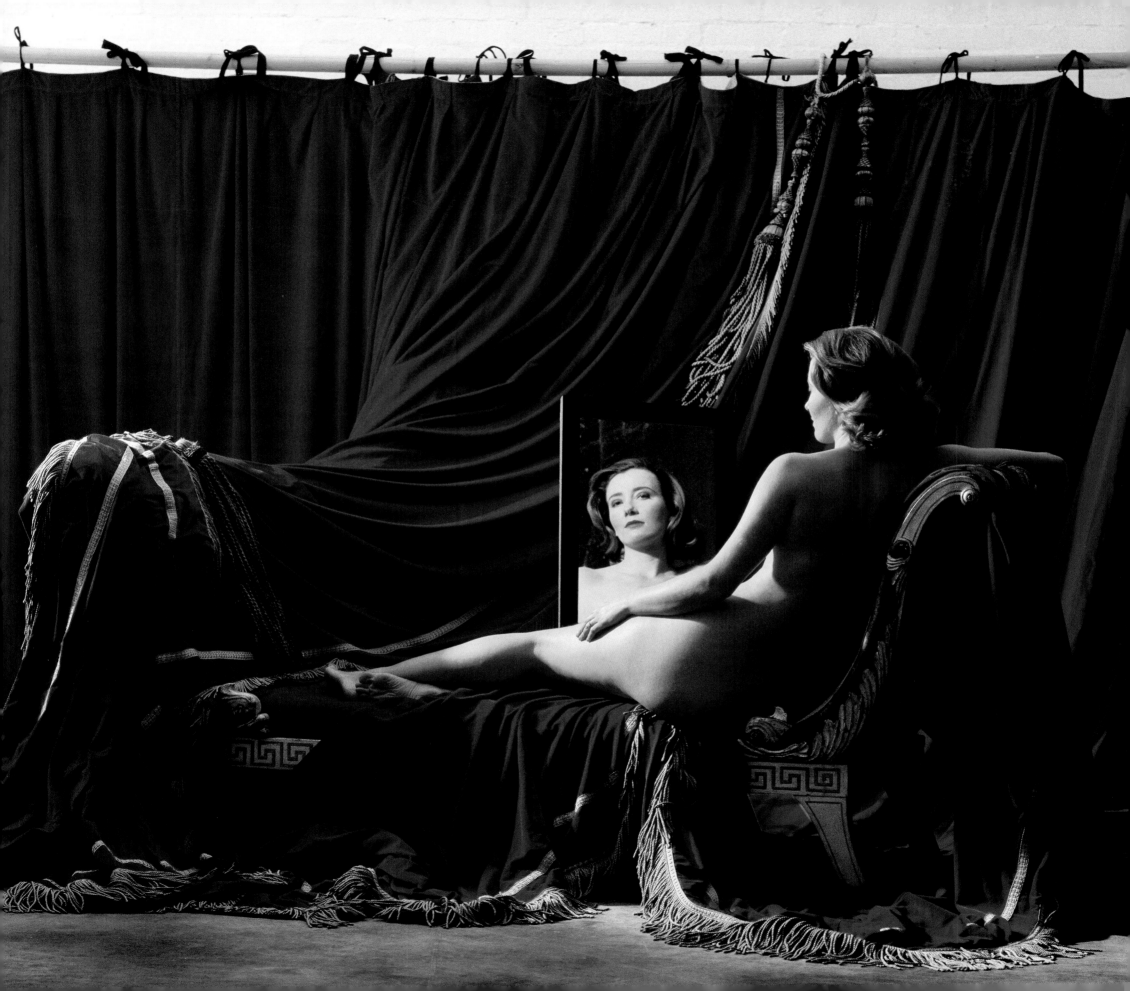

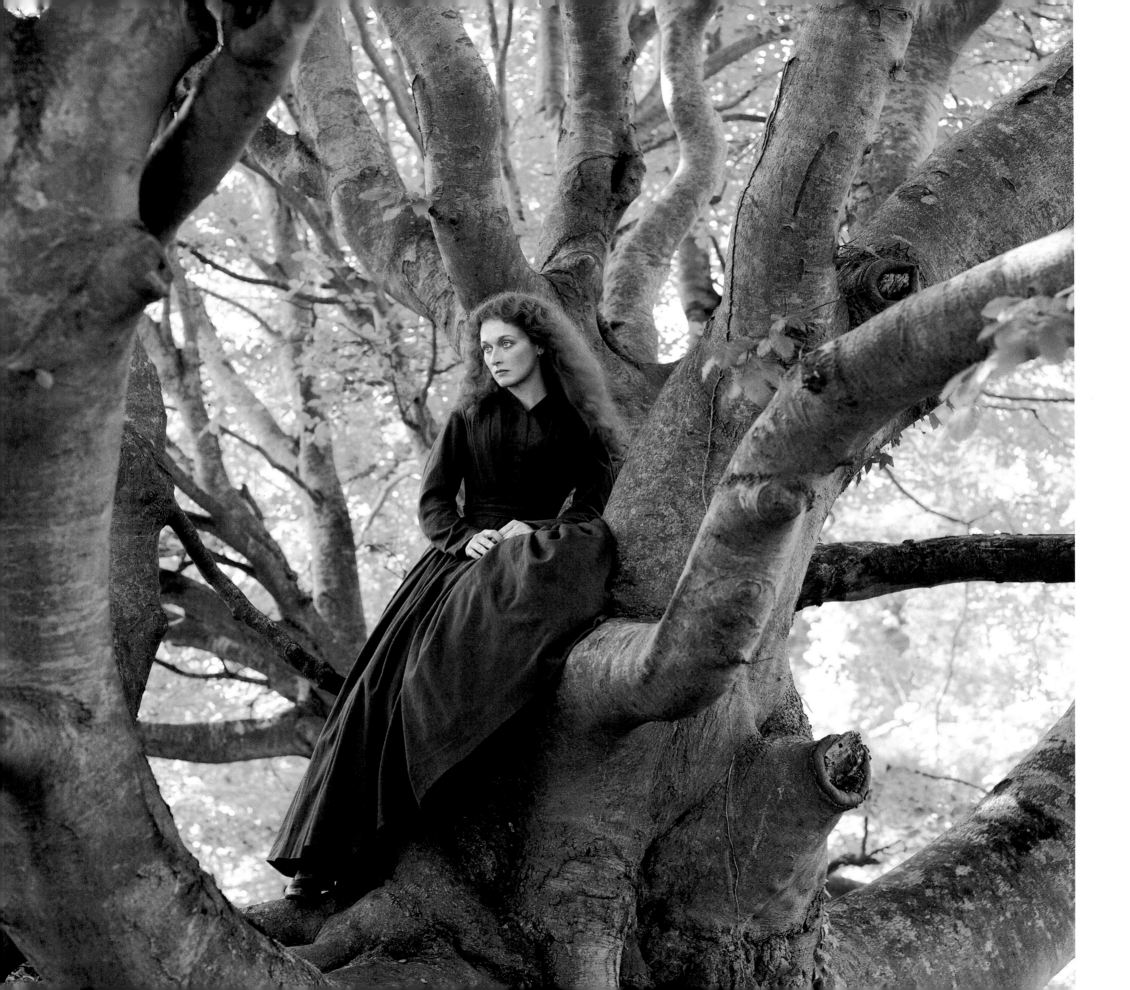

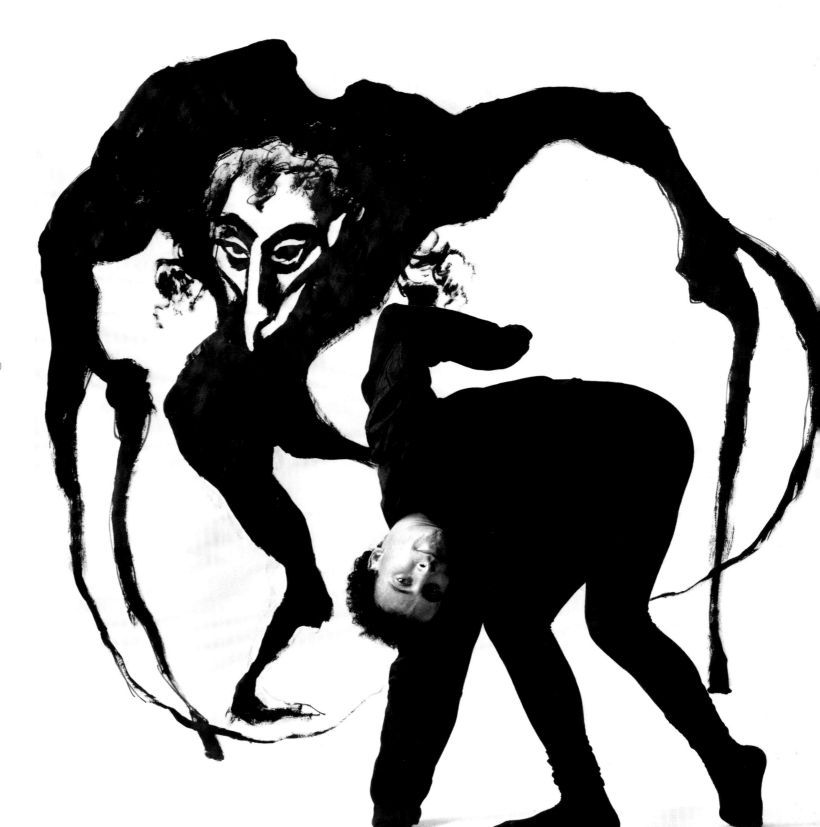

Meryl Streep,
*The French Lieutenant's Woman* 1980

Anthony Sher,
*Richard III* 1985

Deborah Warner 1995

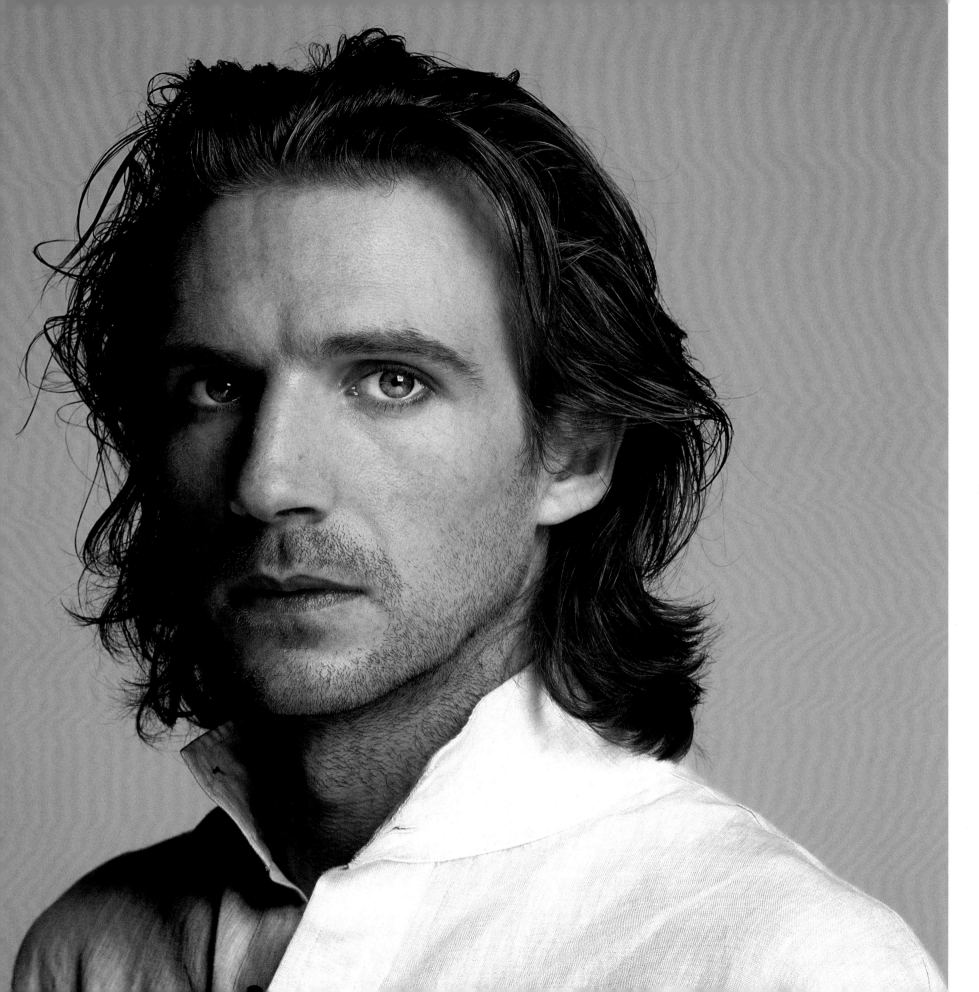

Ralph Fiennes  1995

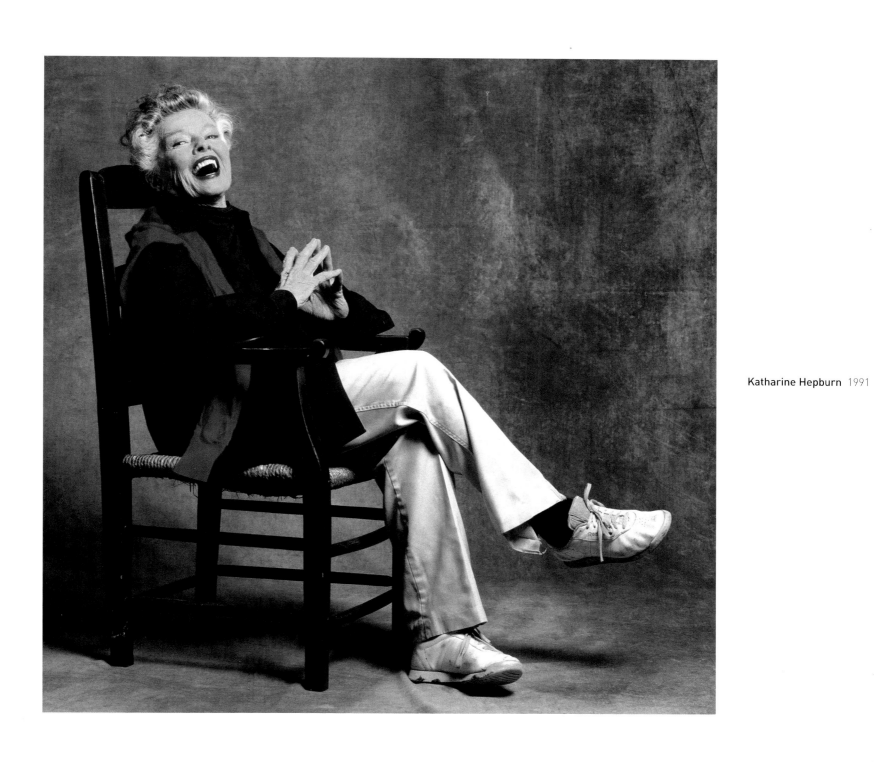

Katharine Hepburn 1991     219

220    Nigel Hawthorne,
       *The Madness of George III* 1994

Jane Horrocks, Iain Glen and
Imogen Stubbs 1995

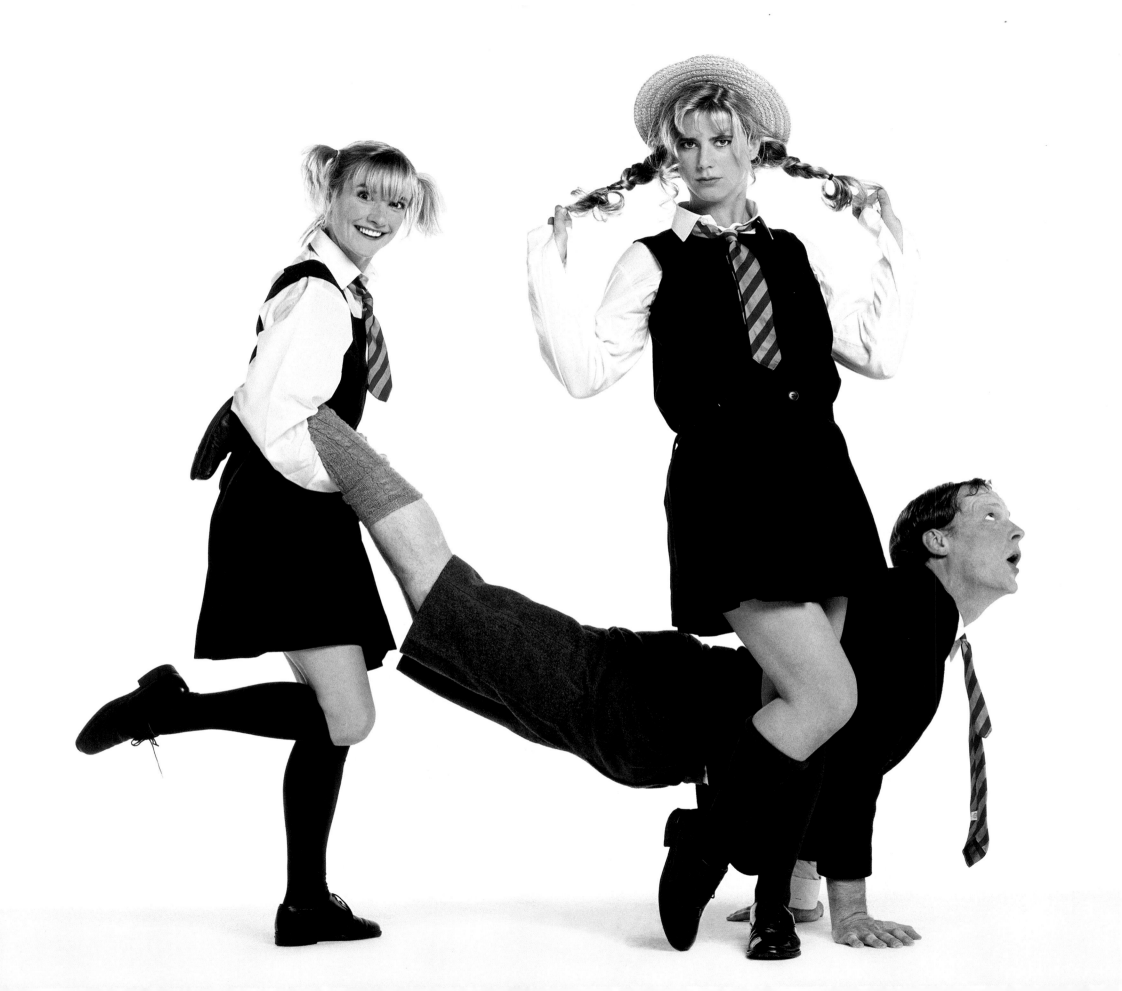

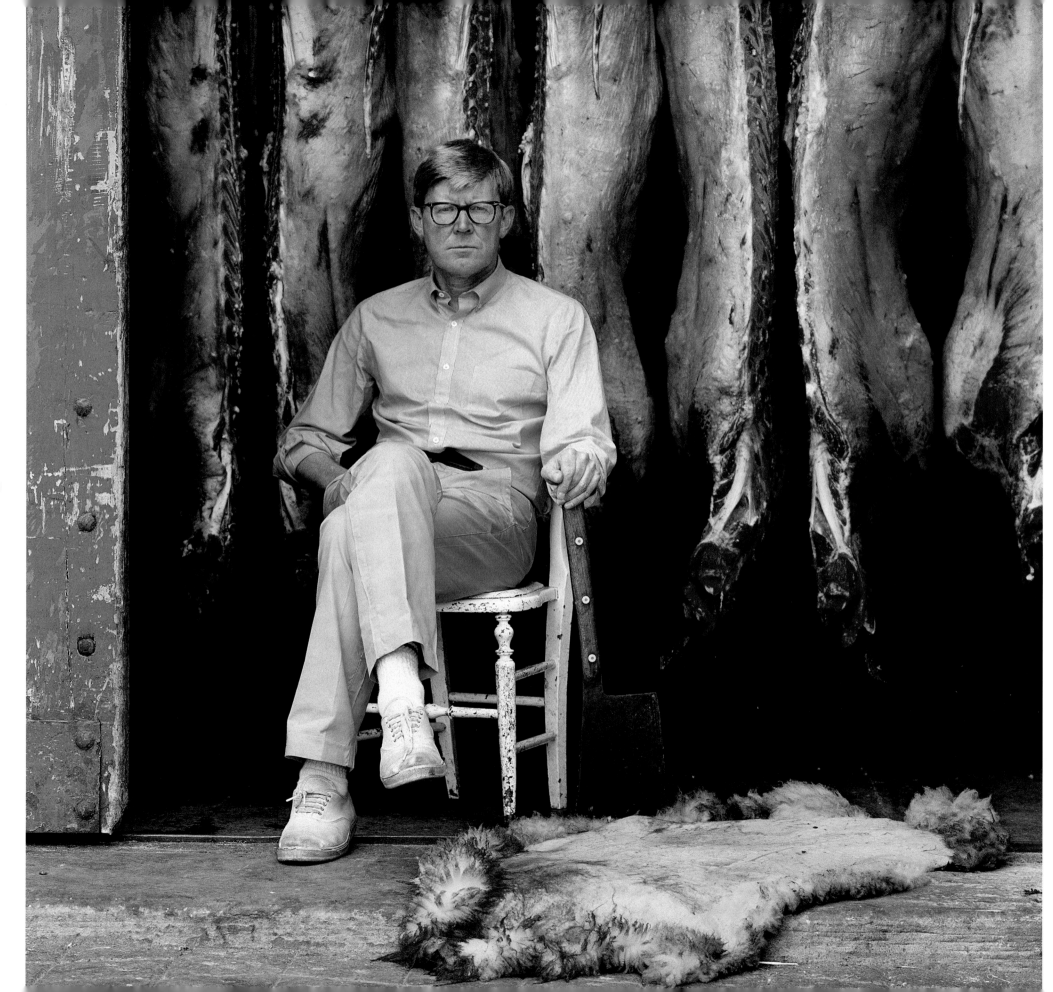

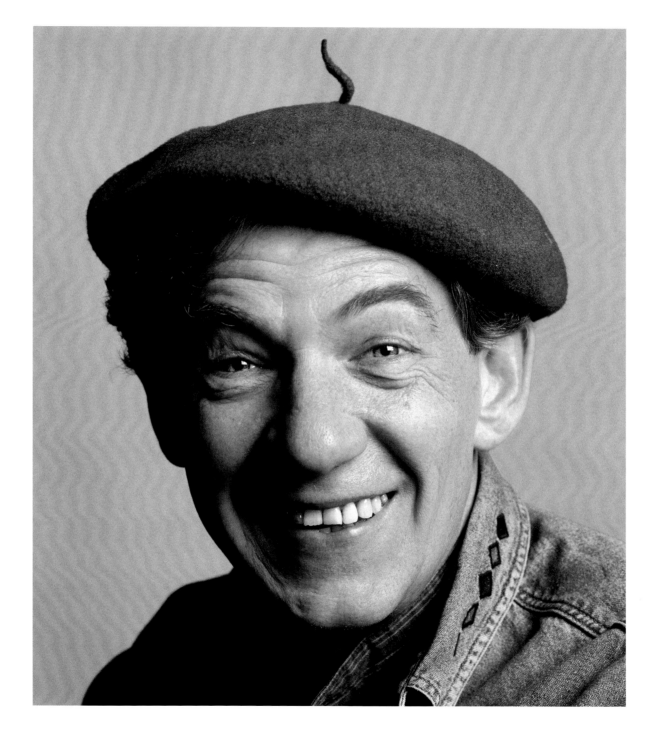

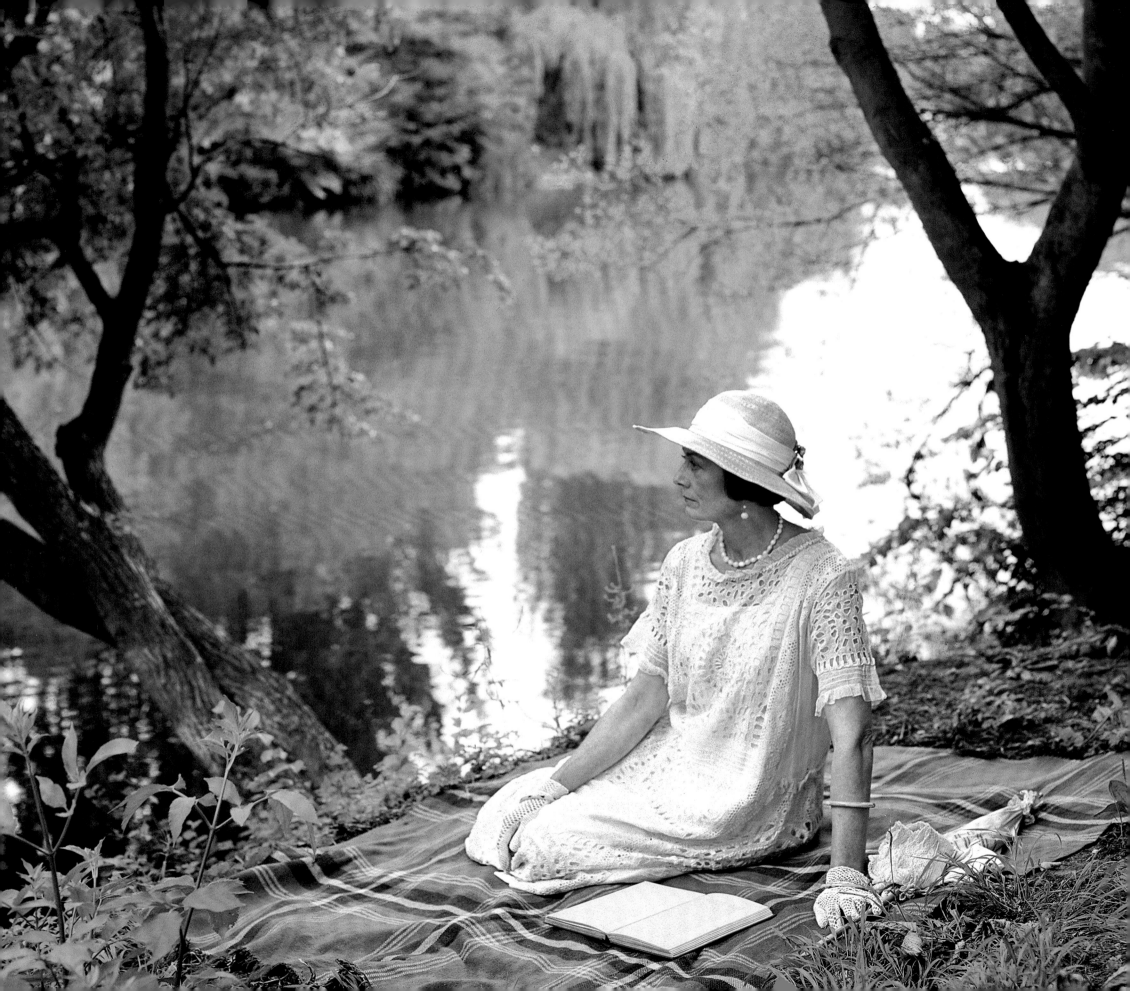

Vanessa Redgrave 1995

Natasha Richardson 1987

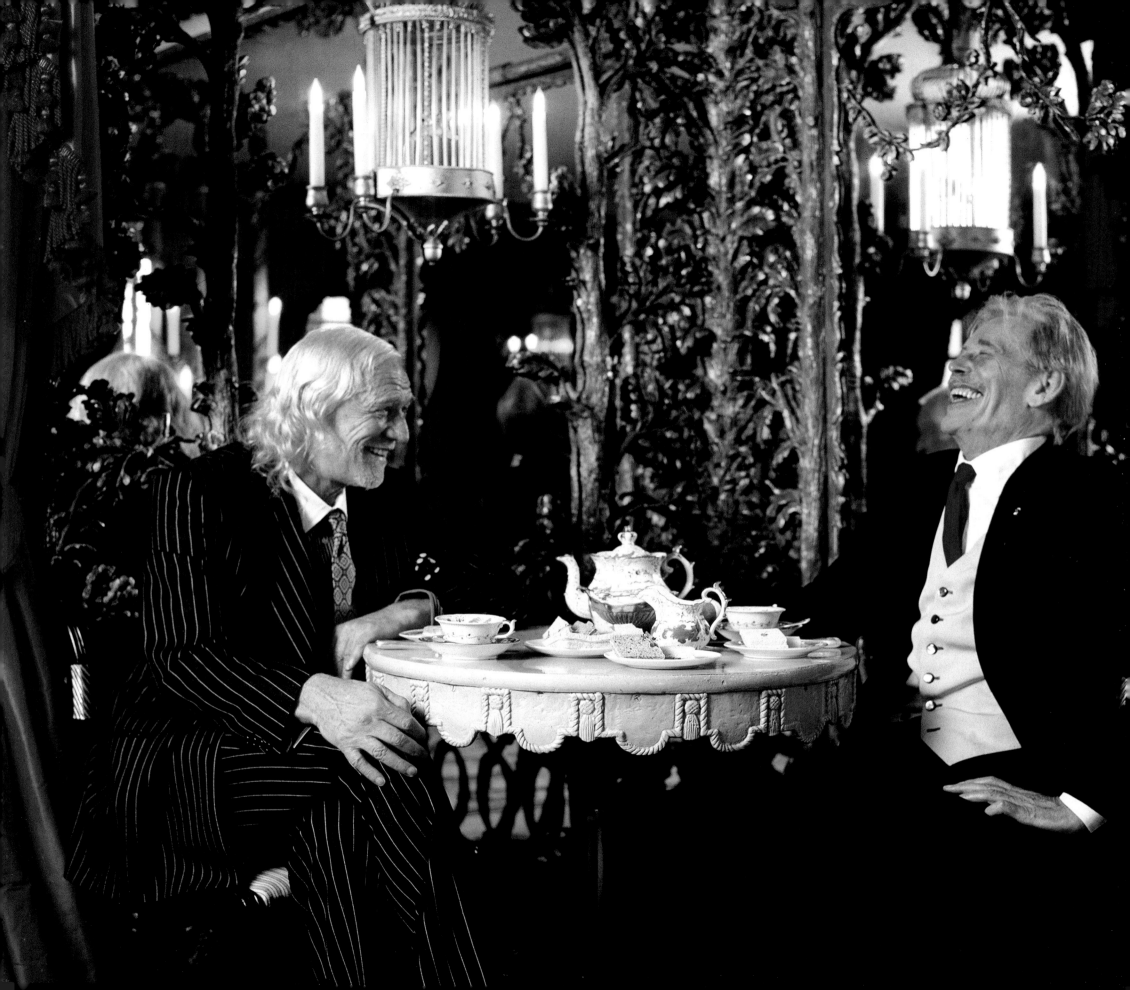

Richard Harris with Peter O'Toole, the Dorchester 1995

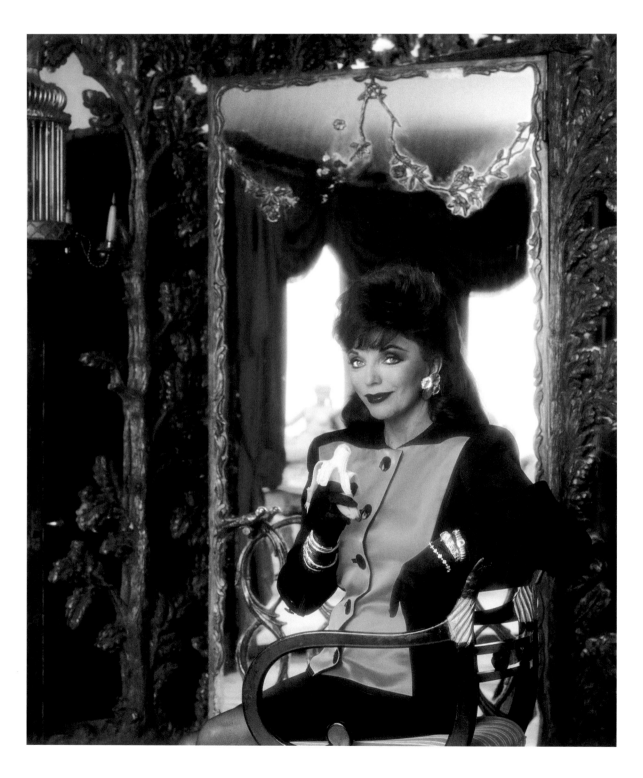

Joan Collins 1988

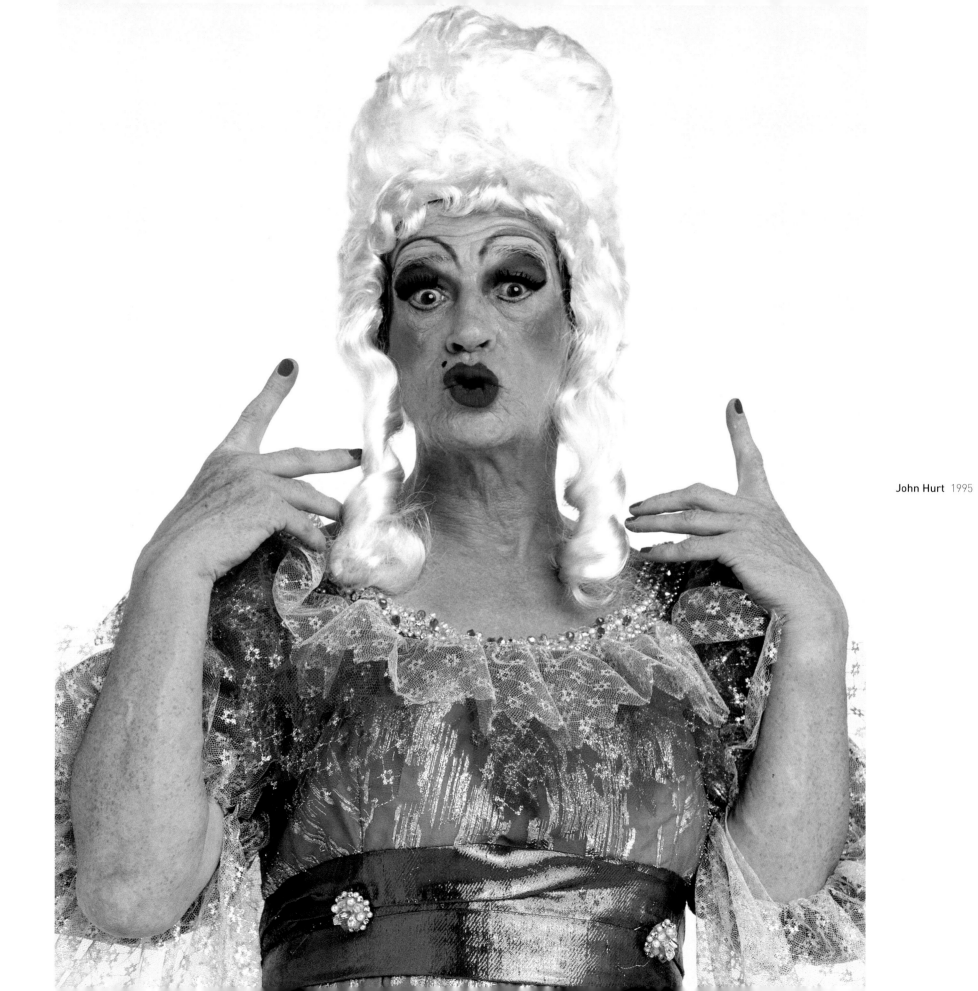

230

Uma Thurman, *The Golden Bowl* 1999

Stephen Fry 1993

# CHRONOLOGY

**1930** Tony Armstrong-Jones born March 7, son of Ronald Armstrong-Jones KC and Anne (neé Messel). Great-grandson of Linley Sambourne, political cartoonist for *Punch*; and nephew of the legendary theatre, ballet and opera designer Oliver Messel.

**1936** Played Peter Pan (three performances). Designed costume out of laurel leaves.

**1943** Left prep school with report from headmaster, 'Armstrong-Jones may be good at something, but it's nothing we teach here'. Went to Eton. Revived the Photographic Society. The Eton *Chronicle* said of his photograph of Upper School after bombing: 'This photograph would have been more lively if there had been people in it'. One year spent in the Royal Infirmary, Liverpool, with polio.

**1948** Went up to Jesus College, Cambridge. Read Natural Sciences for ten days before changing to architecture.

**1950** Contributed photographs to *Varsity* magazine. Coxed Cambridge in the Boat Race. Won by three and a half lengths. Failed exams.

**1951** Started three-year apprenticeship with society and ballet photographer Baron for which his father paid £100. Left after six months. Worked with David Sim, in Shaftesbury Avenue basement, taking actors' portraits for *Spotlight*. First picture published in *Tatler*.

**1952** Opened studio (in a converted ironmonger's shop) in Pimlico. First spread in *Picture Post*: flamenco dancers at an Oliver Messel party.

**1953** A regular contributor to *Tatler* and *Sketch*. Made an underwater camera for *Tatler* feature.

**1954** First theatre photocall: Terence Rattigan's *Separate Tables*. Used minature cameras for theatre pictures rather than the accepted plate camera. First assignment abroad (to Madeira for *Tatler*).

**1956** First photographs for British and American *Vogue*, *Harper's Bazaar* and the *Daily Express*. Large blow-ups used for the first time as theatre front-of-house display. Rented a room on the river in Rotherhithe to research *London*.

**1957** First exhibition *Photocall* at Kodak House, Kingsway. Began regular contributions to Jocelyn Stevens' *Queen* magazine. Official pictures of the Queen.

**1958** Designed high-key photographic sets for John Cranko's *Keep Your Hair On* (closed after two weeks). Designed collection of women's ski-wear.

**1960** Married Princess Margaret.

**1961** David Linley born. Began work on the Aviary at London Zoo with Cedric Price and Frank Newby. Joined staff of Council of Industrial Design. Editorial Adviser to *Design* magazine (until 1987). Honorary Fellow of the Royal Photographic Society. Retained by the *Sunday Times*, mostly for the new colour supplement edited by Mark Boxer.

**1962** Joined the Arts Council and the Council of the National Fund for Research into

Crippling Diseases. First feature for the *Sunday Times* on social issues ('Old Age', published 1965).

**1963** Appointed Constable of Caernarfon Castle.

**1964** Sarah Armstrong-Jones born.

**1965** Aviary opened. Completed the Isle of Man TT course on a Triumph 650cc motorbike in 44 minutes (the then record was 21 minutes).

**1966** Issue of the *Sunday Times* Magazine devoted to Indian coverage – arrested for photographing a bridge. Fourteen-page essay on the English theatre, with text by Penelope Gilliatt, initiating the phrase 'Swinging London'.

**1967** Photo-essays on Venice and Japan for the *Sunday Times*. Came fourth out of fifty-five in the two-way cross-Channel water-ski race (lasting three and a quarter hours, only seven finished).

**1968** First TV documentary (with Derek Hart) *Don't Count the Candles*, about aspects of old age. Wins two Emmys, the St George Prize at Venice, and awards at Barcelona and Prague film festivals; and is shown in 22 countries. Designed 'chairmobile', a motorised platform (5000 sold).

**1969** Responsible for the overall design of the investiture of the Prince of Wales at Caernarfon Castle; brought in Carl Toms as co-designer. Art Director's Club of New York certificate of merit.

**1970** Started work again for British *Vogue*. TV documentary *Love of a Kind* about the incongruous British attitude towards animals, with Derek Hart (who worked on the next two documentaries as well).

**1971** TV documentary *Born to be Small* about the problems facing people of restricted growth (Chicago Hugo Award).

**1972** Exhibition *Assignments* opened in Cologne. Subsequently shown in London, the US, the Far East and Australia. Maiden speech in the House of Lords on mobility for disabled people.

**1973** TV documentary *Happy being Happy*. Fellow of the Society of Industrial Artists and Designers.

**1974** Two historical documentaries for the BBC: *Mary Kingsley* (in Gabon) and *Burke and Wills* (in Australia). Fellow of the Royal Society of Arts.

**1976** Snowdon Report on Integrating the Disabled. Gained access for wheelchairs and guide dogs to the Chelsea Flower Show.

**1977** TV documentary *Peter, Tina and Steve*.

**1978** Married Lucy Lindsay-Hogg. Conferred Royal Designer for Industry (RDI). Royal Photographic Society Hood award for 'promoting concern for children, the disabled and the generally underprivileged.' Member of the Council of the English Stage Company (until 1982). Design and Art Directors' Association silver award.

1979 Frances Armstrong-Jones born.

1980 Founded Snowdon Award Scheme for further education of disabled students.

1981 President (England) International Year of Disabled People. Presented *Snowdon on Camera* for the BBC (BAFTA nomination).

1984 Stills of *A Passage to India*, directed by David Lean. Outstanding Achievement Award of the American Society of Magazine Photographers.

1985 Silver Progress Medal, The Royal Photographic Society.

1986 Appointed Senior Fellow, The Royal College of Art. Photographed the Paris collections for French *Vogue*. Designed (with Jeremy Fry) the 'Squirrel', a wheelchair with four-wheel drive and power steering.

1987 Highly publicised interview with Simon Hornby, Chairman of the Design Council. Resigned as Honorary Adviser to the Design Council.

1988 Patron of Polio Plus. Another highly critical interview, with Sir Robert Reid, Chairman of British Rail, highlighting the company's attitude to disabled passengers.

1989 *Serendipity*, exhibition at the Royal Pavilion, Brighton, Bath and the National Museum for Film, Photography and Television, Bradford. Honorary Doctorates, University of Bath and University of Bradford.

1990 Contract to photograph for the *Telegraph* Magazine. Designed a series of prism clocks. 'Natterjack toad' included in *Life* magazine's 'World's Best Photographs 1980-90'.

1991 Designed 'The Link', a hearing device based on infra-red communication rather than amplification.

1994 Honorary Doctorate, University of Portsmouth.

1995 Provost, Royal College of Art. President of ADAPT (Access for Disabled People to Arts Premises Today). Contributed eighty-eight pictures for 'British Theatre' issue of *Vanity Fair*. Completed *Telegraph* Magazine contract, having photographed 223 pages and 19 covers.

1996 *Snowdon on Stage*, exhibition at the Royal National Theatre.

1997 Edited special 'London' edition of *Country Life*. Official portrait of the Queen and Prince Philip to mark their golden wedding anniversary, subsequently adopted for use as a postage stamp (his twelfth since 1957).

1998 Aviary at London Zoo given Grade II* listing.

2000 Retrospective opened at the National Portrait Gallery, London.

# PUBLICATIONS

*Malta* (with Sir Sacheverell Sitwell), Batsford, 1958

*London*, Weidenfeld & Nicolson, 1958

*Private View* (with John Russell and Bryan Robertson), Nelson, 1965

*A View of Venice*, Olivetti, 1972

*Assignments*, Weidenfeld & Nicolson, 1972

*The Sack of Bath* (with Adam Ferguson), Compton Russell, 1973

*The Inchcape Review*, Inchcape & Co., 1976

*Personal View*, Weidenfeld & Nicolson, 1979

*Pride of the Shires* (with John Oaksey), Hutchinson, 1979

*Tasmania Essay*, R.T. Banks, 1983

*Sittings 1979–83* (introduction by John Mortimer), Weidenfeld & Nicolson, 1983

*My Wales* (with George Thomas), Century Hutchinson, 1986

*Israel – A First View*, Weidenfeld & Nicolson, 1986

*Stills 1983–87* (introduction by Harold Evans), Weidenfeld & Nicolson, 1987

*Serendipity* (introduction by Carl Toms), Royal Pavilion Art Gallery and Museums, Brighton, 1989

*Public Appearances* (introduction by Jocelyn Stevens), Weidenfeld & Nicolson, 1991

*Wild Flowers* (foreword by Roy Strong), Pavilion, 1995

*Hong Kong*, Weidenfeld & Nicolson, 1995

*Snowdon on Stage* (introduction by Simon Callow), Pavilion, 1996

*Wild Fruit* (foreword by David Attenborough), Bloomsbury, 1997

*London Sight Unseen* (with Gwyn Headley), Weidenfeld & Nicolson, 1998

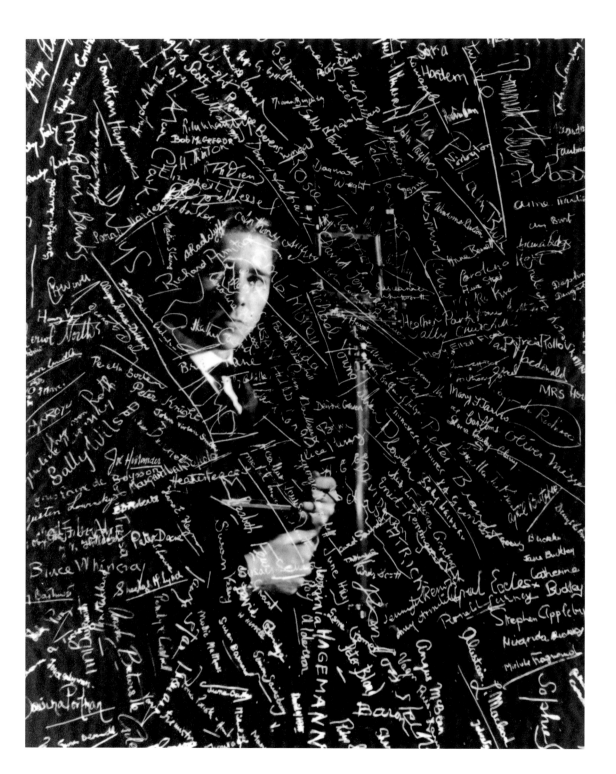

Self-portrait taken through 'visitors''
looking-glass, Pimlico studio 1956

# ACKNOWLEDGEMENTS

I would first like to thank all my patrons since the early Fifties – from theatre directors to magazine and newspaper editors and their art directors: George Weidenfeld, who published my first book on London; Harold Keeble, art director of the *Daily Express* in the 1950s; Mark Boxer, art director of *Queen* magazine, later editor of the *Sunday Times* Magazine; the editors of British *Vogue* Audrey Withers (1940–60); Beatrix Miller (1964–86); Anna Wintour (1986–87); Liz Tilberis (1987–92); and currently Alexandra Shulman; *Vogue* art directors Barney Wan, Sue Mann, John Hind and Robin Derrick; Michael Rand, art director of the *Sunday Times* Magazine; Nigel Horne, editor of the *Telegraph* Magazine; Joan Juliet Buck, editor of French *Vogue*; and Graydon Carter, editor of *Vanity Fair*.

John Barber; Drusilla Beyfus; Isabella Blow; Paul Bowden; Terry Boxall; John Brabourne; Peter Brightman; Julian Broad; Tina Brown; Simon Callow; Victoria Charlton; Ros Chatto; Hannah Christopherson; Felicity Clarke; Nicholas Coleridge; Lillie Davies; Gemma Day; Matthew Donaldson; Michael Dover; Chris Drake; Richard Dudley Smith; Roger Eldridge of Camera Press; Dorothy Everard; Harry Evans; Germano Facetti; Paul Gatt; Jane Gillbe; Richard Goodwin; David Harris; Anna Harvey; David Holden; Georgina Howell; Evelyn Humphries; John Humphries; Maggie Hunt; Tim Jenkins; Patrick Kinmonth; Alex Kroll; Isabella Kullmann; Terry Lack; Alexander Liberman; Candida Lycett-Green; Peter Lyster Todd; Robin Matthews; Simon Mein; Sophie Miller; Mash Mirza; Issey Miyake; John Mortimer; the National Portrait Gallery, London; Ophelia Nicholas; Nonie Niesewand; Nancy Novogrod; Tim O'Sullivan; Charlotte Pilcher; Anthony Powell; Carla Preston; Bryan Robertson; Ann Robin-Banks; John Russell; Nettie Smith; Stephanie Spyrakis; Bo Steer of Robert Montgomery and Partners; Jocelyn Stevens; Carl Toms; Marjorie Wallace; Steve Walsh and Mike Spry of Downtown Darkroom; Simon Warren; Colin Webb; Jill Westray; Susan White; Francis Wyndham.

I would particularly like to thank Graham Piggott, who has worked with me on so many of the sittings over the last few years. I could not have done this book and exhibition without his assistance, tireless energy and continuous support.

Above all I would like to thank more than I can say Ray Watkins and Robin Muir who helped with the choice of photographs and told me which to keep in and which to bin. They both had very determined views. My admiration for Ray started when she was the art director of the *Telegraph* Magazine. Robin arguably knows more about the history of photography than anyone I know, which includes total recall of any photograph that has ever appeared in print – a formidable team of talent and eagle eyes.

238